figure
sketching
school

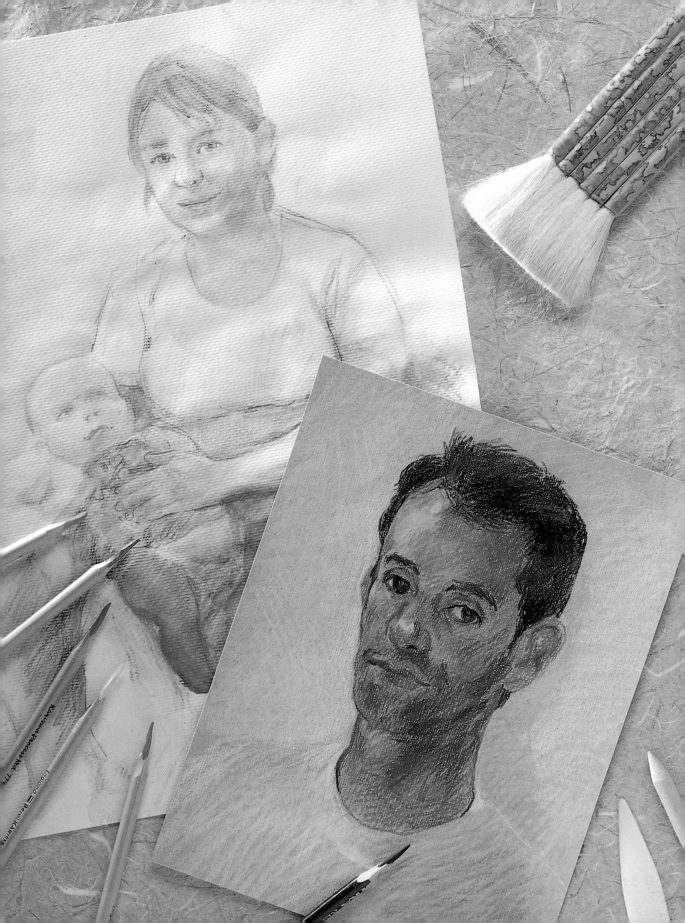

READER'S
DIGEST
Learn-As-You-Go-Guide

figure
sketching
school

Valerie Wiffen

Reader's
Digest

THE READER'S DIGEST ASSOCIATION, INC.
Pleasantville New York Montreal

A READER'S DIGEST BOOK

Designed and edited by Quarto
Publishing Plc

Assistant Art Director *Penny Cobb*
Senior Editors *Diana Craig*,
Kate Kirby
Text Editor *Ian Kearey*
Designer *Anne Fisher*
Picture Researcher *Miriam Hyman*
Photographers *Colin Bowling*,
Laura Wickenden
Managing Editor *Sally MacEachern*
Editorial Director *Pippa Rubinstein*
Art Director *Moira Clinch*

The credits that appear on page
144 are hereby made a part of this
copyright page

Library of Congress Cataloging in
Publication Data

Wiffen, Valerie
 Figure sketching school / Valerie
 Wiffen.
 p. cm. — (Reader's Digest
 learn-as-you-go guide)
 Includes index.
 ISBN 0-7621-0068-0
 1. Human figure in art.
2. Drawing—Technique.
I. Title. II. Series.
NC765.W49 1998
743.4—dc21 97-36243

Contents

Introduction

Even if you consider yourself a complete beginner, you may not be aware of how often you sketch already. If you have drawn simple illustrations to amuse a child, made a map to show someone the way to your home, or recorded the positions of vehicles for insurance after an automobile accident, you have used visual communication confidently. Sketching figures is no more difficult. Once you understand that the task is the same, you can make marks to represent what is seen and accumulate them to create the image of the person, whether those marks are made in pencil, paint, pastel, or any other of the many drawing media available.

Sketching is a way to create pictures and visions, just as letters are used to make words and stories. When you write, the confidence that guides your pen comes from long and frequent practice, and the skill that you acquired when you learned to write can be combined with sound observation to get you started in figure sketching.

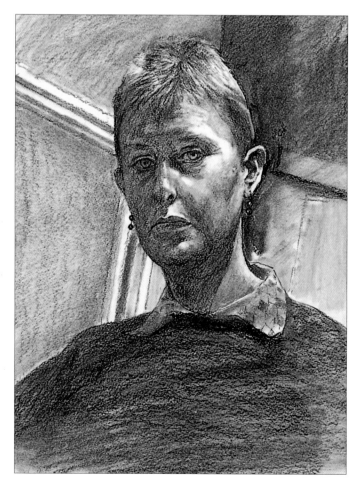

SINGLE PORTRAIT

If enough time is available, you have the opportunity to use a full range of marks and tones to describe the subtlety and detail that are revealed by close observation.

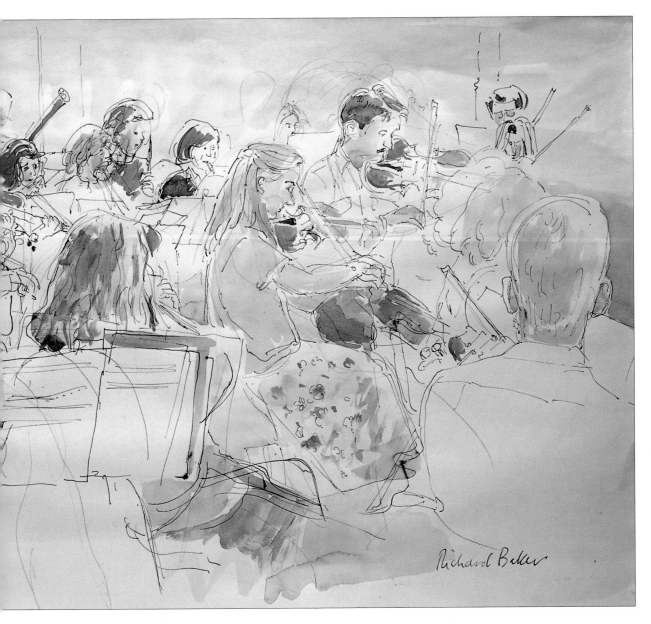

Richard Baker

LEARNING TO LOOK

If you do not look properly at what you see, you will sketch only generalities based on quick glances, which do not convey enough information to your memory for them to be translated into plausible marks. Working from memory alone may produce powerful emotional images, but it is difficult to monitor your skill level accurately without having a true visual comparison.

The most important single skill that is needed is the ability to observe reality. Treat this as a reference library, rather than your memory, and when in doubt, stop drawing and just look. Constantly examining your work against what you actually see points out mismatches and errors, which can be adjusted before a drawing is too far advanced.

The way to successful drawing does not come through copying secondhand reference material. This may be pleasing initially, because translating from an existing source of two-dimensional information is mentally easier than selecting your own material from the three-dimensional space around you, but copying flat work does not teach you to draw.

GROUP OF FIGURES

If your subject is only available for a short time, or if there are several figures in view, use your marks to represent the broad values; the details can be added later.

With practice in observation, you will be able to select what is needed to make a picture work from the unlimited visual information in front of you. This process of selection is part of finding your own personal style, which is as much a part of your identity as your handwriting, and can be worked on for improvement in the same way.

THE FOUR-STEP METHOD
Nearly all the problems encountered in figurative drawing and painting are caused by a lack of careful observation, failing to identify when a sketch diverts from reality, and continuing to work on a picture, in the hope that somehow it can be resolved later. You can avoid this sort of trouble by following a few simple steps, beginning with choosing the right viewpoint for your drawing: portrait (upright) or landscape (horizontal) format, the extent or size of your drawing, and the position from which the drawing is to be made. Once these choices are made, follow the process outlined below.

PORTRAIT STUDIES
Friends, passers-by, and strangers glimpsed while in motion may not yield enough information for fully finished portraits, but a sheet kept in a sketchbook for partial works builds into a useful source of reference.

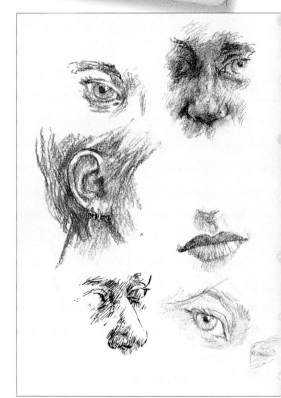

USEFUL FRAGMENTS
When time is short, you may not catch more than an eye, ear, or nose. Snatches are always worthwhile because they familiarize you with all the different facial details.

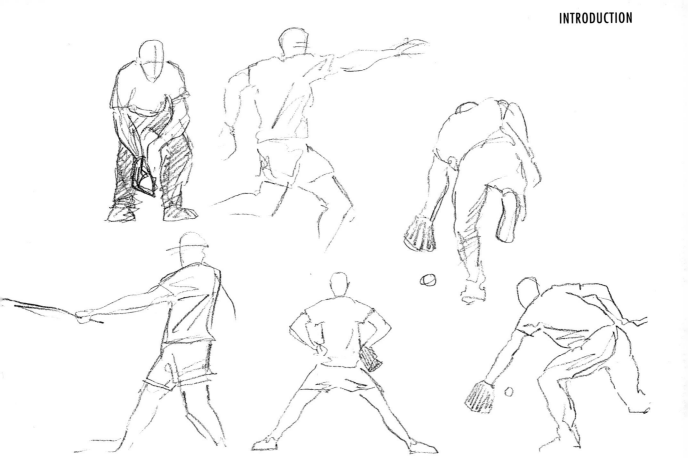

Step one involves your cognitive skills, as well as the physical process of looking. Take a long, hard look at the wealth of visual information available—not a superficial glance—and select the elements of what you see that you wish to represent. Step two is the physical act of making a representative mark, and step three is the stage when you immediately evaluate that mark. This step is essential, because if you go on when you have misrepresented something, your whole drawing will be based on inaccuracies. If you are satisfied that your mark is accurate, step four is using it as a keystone for the next mark. If not, step four is correcting and adapting the initial mark until it is acceptable.

Repeat all of these steps throughout the drawing process, making sure that you stand back regularly to check the overall effect. So long as you correct and adapt where necessary at step three, any problems can be resolved as they come up, and your completed sketch will be a truthful record of your visual experience, for all to see and share.

STUDIES OF MOVEMENT
For fast-moving studies, concentrate on the largest forms and the dynamics of the pose, and glean any details from resting figures.

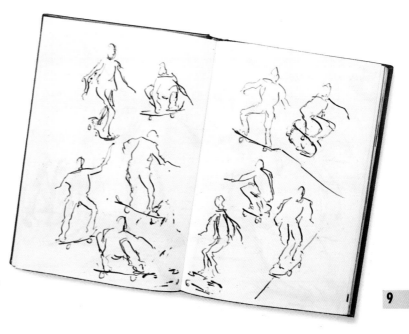

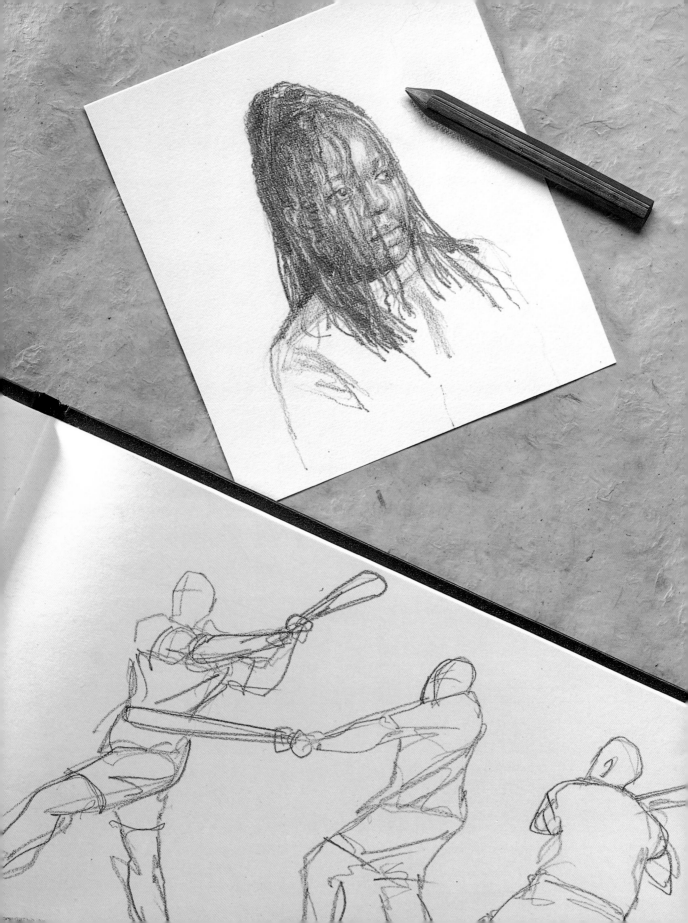

1

Getting Started

Size and Format

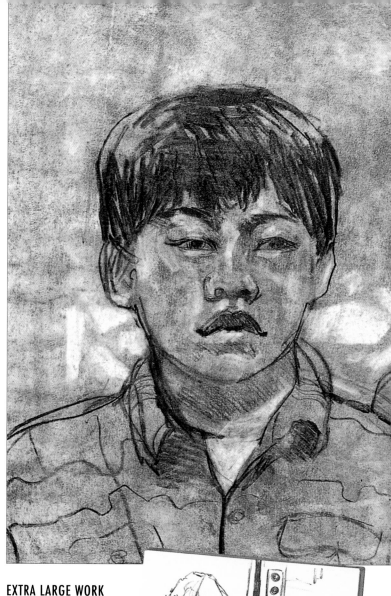

Many factors can influence the size and format you choose to work in, including the amount of time you plan to spend and your purpose for making the drawing. Before you to start to work, decide on these factors because they influence the choice of size. Keepsake portraits are usually small, for example, while a formal portrait might be life-size or more. Transient movements are best drawn in sketchbooks you can take to where the action is, but small drawings can be transposed into a much larger work (see Squaring, right). For observed work, you will avoid complications if you make the marks on the paper match the size you see. Working with marks that are too large or too small requires you to deal with reducing or enlarging uniformly and can cause some problems. To vary scale, work nearer to or farther from your model and draw "sight-size."

FORMAT

Composing a drawing in a rectangular format is the easiest way to work. The eye travels naturally to the line that divides a perfect square from the rectangle; a portrait with the eyes placed on this line will lead the viewer into the picture. The choice of whether to make the drawing portrait (vertical) or landscape (horizontal) is crucial, as it will determine the scope and boundaries of the subject and background. Until you have enough experience to choose how much to include by eye, make rough sketches of the possibilities, or use a viewfinder to visually frame your chosen subject; hold it near your eye to get a broad view, and farther away to select details (see "Making a viewfinder," right).

EXTRA LARGE WORK

Large drawings, such as this charcoal portrait, need to be executed to read from a distance, since the viewer stands back when viewing a final composition.

VERY SMALL DRAWINGS

Tiny drawings in small sketchbooks can be made with minimal marks when trying to capture a fleeting moment, or when you are pressed for time.

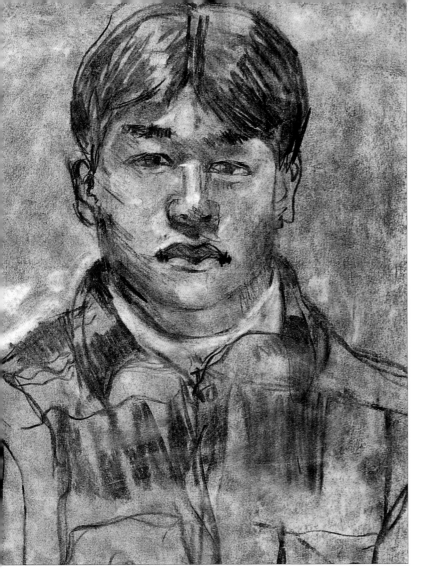

To make a large drawing from a smaller sketch, choose a larger piece of paper of the same format. Use a pencil to make matching marks across and down the smaller sketch, then draw joining lines across to make squares. Square the larger surface with the same number of lines, and transpose the drawing by copying each square. Number the squares if necessary, and include any partial squares.

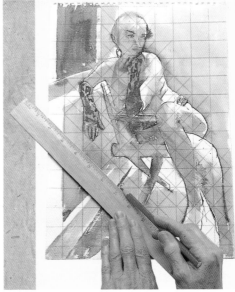

MAKING A VIEWFINDER

Cut out 12 pieces of heavy cardboard. Make three sides of a square, with one piece for each side narrower than the others. Glue each side together, with the narrow piece in the middle, making a groove. Tape the sides to make an arch. Leave the fourth side loose and insert it into the recess to make a square.

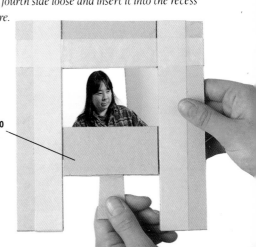

Vary the format to select your choice by pushing the unattached side up or down the groove.

DRAWING THE SITTER SIGHT SIZE

It is important to position yourself so that you can draw the size you see. For large, detailed work, stand close to your sitter, stand farther away for small or more generalized views.

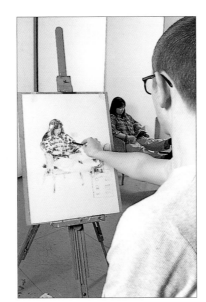

Basic Graphite Kit

GETTING STARTED

Pencil "leads" are made from graphite, a soft crystalline form of carbon, which is mixed with clay and fired in a kiln; a greater clay content makes a paler, harder lead, while more graphite gives a softer, blacker mark. The lead is then encased in wood, usually cedar, which is marked on the side with a number and letter classification. "B" is for black, with more graphite, and "H" is for hard, with more clay. The higher the number, the softer or harder the pencil, so the highest graphite number, 9B, is extremely soft. A selection of 2B, 4B, and 6B pencils is a good starter kit. H-grade pencils are mainly used for technical drawing, and are not suitable for fine-art work. "F" stands for fine; it is a hard, black lead that retains a sharp point, which makes it useful for small-scale work.

OTHER PENCILS

Graphite sticks are shaped like pencils without the covering of wood, and are also graded; 2B is a useful average. Some sticks are lacquered for clean use, so scrape them down if you wish to make broad marks, and wrap uncoated sticks in tinfoil. Graded leads are made for some technical, or propelling, pencils. Office pencils are usually graded HB or B, and ones that make black marks can be used for drawing. Use a sharp craft knife to sharpen your pencils.

ERASERS

Making marks isn't everything; you also need erasers to take marks away. Avoid gritty or smeary ones; flexible white plastic erasers remove marks without abrading the paper. Softening marks is best done with a stump, a piece of soft paper rolled to make a narrow, pointed cone, rather than your finger.

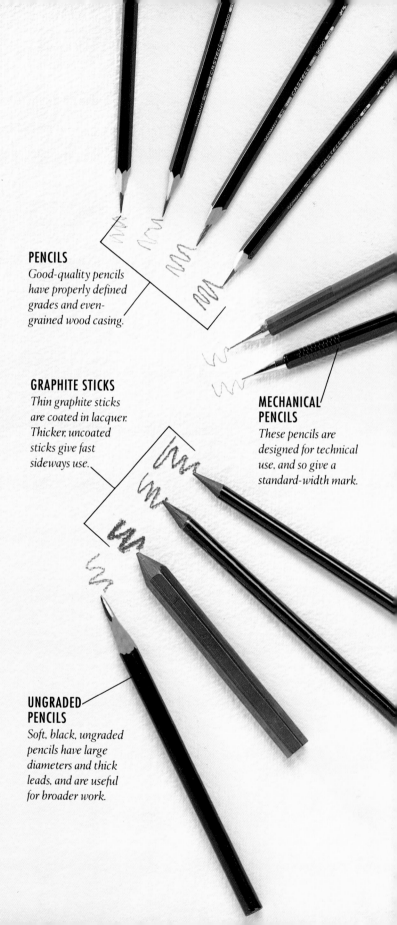

PENCILS
Good-quality pencils have properly defined grades and even-grained wood casing.

GRAPHITE STICKS
Thin graphite sticks are coated in lacquer. Thicker, uncoated sticks give fast sideways use.

MECHANICAL PENCILS
These pencils are designed for technical use, and so give a standard-width mark.

UNGRADED PENCILS
Soft, black, ungraded pencils have large diameters and thick leads, and are useful for broader work.

14

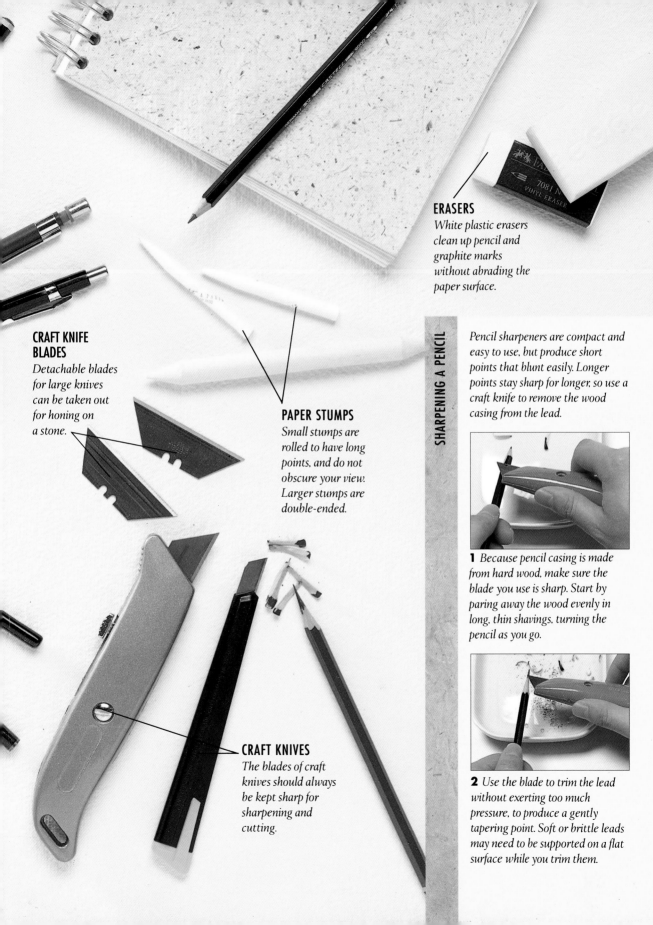

ERASERS

White plastic erasers clean up pencil and graphite marks without abrading the paper surface.

CRAFT KNIFE BLADES

Detachable blades for large knives can be taken out for honing on a stone.

PAPER STUMPS

Small stumps are rolled to have long points, and do not obscure your view. Larger stumps are double-ended.

CRAFT KNIVES

The blades of craft knives should always be kept sharp for sharpening and cutting.

SHARPENING A PENCIL

Pencil sharpeners are compact and easy to use, but produce short points that blunt easily. Longer points stay sharp for longer, so use a craft knife to remove the wood casing from the lead.

1 Because pencil casing is made from hard wood, make sure the blade you use is sharp. Start by paring away the wood evenly in long, thin shavings, turning the pencil as you go.

2 Use the blade to trim the lead without exerting too much pressure, to produce a gently tapering point. Soft or brittle leads may need to be supported on a flat surface while you trim them.

Paper

The surface of a particular paper determines the effect of media on it. There are three types of surface classification: "hot-pressed" (HP) is smooth, "cold-pressed" (CP) has a slight texture, or tooth, and "rough" is unpressed, with a visible raised tooth. The fiber content of paper ensures its longevity. Don't use cheap machine-made newsprint for drawing; it quickly becomes brown and brittle because its fiber content is made of wood, which has a high acid content. Most inexpensive drawing papers and sketchbooks are made of a mixture of wood and other fibers; these are still acidic and are acceptable for rough work, but not for much else. Better-quality paper is neutralized to counteract acidity, and is usually labeled "acid-free." Modern "mold-made" papers are manufactured by machine from new cotton fibers, but have many of the same qualities as handmade papers; buy these in roll form if possible, as cutting your own sheets is a great saving over buying ready-made books and loose paper. Handmade papers may seem expensive, but they are worth considering, particularly for watercolors, where some tooth is helpful.

BUYING PAPER

Shop around for good types of paper, as different paper mills vary widely in their choices of surface, weight, and price. Look for sale bargains or sample swatches of paper, and be prepared to experiment. It is worth trying Asian-made papers, which are made of bamboo, rice, jute, and other plant fibers. Colored papers are useful as toned grounds for pastels, chalks, and charcoal, but they may be acidic, and some cheaper types fade quickly. Store paper in a dry place and don't keep it in acidic wrapping.

TYPES OF PAPER

Paper is sold in loose sheets of various sizes as well as in sketchbooks in both landscape and portrait formats. Match purchases to the media you intend to use: smooth, hot-pressed paper for pen work, cold-pressed for pencil and chalk, and rough paper with a heavy tooth for wet media. Remember that transparent watercolors exhibit a color bias because the ground shows through.

Tiny or medium-sized pads can travel with you in a bag or pocket.

A large sheet of handmade, heavyweight cold-pressed paper

Rough paper with a pronounced tooth and cream tint

A specially created hammered effect in rough white paper

Heavy, hot-pressed paper in an off-white shade

Medium-weight, hot-pressed papers in cream, green, and gray

Lightweight, mold-made Ingres papers in tan and blue-gray

Lightly sized, absorbent heavyweights in green, cream, and two tones of buff

Large pads can be taken out for major works when you need extra space for big subjects or several small sketches together on one sheet.

Neutral shades are easy to use, but brightly colored papers are good to try when you want to influence the overall warmth or coolness of your color scheme, or to create a base to shine through chalk or pastel.

CUTTING PAPER

Ideally, it is best to use a paper cutter for cutting paper. But, if you don't have one available, here is a method that will enable you to tear paper neatly.

1 *If you have to tear by hand, use a bone folder (or smooth plastic substitute) to press in a crease first.*

2 *Paper has a "grain" and tears more easily one way than the other. If you find one direction difficult, start from the other side.*

STRETCHING PAPER

If you use a wet medium, such as watercolor, you will need to stretch all but the heaviest papers on a thick wooden board with a mat surface to prevent the paper from buckling when you apply the medium.

1 *Dampen thin paper lightly, using a sponge and clean water; because thin papers buckle quickly, work as fast as possible. Immerse heavier-weight papers briefly in a bathtub or sink.*

2 *Moisten pre-cut strips of gummed paper tape on a damp sponge, one by one as you work. Do not use tape made with contact adhesive, as this does not stick when wet.*

3 *Stick each strip, one by one, along an edge, half on the paper, half on the wood. Press the tape down and continue around all sides, checking that it has adhered to both surfaces.*

4 *If the tape lifts, dampen its surface and press it down again, or lay on an extra strip of tape with an overlap. When the picture is dry, use a sharp blade to cut sideways through the tape.*

Working Comfortably and Efficiently

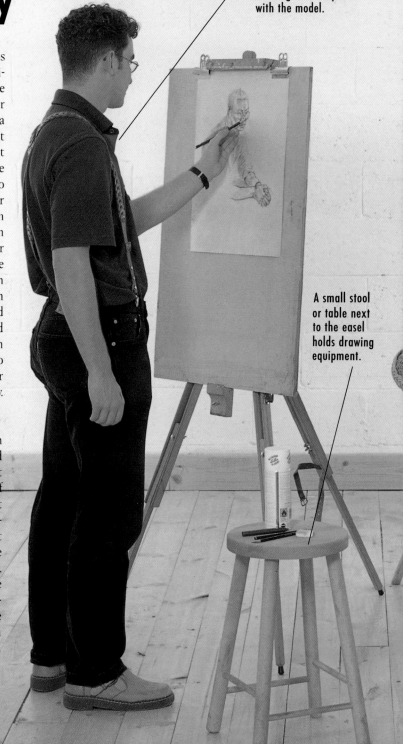

When working at an easel, stand back at regular intervals to judge your drawing and compare it with the model.

GETTING STARTED

Being comfortable helps you to work more efficiently, so take time to decide on the best situation for yourself. When working at a table, make sure that you sit in the correct way: don't place your drawing surface flat on the table top and then lean over it, as this leads to hunching and can cause neck and shoulder pain, as well as making you draw too large on the area of paper that is furthest away from you. The ideal solution is to pull your chair back and rest the drawing board against the edge of the table, with the board's bottom edge resting on your lap. This gives you an equidistant view of the drawing surface and enables you to evaluate the perspective and proportions of the drawing correctly. With powdery or wet drawing media, remember to wear an apron or protective garment on your lap, to prevent your clothes from getting dirty.

WORKING AT AN EASEL

Although this may be tiring at first, you soon get used to working with an outstretched arm, and the results are gratifying. It is almost impossible to smudge powdery media, and if you are standing, it is easy to step back to get an overview of your work. The biggest advantage is that you can see your drawing right next to your subject, and can thus evaluate your progress at a glance. To achieve this, position the easel to your right if you are right-handed, and on the left if you are left-handed, and place it just on the edge of where you can focus. In this position, you can run your eye quickly between your work and your subject without turning your head.

A small stool or table next to the easel holds drawing equipment.

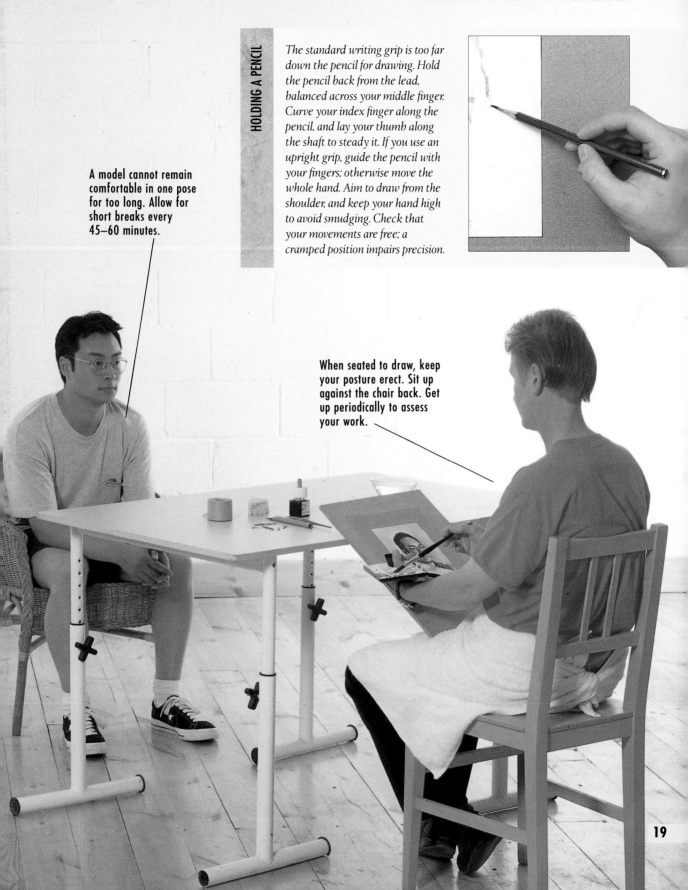

HOLDING A PENCIL

The standard writing grip is too far down the pencil for drawing. Hold the pencil back from the lead, balanced across your middle finger. Curve your index finger along the pencil, and lay your thumb along the shaft to steady it. If you use an upright grip, guide the pencil with your fingers; otherwise move the whole hand. Aim to draw from the shoulder, and keep your hand high to avoid smudging. Check that your movements are free; a cramped position impairs precision.

A model cannot remain comfortable in one pose for too long. Allow for short breaks every 45–60 minutes.

When seated to draw, keep your posture erect. Sit up against the chair back. Get up periodically to assess your work.

19

Making Marks with Graphite

GETTING
STARTED

Whenever you start to work with a new medium, take time to experiment. When you are ready to make a drawing, you will need to concentrate on controlling that medium. Work through your basic graphite kit (see page 14) on scrap paper, making random trial marks and observing their separate qualities. When you have tried and compared the characteristics of the different grades, look at all the marks together; a soft, dark mark reduces the silvery tone of a harder grade almost to insignificance. This effect can broaden your creative horizons, but be careful that mixing grades does not lead to problems with light and shade (see page 28). Choose the right grade, and you will need only one pencil for your drawing because of the subtle, responsive nature of the medium.

CHOOSING A GRADE

Your first consideration should be the size of your drawing, as this will have a bearing on your choice of grade. Large works are usually viewed from a distance, and while pencil is a versatile medium, it may lack the necessary impact that charcoal, for example, can provide. You can use soft grades for any size work, but reserve the harder grades for small work, where the paler marks will be seen from close up. Time is another factor: because pencil is a linear medium, even when working fast it takes a while to build up density. Hard grades are slow to work with, soft pencils are quicker, and graphite sticks are fast when used broadly. Link the grade to your subject; for example, use soft grades to draw heavy shadows. You will also need to erase pencil marks, and this, too, requires practice. When working in small or narrow areas, cut an edge in a worn eraser using a craft knife.

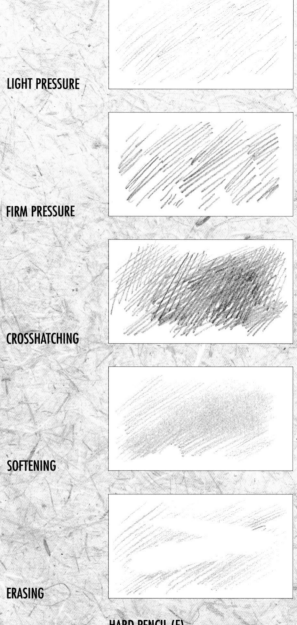

LIGHT PRESSURE

FIRM PRESSURE

CROSSHATCHING

SOFTENING

ERASING

HARD PENCIL (F)
An "F" grade, indicating "fine," has a firm enough consistency to maintain a good point, while providing the blackness of "B" grades.

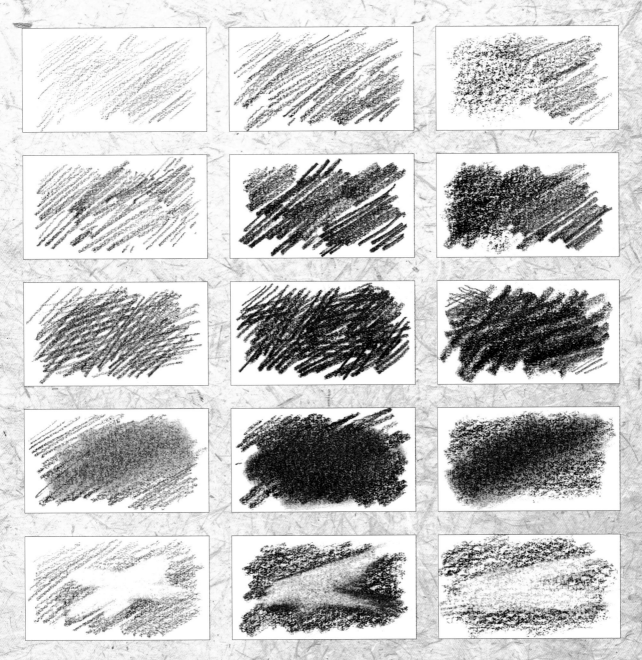

MEDIUM GRADE PENCIL (2B)

Medium grade pencils are the artist's workhorses, coupling flexibility with a sympathetic, soft mark. The best all-round medium grade pencil is a 2B, but choose a 3B if you prefer a blacker effect. These grades soften very well, and are not so soft that they smudge when being erased.

SOFT PENCIL (6B)

"B" stands for "black," and soft pencils, from 4B upward, darken the surface beautifully. Learn to keep your drawing hand off the paper as you work; the softness that makes these grades expressive to use is easy to smear. Erase with care, as they smudge if attacked too vigorously.

GRAPHITE STICK (2B)

You will find graphite in stick form the easiest drawing tool to cover large surfaces fast. You can buy most grades up to 9B as sticks. Try to use the side of your stick for rapid darkening, scraping off the surface glaze, if necessary.

Looking at Figure Shapes

When we begin to draw figures, most of us draw a line that represents the outline of a person. This is partly the result of our experience of writing—making linear marks. It also has much to do with our innate ability to recognize things at a glance by their silhouettes. Although this is a vital survival skill, using it for drawing is unlikely to bring success, as concentrating on the line loses the solid presence. In fact, an outline marks the point at which a three-dimensional form turns and disappears from our view—much like the horizon that marks the perceived "edge" of a land mass or sea.

DRAWING NEGATIVE SPACES

Any outline of a figure must take into account both the solidity of the body and the surrounding empty space that defines it. For practice, stand in front of a large mirror, rest your non-drawing hand on your hip, and make a simple sketch. You will find that drawing the triangular space enclosed by your arm and torso is much easier than determining the angles of the upper and lower arm; drawing this abstract shape will help you to establish these angles (see the drawing at the top of page 23). It also helps to practice using your peripheral vision. By looking slightly past your subject, you place it just outside the focused center of your vision—which has a cone-shaped span—and thus see large shapes rather than details, which can be added afterwards.

Blocks of simple tone, combined with line, show solid figure shapes. Look for the largest elements first, and keep your drawing simple; build up dark or shadow tones by working across the solid form, and include lines when required for extra definition. Make light marks on the paper at first so that you can correct or erase unwanted marks and only consolidate them when any amendments are complete.

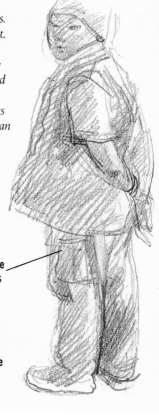

The basic information about the shape of the standing figure in this sketch is created by using tone with line, to depict large forms in a simple way. Details can be added once the overall shape is established.

ESTABLISHING A SOLID SHAPE

The illusion of solidity is vital when drawing figure shapes. Work hard to convey the broad mass of the figure, particularly if it is in a hunched or crouched pose.

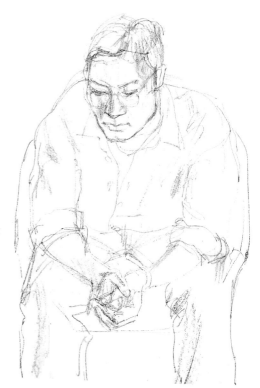

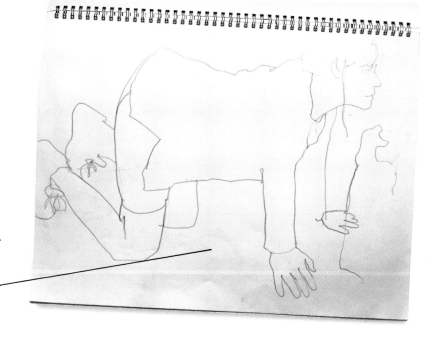

NEGATIVE SPACE

Because line drawing must take account of the negative space around a figure, which is seen as much as its positive shapes, observe and draw them carefully.

The almost rectangular shape of the space under the body defines the limbs.

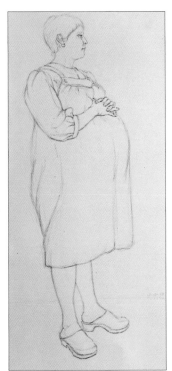

MOTHER-TO-BE

The altered body shape and posture of expectant mothers make them excellent subjects for figure drawing. Sketch them quickly, because holding a standing pose for long may tax their strength.

BALANCING THE FIGURE

When drawing figures, look carefully at the body's ability to act as a self-balancing mechanism. In people, balance is achieved by constant adjustments between the upper body and the hips, so begin by checking whether the weight is being taken by one side or the other. Other factors to watch out for are foreshortening and perspective (see pages 72–75), which also require adjustments to be made to the symmetrical shape of the body and limbs.

The vertical lines indicate where the central axis would lie in a figure standing to attention. The arrows show the direction of adjustments made to achieve balance in the poses.

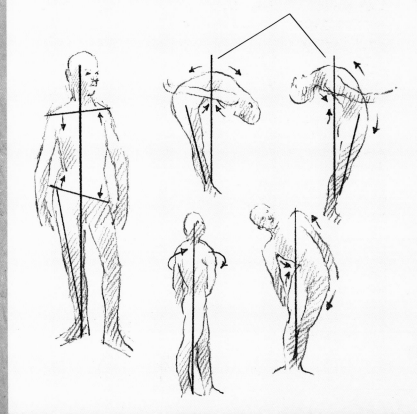

Understanding Form

Because of the problems encountered in representing the human form, figure drawing is often assumed to be difficult. In fact, the hardest problem is the same for any subject: how to represent reality, or three dimensions, on a flat surface, which has two. The marks artists make show the lost third dimension by creating an illusion of form in space. Without light, form cannot be seen, so by representing light and its absence, shadow, the artist shows form. Volume is also perceived according to tone; dark areas look smaller than light ones the same size. For all these reasons, concentrating solely on line, and putting off adding tone and shading until the pose is defined, only makes the task harder.

DRAWING WHAT YOU SEE

The most important thing to remember is that your eye does not edit the form it sees. To create effective form, attempt to deal with all the elements you observe at the same time. These include the space around your model, which gives you both a cross-check from the negative shapes it creates, and a figure that is convincingly related to its surroundings. But don't try to recreate photographic reality. Because cameras can only focus on a single depth band or infinity, they cannot select the essential information that shows form. However, you can, and a simple exercise will help: Make a figure sketch in full but light tones, then work backwards, erasing faint tones first, then medium, and finally the darkest. As they are removed, you will see which marks were the most telling. The line drawing you end up with will enclose the form as white shapes, and you can then redraw the tones.

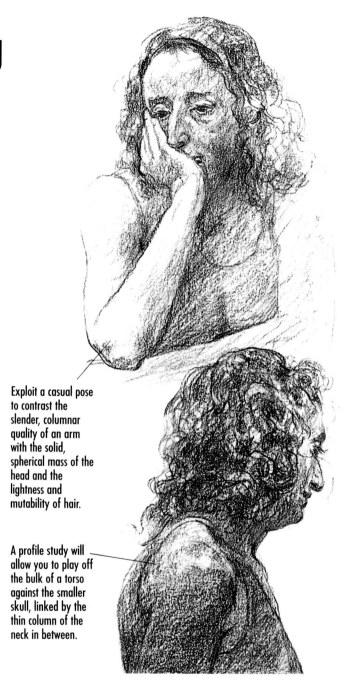

Exploit a casual pose to contrast the slender, columnar quality of an arm with the solid, spherical mass of the head and the lightness and mutability of hair.

A profile study will allow you to play off the bulk of a torso against the smaller skull, linked by the thin column of the neck in between.

TWO VANTAGE POINTS

It is often easier to perceive form by observing your sitter from different viewpoints. This will give you a better understanding of the conformity required.

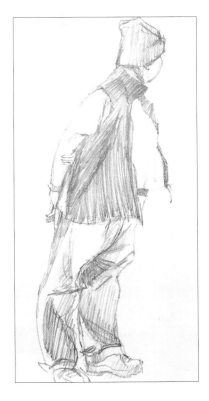

CAPTURING FORM QUICKLY

When working quickly, make sure that you record the largest forms first. Details can be added on if time allows.

WORKING LIGHTLY

Make sure that you include any areas of tone or shade in your opening statement. Keep the tonal information light until you have established the entire drawing to enable you to make final adjustments as needed.

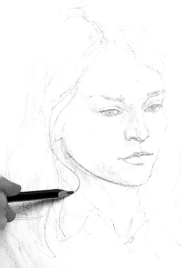

NEWSPRINT COLLAGES

Making a newsprint collage demonstrates that the depth of tone, and the area this occupies, are what reveal form. Use a base sheet of paper, old newspapers, scissors, and rubber cement—the drier the better. Cut out solid darks and fine and dense type to represent light and medium tones. To build up the collage, stick onto the paper the pieces of newsprint where the tone corresponds to the mark you would make with a pencil; form emerges as the newsprint darkens the base sheet to the right degree and in the right place. Make changes by sticking new pieces of newsprint where necessary on top.

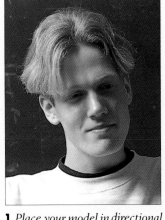

1 *Place your model in directional light so that shadows are clean-edged. If solid-colored clothing is worn tones are easy to see.*

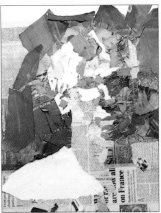

2 *Start by pasting down large areas to give a broad key to the tones. Don't attempt to include too much detail at this stage.*

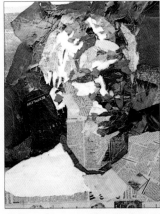

3 *Next, begin to refine the form of the picture by adding further nuances of tone. Work over the entire picture in this way.*

4 *In the final stages, include more precise shaping of the newsprint pieces. Make sure that the right tone occupies the correct area of the picture to define the details there.*

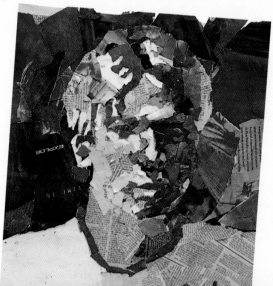

Understanding Contour

GETTING STARTED

A drawn mark conveys a degree of tonality but is not enough to show contours well. Where circular lines are used to indicate modelling, around the eye, jaw, or cheek, for example, the lines lead the viewer's eye in a general direction. There are subtle complexities that must be represented: though they are broadly round or cylindrical, heads, bodies, and limbs show considerable variations in volume and changes in curvature throughout their length. The contours in parts, such as hands, feet, and facial features, alter within a tiny span, and directional lines cannot describe them accurately. If you use linear shading, keep it in one direction; form is shown by the correct intensity of the mark, and subtle variations in tone are the best way to imply contours.

USEFUL AIDS TO DRAWING CONTOURS

Stripes, checks, plaids, and repeating patterns on garments may seem like unnecessary complications when drawing, but they provide the opportunity to illustrate contours, as they always turn with the form. If your sitter wears a striped top, the stripes will describe the curvature of the arms and body; plaid slacks show the form of thighs or shins as the pattern curves around the leg. Spots, sprigs, and other repeated designs indicate contours, too, because they are seen in perspective and will be condensed or foreshortened as they follow a form. Patterned hats and headscarves do the same for heads, as does the lettering on sweatshirts or baseball caps. Patterned backgrounds and surroundings, such as upholstery, wallpaper, and curtains, all show contours and angles. Shelves, window bars, and blinds provide a built-in reference grid that helps define the proportions of figures seen against them.

A self-portrait is a good way to look at contour, form, and structure closely. Dress in stripes, checks, or prints, so that you can examine the contours described by patterns. If possible, place yourself in front of shelves, slatted blinds, or a linear structure; hold your pencil out vertically or horizontally, and gauge the steep or shallow angles against it. Sketch the entire view lightly, and don't reinforce tone or fill in details until the contours are well placed.

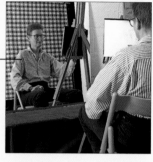

Position a mirror so that you can see yourself by a single light source; using multi-directional light will diffuse shadows and make it harder to see the form.

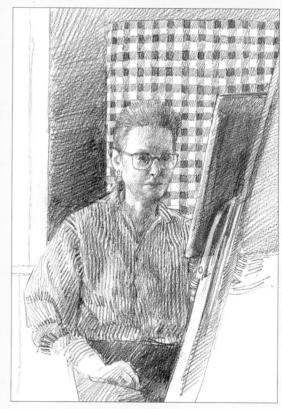

Choose a flexible medium, such as graphite, so that you can include all the pattern elements broadly in the first draft, and can remove any errors later. Even development is the key to handling complex patterns to show contour. You do not have to draw the details of every element, so aim to simplify them.

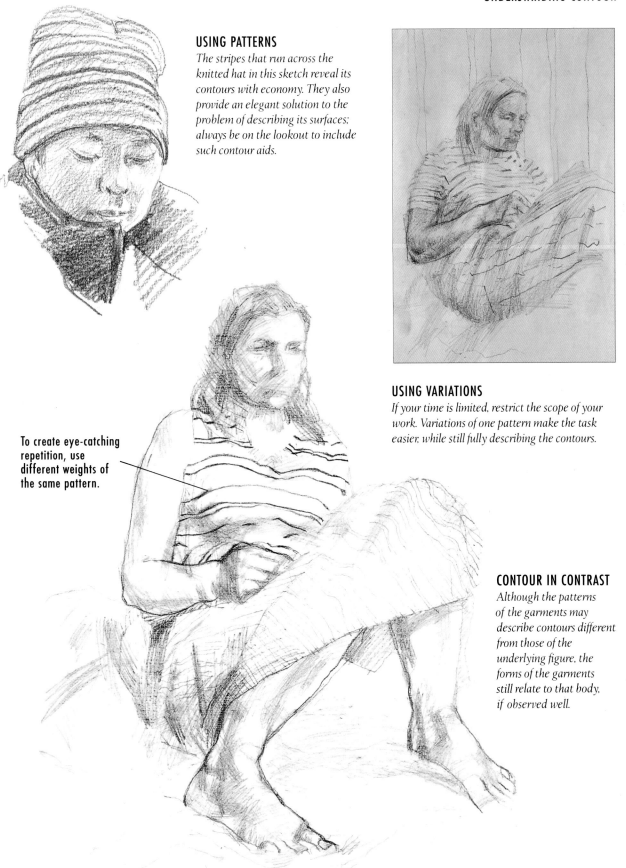

USING PATTERNS

The stripes that run across the knitted hat in this sketch reveal its contours with economy. They also provide an elegant solution to the problem of describing its surfaces; always be on the lookout to include such contour aids.

USING VARIATIONS

If your time is limited, restrict the scope of your work. Variations of one pattern make the task easier, while still fully describing the contours.

To create eye-catching repetition, use different weights of the same pattern.

CONTOUR IN CONTRAST

Although the patterns of the garments may describe contours different from those of the underlying figure, the forms of the garments still relate to that body, if observed well.

Light and Shadow

It is light alone that triggers sight and recognition, allowing you to perceive all other visual elements. Color, tone, texture, and volume are each seen according to the intensity and direction of the prevailing light source. Your own position in relation to light influences the character of a sketch: drawing from the lit side of a pose offers full color and slight tone, while the dark side, against the light, shows intense tone and little color. Placing a strong light source behind you at an angle creates sharp-edged shadows that fall partially across the form. Draw them as precisely as you can, since they will define clearly the contour of the form they fall across. Where shadows are nebulous, represent them as such—over-defined soft shadows often appear as holes or troughs in a drawing, so observe their gradations well. Set up situations for drawing sitters under different light conditions: natural daylight, with its cool cast and beautiful shadows, the yellow glare of electric light bulbs, white, glittering halogen, or candlelight.

DRAWING TONE

Always observe and establish the richest darks and brightest lights from the start, so that you can define the medium tones between these extremes. If you have difficulty discerning tone, this may be because color information is confusing; some colors are bright but not light. Red, for example, is a dark color tonally, despite its brightness. The other cause of difficulty can be over-drawing bounced or reflected lights within shadows, or over-darkening less brilliant lights. Their true intensity can be seen by half-closing your eyes and peering at the values to simplify tone. Check your sketch for accuracy using the same technique.

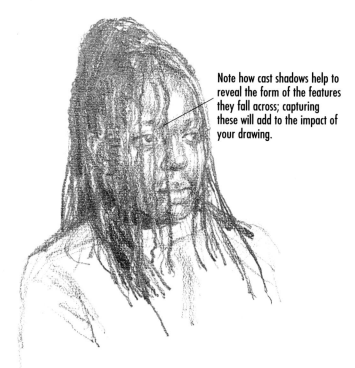

Note how cast shadows help to reveal the form of the features they fall across; capturing these will add to the impact of your drawing.

CONFIRMING FORM WITH SHADOWS

It is important to establish the major features of the form and scale of the head and shoulders before you begin to depict subtleties, such as dappled or broken shadows.

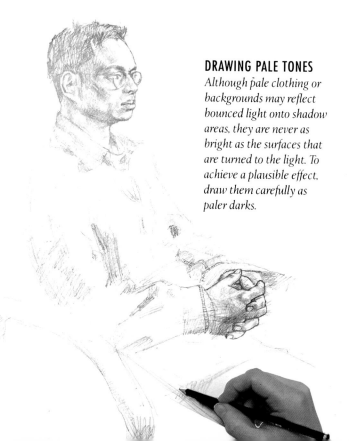

DRAWING PALE TONES

Although pale clothing or backgrounds may reflect bounced light onto shadow areas, they are never as bright as the surfaces that are turned to the light. To achieve a plausible effect, draw them carefully as paler darks.

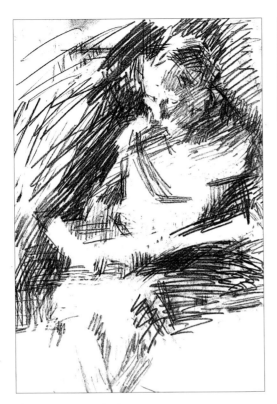

BLOCKING IN SHADOWS

The areas of tone that create shadows can be tackled broadly from the start. You can use blocks of dark tone to reveal form even before adding linear marks.

RELATIVE VALUES

Don't assume that, because Caucasian skin is pale, you need to use only light tones. In cast shadow, light skin colors often appear relatively dark and somber.

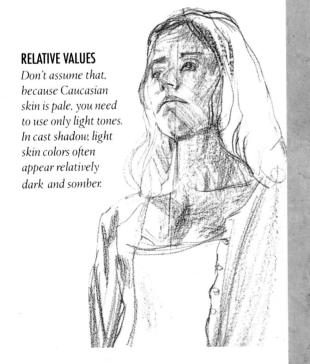

If you have no alternative to using photographs as reference, you may face difficulties in representing light and shadows. Photographic tones are confusing because they are indiscriminate and provide only a small fraction of the range you gather by observation. The camera is a mechanical device that does not have your ability to look into shadows and interpret their tones. Photographic shadows have a dense, flat look compared to real ones, so don't copy them literally, or your sketch will look flat, too. If you take reference photographs yourself, make sure you ally them with sketches and observation; otherwise, rely on intelligent guesswork, based on your experience of drawing real shadows.

1 When you have established the basic underlying forms, you can begin, through careful observation of tones, to work in the shadows.

2 Continue in this way, building up areas of light and shade to produce a three-dimensional effect.

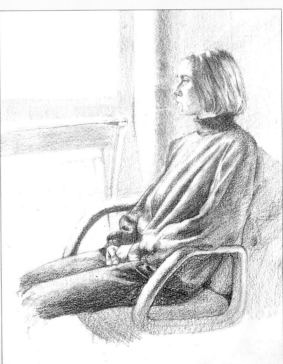

Working Outside for the First Time

By working outside you will observe first hand the limitless variety of figure subjects to draw. And by doing so, you will rapidly increase your responsiveness. Plan your first sketching outing so that you can work without a hitch once you get settled. Consider your location in advance (see below), and find a suitable box or case for your graphite kit, for ease of carrying and to prevent damage. Also, take along a small amount of fixative; marks made by the softest pencil grades may rub on your way home, so fix them when you are done.

CHOOSING A SKETCHBOOK

A moderate-sized sketchbook is best; large ones are cumbersome and hard to hold, and you may feel cramped sketching in a small one. Choose a size that you can carry easily, and be prepared to sketch whenever you have the opportunity. Spiral-bound sketchbooks allow you to remove sketches easily if you wish to use several for reference, but the book form is more durable. Purchase a book with acid-free paper (see page 16), so that it will have a long shelf life as a reference work.

CHOOSING A LOCATION

Drawing spontaneously comes easily with time, but until you have had some experience of working in public, choose a place where you can draw fairly static figures in context. Good examples are settings where people are stationary for a while: in diners or libraries, or at concerts. As people move, work on the surroundings until they resume the pose, or draw another. If the setting is not large enough for you to draw at a distance, be discreet, and if someone seems unhappy about being observed, abandon the work and find another subject.

EXTRA EQUIPMENT

- ✓ Portable easel
- ✓ Small, lightweight drawing board, for holding loose sheets of paper
- ✓ Large spring clips, to secure paper in windy weather
- ✓ Cord, for tying your easel to a log or rock to keep it steady in windy weather
- ✓ Lightweight camping chair or stool
- ✓ Hat with brim, for working in bright sun
- ✓ Fingerless gloves, for better pencil control on cold days
- ✓ Viewfinder (see page 13)

SKETCHBOOK CHOICES

A small sketchbook to carry in a bag or pocket will always be handy when wanted. Spiral-bound books are easier to open flat, but the ring binding does not allow you to extend sketches across two pages, if required.

DRAWING IN A PARK

It is not possible to finish every drawing on location, but there is always another person, or the same one in a different pose. Record as much as you can.

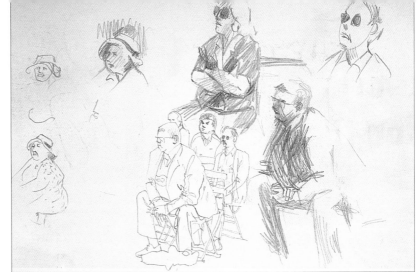

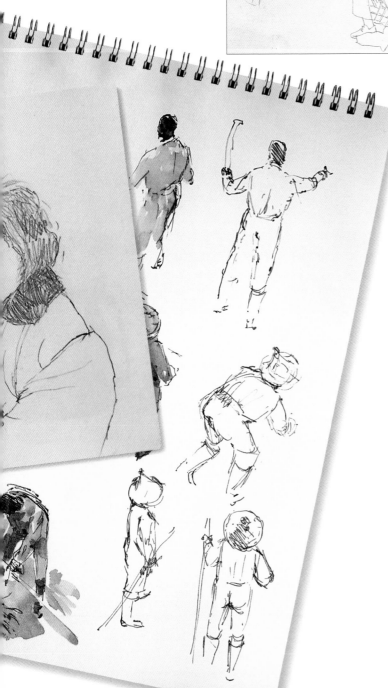

USING FIXATIVE

"Soft" media, such as charcoal, chalk, and soft pencils and pastels, rub off and smudge when touched or transported. This can be avoided by using fixative, a transparent resin dissolved in alcohol that secures the pigments to the paper. Most artists use an aerosol can that sprays fine particles of fixative onto the work. An alternative is to use bottled fixative with a mouth atomizer, though this needs some practice. When spraying inside, make sure a window is open and leave the room for a while, with the door shut. In either case, keep the application as light as possible.

Use bottled fixative with a mouth atomizer (above), or apply an aerosol spray (below).

Sketching Movement

The best way to begin to sketch movement is to make studies of simple, limited, repetitive actions: playing an instrument, feeding a child, and digging by hand are all good starting points. Similar poses are returned to frequently, and by noting them in stages you can work on a series of drawings and eventually capture the entire sequence. Before you begin drawing, look for patterns of movement—the turns and changes of weight distribution and characteristic gestures. When you recognize the limits within which the activity varies, select three or four stages in the process and sketch them on a piece of paper large enough to work on consecutively. If the movements stop before you have finished your sketches, finish them in stages as the poses return; the reason for working sequentially is to add to each sketch as you see your chosen view, thus accumulating observed information gradually. This may seem slow at first, but a fresh look at each work in a sequence helps to evaluate each sketch in turn, so that you notice discrepancies and amend them. Remember to pay attention to the composition on the paper, particularly if you're sketching several poses; much of the impact will be lost if your figures are random or if you've turned the paper in various directions.

OBSERVING MOVEMENT

The need to select a useful piece of information and record it swiftly sharpens your observation and encourages economy of expression. Holding the impression long enough to make a representative mark also helps to train your visual memory. Most drawing problems are caused by failure to look carefully, to select effectively, to represent accurately, or to evaluate properly.

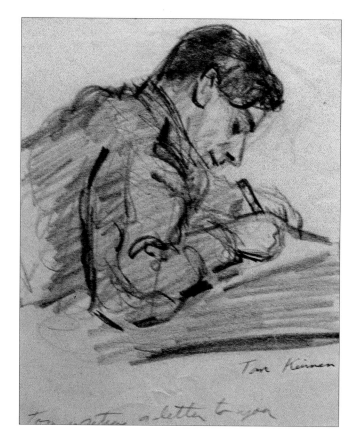

WORKING QUICKLY
When drawing time is limited, work decisively, blocking in a broad mass of tone with strong simple strokes to produce an economical and concise sketch.

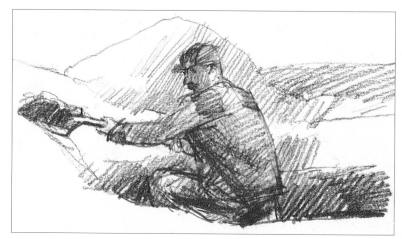

PHYSICAL WORK
Because working with hand tools is usually done at a slow pace, such as when gardening, you will have the time to sketch your subject carefully.

FINDING A LOCATION

If you intend to spend some time sketching, choose a location where you are likely to find more than one subject. Open markets, docks, and waterside settings are always the scene of a lot of activity.

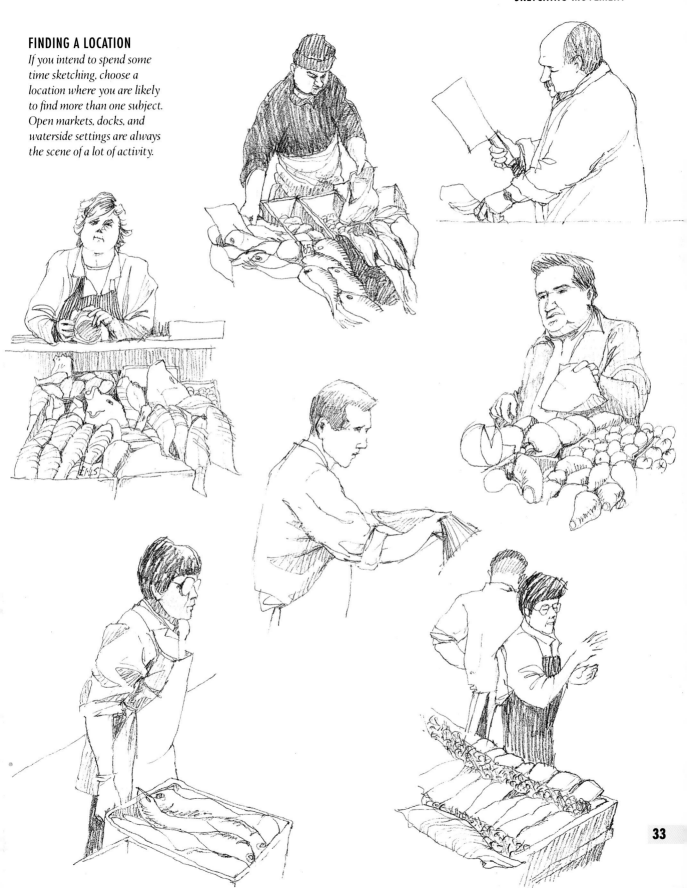

Capturing Different Tempos

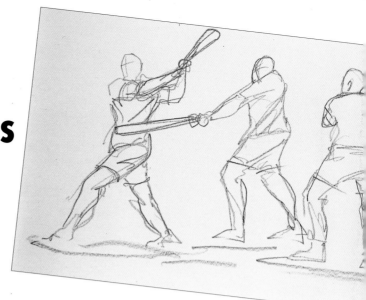

As you train your eye and memory to be receptive to the rhythms and dynamics of motion, you can use sequence drawings to depict activities where figures repeat regular, predictable movements more quickly, such as dancing or slow swimming. A good way to practice coordinating the acts of looking and drawing is to make sequence sketches of your free hand rolling over at an increasing rate, or your face as you turn your head faster; these will help you get used to gathering information quickly and recording it concisely. Such multiple images will convey more presence of the moving form than single ones. For really fast movements, such as running or riding, where a figure appears transient, either use sequence drawings or fragments to compile a single drawing later, or choose a situation where a compilation can be made at once.

MAKING A SINGLE DRAWING

Take your sketchbook to a sports field or park, and sketch elements from figures engaged in the same activity, for example, playing baseball. This will give you the opportunity to observe the same movement repeated over and over again. You can then compile a single drawing from many sketches of one individual, or make a compound drawing from different people, all performing the same action. Adding the various elements in this way will not produce an image of one particular person, but produces a plausible, informative drawing that has all the veracity of direct observation. More of the action and motion will be contained here than in a single photographic image, because any photograph of moving figures can trap only a fraction of a second of the action.

MOVEMENTS AT DIFFERENT SPEEDS

Sports often involve static and moving figures at the same time. Warm up by drawing the less active ones, and then add to the rapid figures or set down complete poses.

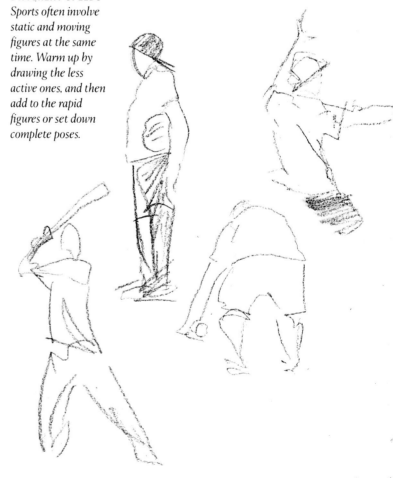

34

FOLLOWING A MOVEMENT THROUGH

Study a figure engaged in a simple, repetitive action, such as batting. Break up the act into the main positions, making a sketch for each one.

COMPARING PENCIL GRADES

Using different pencil grades for different purposes is good practice and enables you to complete drawings successfully. In general, the high graphite content of the softer grades produces darker marks that can be seen clearly from a distance, and makes them best for larger work, executed at speed. The harder grades have less depth of tone and are firm enough to retain sharp points, which makes them more suitable for fine work and more detailed studies, designed to be seen from a closer viewpoint.

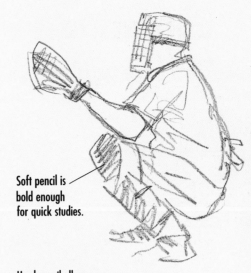

Soft pencil is bold enough for quick studies.

Hard pencil allows you to focus on details.

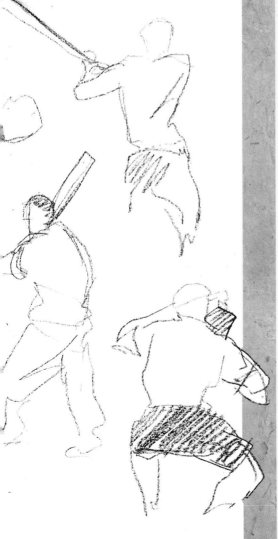

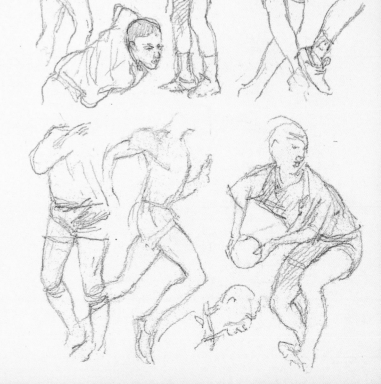

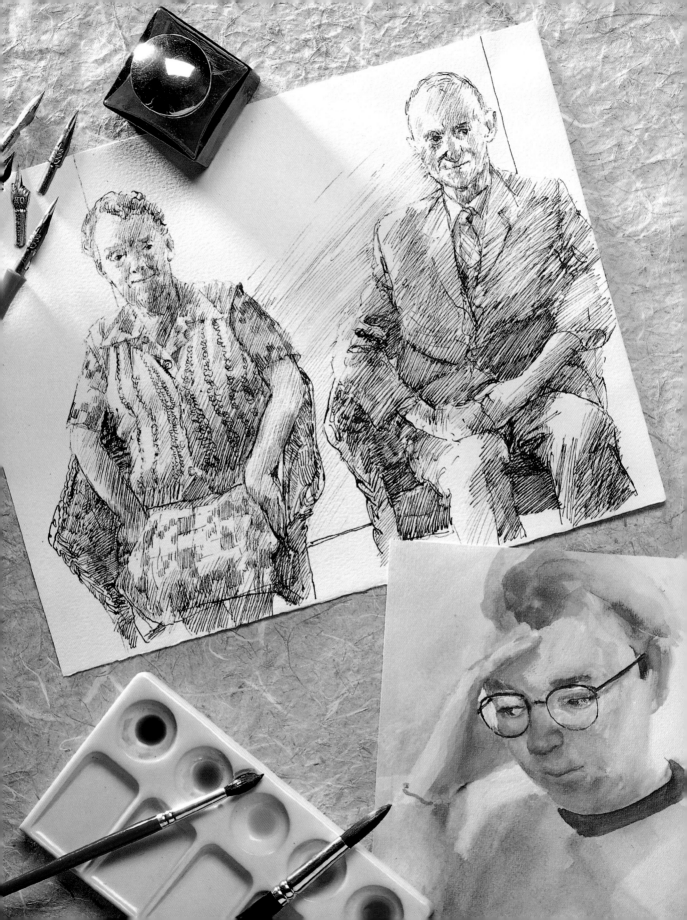

2

Looking at Other Media

Looking at Materials

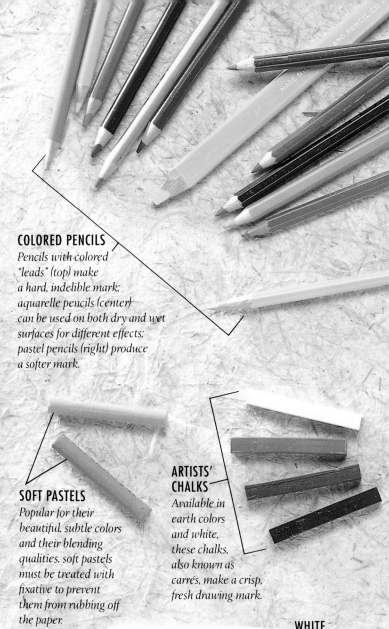

LOOKING AT OTHER MEDIA

Experimenting with different media can improve your drawing enormously, because they provide new insights as well as alternative textural qualities. There are materials to suit all purposes, and developing a familiarity with each medium's different characteristics enables you to make the right choice for your subject, expand your repertoire, build on your experience, and develop your skills. To begin, try working in monotone: charcoal is inexpensive, and provides a breadth unavailable in pencil, the speed to capture movement, and great depth of tone. Drawing with a brush and water-based paints or diluted inks combines ease and speed of application with the ability to depict a wide range of tones.

CHOOSING DRAWING TOOLS

There are various factors to be considered when making a choice of drawing materials. If you have to carry your materials to a location, they should be light and easily portable; if you are working in a carpeted public area, use media that don't shed dust or make a mess. If drawing time is short, choose materials that can be worked quickly. When working on a large drawing that will be viewed from some distance, select media that produce strong tones. Experience helps you to match the medium to the situation, so practice using a range of media to gain maximum flexibility. To extend the choices available to you, it is worth looking at materials designed for engineers, graphic artists, and calligraphers, such as broad calligraphy nibs, short, squared-off lettering nibs, technical pens, and waxy china marker pencils.

COLORED PENCILS
Pencils with colored "leads" (top) make a hard, indelible mark; aquarelle pencils (center) can be used on both dry and wet surfaces for different effects; pastel pencils (right) produce a softer mark.

SOFT PASTELS
Popular for their beautiful, subtle colors and their blending qualities, soft pastels must be treated with fixative to prevent them from rubbing off the paper.

ARTISTS' CHALKS
Available in earth colors and white, these chalks, also known as carrés, make a crisp, fresh drawing mark.

WHITE CHALKS
Plain chalks are often used with charcoal on colored paper.

CHARCOAL
Charcoal sticks (near left) are sold in various grades; processed sticks make a more permanent mark. Charcoal pencils (far left) make fine marks.

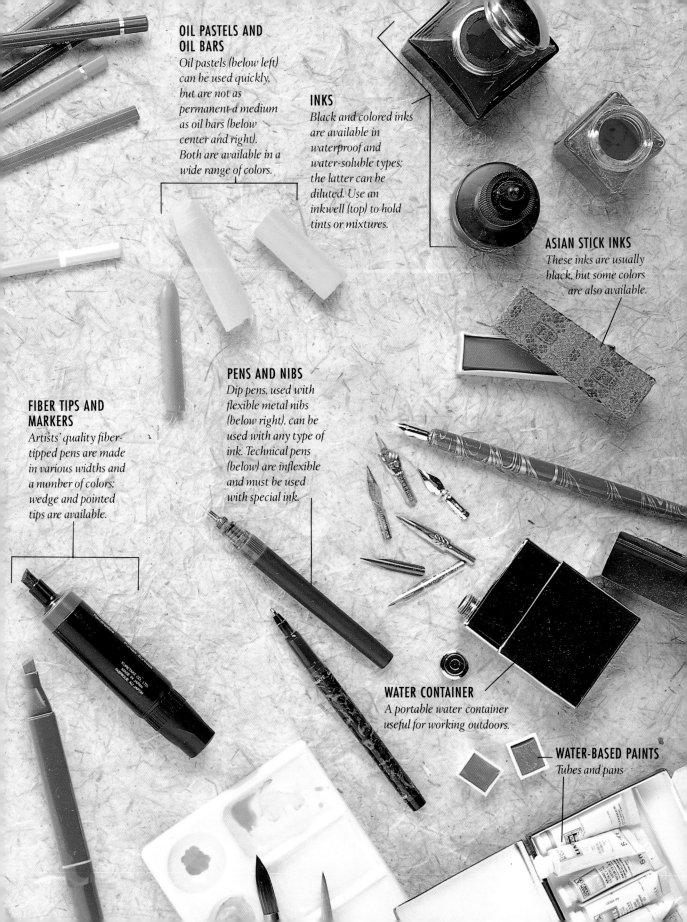

OIL PASTELS AND OIL BARS

Oil pastels (below left) can be used quickly, but are not as permanent a medium as oil bars (below center and right). Both are available in a wide range of colors.

INKS

Black and colored inks are available in waterproof and water-soluble types; the latter can be diluted. Use an inkwell (top) to hold tints or mixtures.

ASIAN STICK INKS

These inks are usually black, but some colors are also available.

PENS AND NIBS

Dip pens, used with flexible metal nibs (below right), can be used with any type of ink. Technical pens (below) are inflexible and must be used with special ink.

FIBER TIPS AND MARKERS

Artists' quality fiber-tipped pens are made in various widths and a number of colors; wedge and pointed tips are available.

WATER CONTAINER

A portable water container useful for working outdoors.

WATER-BASED PAINTS

Tubes and pans

Comparing Marks

LOOKING AT OTHER MEDIA

The types of marks you can make on paper depend on the medium and tools you use; some are flexible and can be varied by pressure and speed, while others are inflexible and produce a uniform line. Technical, ballpoint, and narrow-point fiber-tipped pens are all inflexible. Broad-point fiber-tipped pens offer the option of making narrow or wide marks, using the side or tip of the point. Bamboo pens offer only a broad or narrow tip, but steel, reed, and crow-quill pens flex with pressure. Spread marks and dots and dashes made with the nib point all help create individual effects. Brush drawing extends the choice further, offering wide marks from a spread, full brush, broken effects from dry dragging, and an extra-fine mark from the point.

USING DRY MEDIA

Charcoal, chalks, and pastels are all rigid, variable media, that snap if you exert too much pressure on them. The skill here is to use the tip for narrow marks and the side for broad ones, and to employ light pressure to give broken marks. The dust from these media can be applied with a paper stump to give subtle tones. Oil bars and oil pastels make comparatively inflexible marks, but these can be varied easily by further treatment. You can scratch into or completely remove oil pastel marks using a metal tool such as a sharp knife. Oil bars, on the other hand, can be spread, blended, or reduced to a tint very effectively using turpentine.

The paper surface on which you work also affects the marks you make; generally, the rougher the surface, the more broken the marks will be. The marks shown here were all made on cold-pressed watercolor paper. (See also pages 16-17.)

LIGHT PRESSURE

FIRM PRESSURE

CROSSHATCHING

SOFTENING

ERASING

CHARCOAL STICKS
Use natural charcoal sticks when you need speed and immediacy in a drawing. The rich tones of the burnt wood marks can be seen from a distance, and you can remove them easily using a kneaded putty eraser.

CHARCOAL PENCILS
Charcoal pencils combine fine, pencil-like lines created by a sharpened point with the deep tones of charcoal. Unlike charcoal sticks, however, the mark of the processed charcoal core leaves a trace when erased.

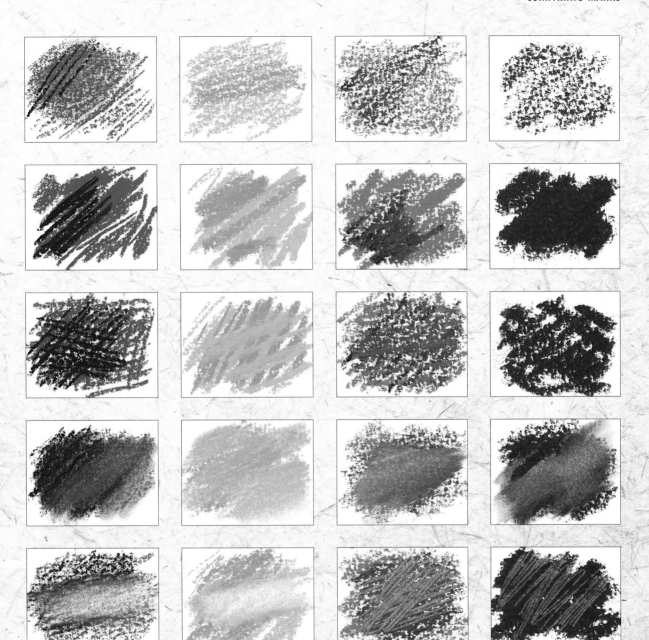

ARTISTS' CHALKS

Chalks, or carrés, enable you to work with simple earth colors as an introduction to color drawing. They are quick to use and light to carry, but their delicate marks will rub off if they are not fixed.

SOFT PASTELS

The many beautiful hues of soft pastels are an asset when the colors of your subject are the main priority. They are convenient to use but bulky, so choose a basic selection for outdoor work. (See page 50 for fixing.)

OIL PASTELS

These pastels create glowing colors and are easy to work with and carry on location. However, they smudge easily, so take a loose sheet of clear film to protect finished work, or use a special fixative.

OIL BARS

Oil bars offer the rich colors of oil paint in portable form. They are clean to use, but take care when using turpentine to make washes, because the thin veils of color become muddied if they are overmixed.

LIGHT PRESSURE

FIRM PRESSURE

CROSSHATCHING

SOFTENING

ERASING

COLORED PENCILS

These pencils are familiar to most people from childhood. They provide clean and portable colors that can be used where most dusty media would be messy to use or cumbersome to carry.

WATER-SOLUBLE COLORED PENCILS

These are useful for working outside when you don't want to carry brushes and sponges. Water-soluble colored pencils can be used wet, to create color washes, and dry, like colored pencils.

FIBER-TIPPED PENS

The wedge-tipped types are a very fast medium for covering large areas with bold colors, and fine fiber tips can be used delicately for smaller work. The dark tones tend to dominate, so use carefully.

NON-WATERPROOF BLACK INKS

Wash drawing in dilutions of this ink gives you the potential for expressing a full range of tones, from delicate to somber. Use a dip-pen for fine work, and a brush for speedier application.

TECHNICAL PENS

It is worth carrying a technical pen in your pocket or bag at all times, to capture the look of a subject while on the move, or for discreet use when other materials would attract unwanted attention.

WATERPROOF COLORED INKS

The jewel-like colors of colored inks outshine the brilliance seen in artist-quality paints. They can be used fast and overlays of their clear colors provide an extremely luminous effect.

TRANSPARENT WATERCOLORS

Watercolors can be mixed to produce any shade or hue. They are available in compact boxes of tubes or pans, and are ideal for full color work in any situation. Use good-quality brushes and paper.

OPAQUE WATERCOLORS

The opaque range of water-based paints includes gouache, tempera, and poster colors. They have good covering power and, because you can make corrections, they are useful when you are still building up confidence or tackling difficult work.

43

Color

The colors of drawing media range from the limited earth hues of chalks to the enormous variety available in media that cannot be mixed before drawing, such as pastels and colored pencils. For media that can be premixed, such as paints, a small, carefully chosen selection allows you to match any shade or hue. Different manufacturers use different names for their colors, but you can make a good starter set by using the colors listed below, whatever titles they are given.

CHOOSING COLORS

The best single yellow is a true egg or sunshine-colored one, as it produces a clear orange when mixed with red, and a good lemon color when mixed with green and white. Choose two medium-reds—an orange red for mixing oranges and browns, and a crimson for purples or for warming up cool color mixtures. A warm dark brown works well for mixing other browns, and a cool medium-green is easily mixed with yellow to make warm shades, or with blue for cool greens and turquoise. French ultramarine is the best all-around blue, but the true medium-blue of cobalt blue is good for mixing greenish blues. Black is good for mixing browns with red, or greens with yellow, but it can create muddy shades when used for darkening hues—shadow colors are best made from darker versions of the hue itself. White is essential for lightening opaque media; although you can add white gouache to pale watercolor mixes and use it to give covering power to washes, the transparent quality will be lost, and it is better to let the paper surface work as white and shine through thin washes to produce pale shades.

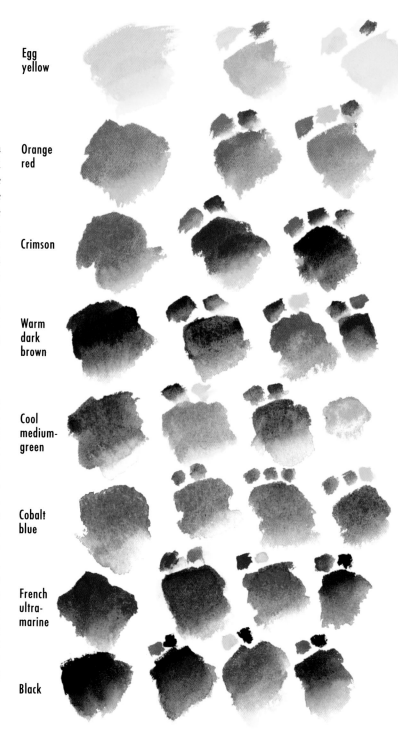

Egg
yellow

Orange
red

Crimson

Warm
dark
brown

Cool
medium-
green

Cobalt
blue

French
ultra-
marine

Black

COLOR MIXING

You can mix whatever paint colors you require from eight basic colors. Adding white makes pale tints, but don't darken with black, this muddies color. Instead, add associated dark colors.

USING OVERLAYS IN WATERCOLOR

Mixing colors together before applying them to paper will lose some of their brilliance, especially if you make complicated mixtures. Instead, use overlays of washes in waterproof ink or watercolor paint, which will produce better results. Overlays retain more brilliance than pre-application mixing. Blue washed over yellow, or yellow over blue, will make more lively greens than premixed shades.

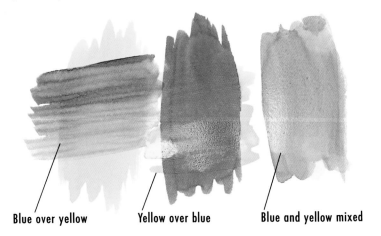

Blue over yellow　　**Yellow over blue**　　**Blue and yellow mixed**

RANDOM WASH APPLICATION

Although you may use them only rarely, for swift work to depict backgrounds, or for landscape backgrounds, you can achieve some lovely colors from random wet washes. Use any number of colors on a predampened area.

To check that the colors you use do not fade in light, draw or paint strips of each color across a sheet of acid-free paper, then cut the paper vertically. Date both strips, put one half away in a dark place, and hang the other half in good light, such as a sunny window. Compare the strips at intervals of one, three, and six months, noting which colors are lightfast, and which have faded.

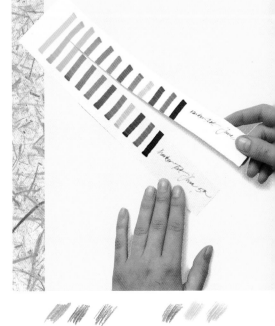
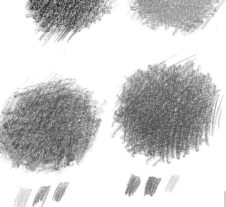

COLORS WITHOUT A NAME

In many cases, unsatisfactory results in color mixing are caused by a failure to observe the subtleties of some blends of color. A great number of colored pencil colors are unnamed mixtures of other colors, or quiet shades of neutral hues. Colors of equal brilliance should be used with equal pressure. Pale or moderate colors require firmer pressure to register in the mixture. The overlays of color blend to form more subtle mixes.

Charcoal

Charcoal is manufactured by slowly burning willow or vine twigs in oxygen-deprived conditions, until only carbon is left. Because there are differences in the raw material, there may be variations in texture and color. Charcoal sticks are sold in different grades and widths —thin, medium, and thick—usually in boxed bundles of a single type. The grades vary only in their consistency: soft is best for fast work, and can be blended and softened easily, while medium and hard are less smooth to apply, are slower to wear down, and can be used to make finer linear marks.

DRAWING WITH CHARCOAL

As with any new medium, learn to recognize and work with charcoal's unique qualities. Make use of its breadth of mark to create large-scale works, and utilize its smoothness of application when working quickly or energetically. Although its stick form may suggest drawing lines, using the side produces a lighter, less condensed tone that is good for creating "broken cover"—irregular, uneven coverage—or working fast. Another bonus is that almost all charcoal marks can be erased, using a kneaded eraser, which allows you to make radical changes to your drawing if necessary. Charcoal is, however, a messy medium, so roll up your sleeves and cover the floor before starting.

CHARCOAL PENCILS

These pencils contain compressed charcoal and can be sharpened to make a point. Their advantage lies in their ability to make the fine lines available to graphite pencils, but with the density of charcoal sticks; the disadvantage is that the marks cannot be fully erased. (See also pages 38-9.)

CHARCOAL TYPES

Charcoal may be compressed, as pencils or sticks, or unprocessed, as sticks or blocks. All grades of pencils produce the same rich blacks. Unprocessed sticks show slight variations in color, depending on the type of wood, density, and hardness. Very large charcoal blocks may be ungraded. Collect charcoal dust and apply it with a paper stump.

Charcoal pencils
Stick cut from large block
Fine charcoal stick
Medium charcoal stick
Large charcoal sticks
Charcoal block

USING CHARCOAL PENCILS

Charcoal pencils are graded, but not always in the same way as lead pencils. Broad groupings, such as "hard" or "extra soft," vary among manufacturers, so test the marks first. They don't erase well, so build up tones gradually.

1 *Start by drawing the whole figure in faint lines and open hatching (using lines to create shading). This will give you enough flexibility to make adjustments to dimensions and proportions, and to correct the pose if necessary.*

2 *Make sure you work on all the drawing evenly as you begin to reinforce it. This will help you to keep a grip on the relative tonal values (the relationship between the tones), and to progress the drawing as a whole.*

3 *Once you are satisfied that you have made all the necessary adjustments and that the structure of the drawing is correct, you can start to introduce details and to develop the areas of light and dark, which you need to give the image a sense of three-dimensional form.*

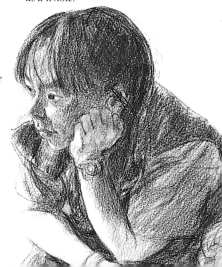

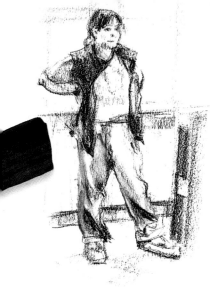

COMPRESSED CHARCOAL

Compressed charcoal sticks are manufactured in the same way as charcoal pencils. They give the dense, rich, and broad effects demonstrated in this lively standing pose, without the variations in color found in uncompressed sticks.

USING A KNEADED ERASER

A kneaded eraser is the most efficient tool for removing dust from charcoal drawings. Use its tacky surface to lift off surface dust before rubbing the residue out carefully.

Where the charcoal shading is light, pick out highlights using an eraser kneaded or cut to the required shape.

USING CHARCOAL STICKS

Unprocessed charcoal sticks enable you to get to work quickly. You can make anything from drastic changes to small alterations easily, by erasing, softening, and blending, so use them freely and boldly at first.

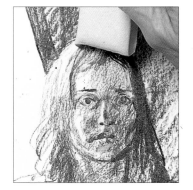

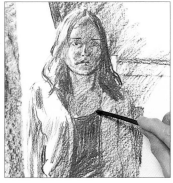

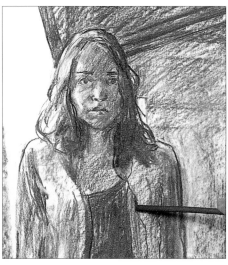

1 *Draw across the form rapidly, to establish a full range of tones. Use a kneaded eraser to clean up any areas that are too dark at this stage.*

2 *Combine broken cover with crisp marks to exploit a range of tones and textural variations. Do not lean on the drawn area to avoid smudging.*

3 *Leave the sharper details until last, and add them with the edge of a fine stick or a charcoal pencil. Check the overall effect carefully before using fixative.*

SOFTENING CHARCOAL

Softening charcoal makes the overall tone more even, fills the tooth of the paper, and usually lightens the worked area. These techniques enable you to create varied tones and textures, and to increase your subtlety of expression.

Spread and smooth charcoal dust over the paper surface, using a bristle brush. The charcoal dust that collects on the brush can be used to modify shading.

For a more direct method of softening charcoal in large areas, wipe the surface with a hard, soft, or textured cloth.

Subtle blending and softening are best done with a paper stump. Once the stump is dusty, use it to draw delicate tones, gradations, and light details.

Artists' Chalks

Artists' chalks, or crayons, are interchangeable terms for hard, brittle sticks with a compact texture and a faint sheen on the surface. Some hard pastels also fit this description, but these are made in many colors; artists' chalks, also called carrés, come in only four pigments, made from chalk, soft stones, earths, and other minerals. The colors are black, white, a cool dark brown called bister, and an earth red called sanguine. This last is usually the color of terra-cotta, but you may find anything between plant-pot red and reddish-brown. The composition of artists' chalks has a bearing on their performance: as well as the pigment and kaolin and china clay, they contain a small amount of oil or wax. When the sticks are briefly baked hard, these elements combine to produce an imperceptible oily mark, which cannot be erased entirely; in particular, the black remains fixed.

USING ARTISTS' CHALKS

Because you cannot completely erase artists' chalks, they are good practice for developing methods of working in fixed media, such as ink and watercolor. You have to get the mark in the right place first time around, so raise the level of your concentration and observation as much as possible, and start by producing light marks. This will give you some room to change your mind and make alterations using firmer strokes of the chalk. The more you use artists' chalks, the more you will appreciate their crisp, fresh qualities, but be careful not to let this distract you from your drawing. Keep the use of a blending stump to a minimum, and try hatching (using criss-crossing lines) to create color blends. Remember to fix the finished work (see pages 31 and 38-9.)

MAKING VARIED MARKS IN MONOCHROME

The four basic earth pigments—black, white, bister, and sanguine—make strong, powerful marks. Because most artists' chalks are hard, it is easy to work incisively, but doing so can result in an indelible stain when you try to erase a mark.

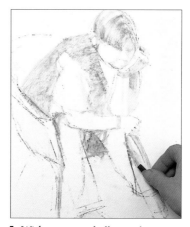

1 *With a square chalk, use the edges and corners to create fine marks. Work lightly at this stage, making adjustments as needed. You can then use the broader sides to block in darker tones.*

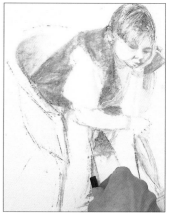

2 *As you begin to make more confident strokes and build up the figure, keep scanning the whole drawing to make sure that the figure works in the setting. Surrounding details help to define the sitter and make it easier to observe proportions accurately.*

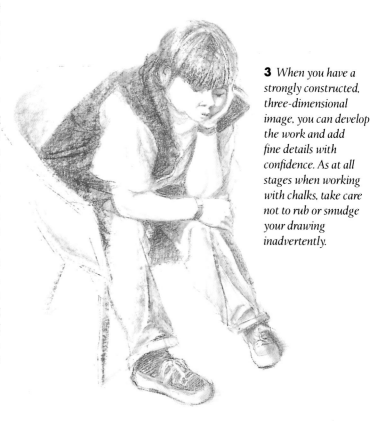

3 *When you have a strongly constructed, three-dimensional image, you can develop the work and add fine details with confidence. As at all stages when working with chalks, take care not to rub or smudge your drawing inadvertently.*

COLOR ACCENTS TO ENRICH MONOCHROME CHALKS

When drawing mainly in monochrome, you can create a lively effect by adding color accents to selected parts of the drawing. By blending and varying the pressure as you apply the colors, you can produce tints and so imply more color than is being used.

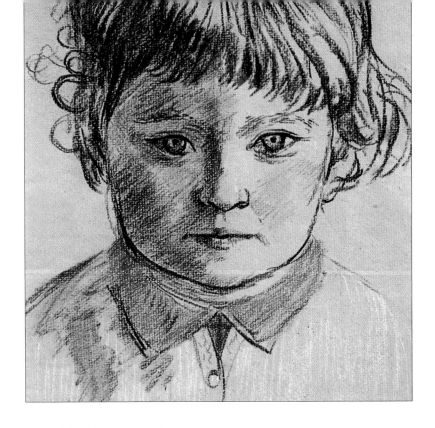

USING COLORED PAPER

Colored paper is an excellent ground for artists' chalks because its shade can be used as part of the overall scheme of tones and colors in a drawing. Although colored papers are sold in a variety of shades, start with a medium-toned color, so that both light and dark chalk marks register with equal emphasis. Make sure you add white, if required, from the beginning: in addition to helping you to gauge its correct intensity, it will act as a counterbalance with the dark tones and enable you to use the colored paper to best effect.

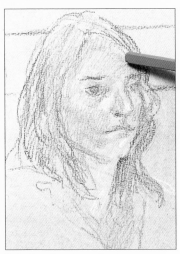

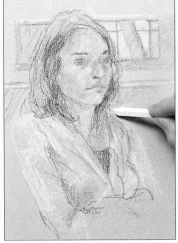

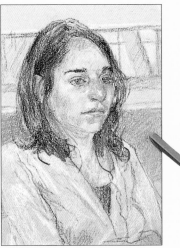

1 *Before drawing, take time to calculate which areas of medium tone you want the paper to describe. Leave these areas clean while you draw in darker and lighter colors to contrast with them.*

2 *Light colors are graded, just the same as dark ones. It is important to use white from the very start, so that you can use it to gauge the intensity of all the lighter tones.*

3 *The best results are achieved by an even development of all your colors. Always use the paper color as a tone, and don't leave random areas undrawn, as these can look flat on the finished drawing.*

Soft Pastels

LOOKING AT OTHER MEDIA

Soft pastels have a high content of pure pigment, and their smooth consistency, achieved by blending finely ground particles with a little binder, make it easy to mix and blend shades. They may also be used for laying down solid areas of color. This broad use can be thought of as "dry painting," since large areas are covered with a sweep. Limit yourself to basic colors at first and be prepared to mix the colors freely. When purchasing soft pastels, try out different brands until you find one whose pastels have an even consistency, because it is difficult to work responsively if some colors are gritty and others are extra-soft. In addition, check the permanence ratings.

USING SOFT PASTELS

When mixing colors, aim to strike a balance between struggling to achieve exactitude and preserving the brilliance of the colors. Manufacturers usually place pure colors in the center of their ranges, and gradations are made by adding black or white. You can add your own white to save buying the lighter colors, but darker shades are best made using colors. On its own, black is too stark for medium-dark shades, yet it can turn yellow into green, for example. If you have to sacrifice the exact hue you observe, make sure that you achieve the right tonal value and color temperature, or the perceived degree of warmth or coolness. Because soft pastels use only a small amount of binder, the very softness that makes them easy to use also means that the finished work must be fixed before it deteriorates (see page 31). Use only a minimum of fixative, however, as the resin content can stain or make pigments transparent, which deadens the colors. (See also pages 38-9.)

TINTING PAPER

Check that pastel papers and boards are acid-free, particularly the colored papers. If you use an alternative, make sure it is toothed. If you are using white paper, pale pastels can appear dark at first. Avoid this problem by tinting your paper with a color wash, stretching it first so that it won't buckle.

DRY PAINTING WITH SOFT PASTELS

Pastels have to be mixed on the surface and this process will impact on your tone and color schemes, so start mixing at the beginning, not half-way through the work.

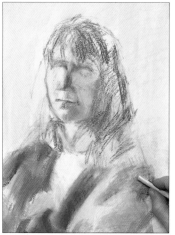

1 *Mixtures that are too dark can be adjusted by adding light colors but you will lose the brilliance of pure color.*

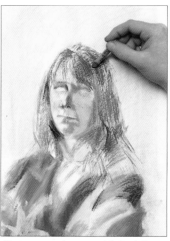

2 *Once you have established the framework, put darker accents in strongly by pressing more firmly on your pastels.*

3 *As a result of its strong tones and the way in which the pastel stick was used—with broad strokes, like a brush—the finished picture has a painterly look.*

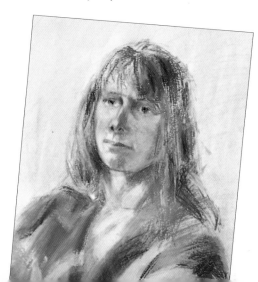

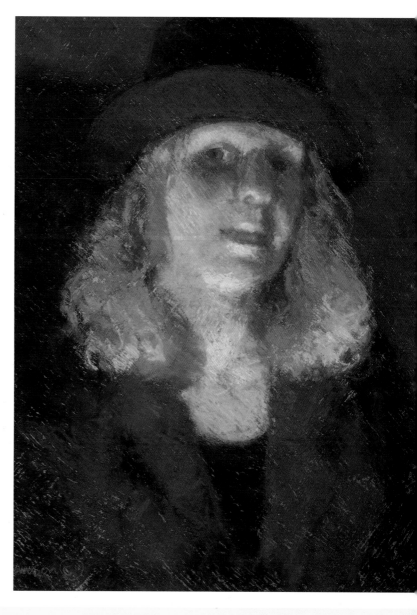

USING COLORED PAPER

Use a neutral background shade to show pale colors to good advantage (above). This also provides a medium tone to avoid dark color dominance.

CREATING RICH COLORS

It is often assumed that all pastels are pale-colored, because the word "pastel" is used to describe light colors. In fact, pastels are capable of depicting rich, strong, and even dramatic colors and tones, and lend themselves to quick, bold work (right).

SOFTENING AND BLENDING

Broad marks and areas of color can be softened with a rag or soft brush—not a finger, which creates smudges. Work lightly, unless you are reducing the color in preparation for reworking. Details are best thinned using cotton swabs or a kneaded eraser, and the pastel dust can be moved with a blending stump. Avoid overworking and losing the colors' freshness.

Wiping pastel marks with a piece of fabric or paper towel is a broad method of softening a large area, or of cleaning a surface that is ready for redefinition.

If you need to remove excess material from a small area, or want to soften colors quickly without creating a hard edge, practice using cotton swabs.

Oil Pastels

Oil pastels have a completely different nature from soft pastels or artists' chalks. Their animal-fat content means that drawing with oil pastels is akin to painting with oil paints; while the colors of oil pastels have a subtle glow compared to the richness of oil paints, they have a unique intensity among the directly applied drawing media. However, in many cases the pigment content of oil pastels is not stated. Where no information is given, assume doubtful permanence and lightfastness. There are also considerable variations in the fat content, depending on the manufacturer: some sticks glide with an easy smoothness, while others have a stiffer feel that encourages a more decisive mark. If your art supply store sells single sticks, try different brands before making your final choice.

USING OIL PASTELS

Making marks with oil pastels reveals a very adaptable medium, with great flexibility and mobility on the paper surface, due to the fatty consistency. The sticks encourage spontaneous, innovative use and a robust drawing technique, and you can push them around the paper almost indefinitely. Sgraffito (scratching into the surface to reveal layers beneath) effects are popular with oil pastels: use worn edges to create hatching, or else scrape this off to reveal a different colored base stain underneath. The main drawback to oil pastels is the undried finished surface, which is susceptible to dirt and damage, and means that they are mostly used as a fast, non-permanent medium. If you require the same working qualities with a permanent finish, use oil bars, which have a content of real oil paint and can be varnished for protection (see pages 38-9).

SURFACE MIXING

Oil pastels have to be mixed on a surface. They work well on colored paper, where the shades show to good advantage. Once used, the sticks make wide marks, so vary the pressure or turn worn edges to achieve diversity in their otherwise uniform texture.

1 *Block in the main variations of color and tone. This will enable you to check the proportions and dimensions of the drawing before applying denser cover, which may be hard to change later.*

COMBINING OIL PASTELS AND OIL BARS

Oil pastels and oil bars are a good combination for large works, as the covering power and drying qualities of oil bars blend well with the wide color range and capacity for drawing details provided by oil pastels.

1 *Lay a general groundwork drawing using oil bars, keeping the colors light until you have established the framework. Remember to stand back frequently, so you can check the drawing for accuracy.*

2 *As you cover the paper with oil color and expand the range of tones and colors, begin to surface-mix colors, still working broadly.*

3 *Use various techniques— blending with turpentine, scratching out, adding details with oil pastels, or using oil bars for painterly effect—to produce a finished piece with a range of tones, and areas of light and shade that give an impression of depth and form.*

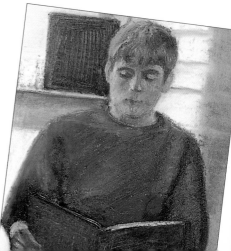

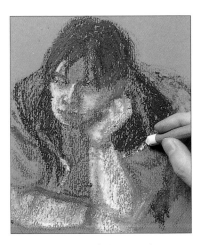

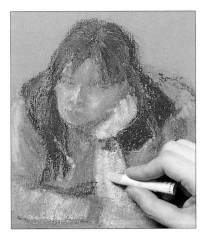

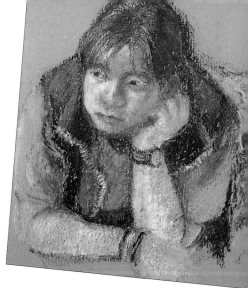

2 *Begin to use the full range of tones, adding both light and dark colors in a broad way at first. Concentrate on defining the solidity of your sitter, although you can start to blend carefully at this stage.*

3 *Continue mixing colors on the surface, taking into account subtle changes during the process of mixing and matching. As you add colors be prepared to refine the tonal changes throughout the drawing.*

4 *The final stages require careful touches and small strokes with blunt-ended sticks for the fine details, for example around the lower jaw and neck.*

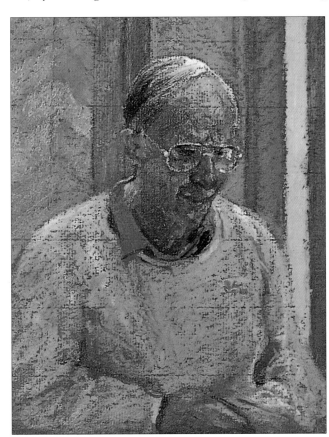

COLOR BRILLIANCE
Use the glowing colors of oil pastel to capture the brilliant effects of electric light. Add tiny strokes where subtle changes of color occur.

CREATING WASHES WITH TURPENTINE

To vary the surface depth of oil pastels and oil bars, and to create tints, you can use turpentine to thin them to a wash. It is important first to stretch and then seal the paper; if you apply turpentine to unsealed paper, it can soak in and stiffen the washes. To seal paper, apply a thin layer of diluted water-based glue to the damp paper after the gummed paper strips have been fixed (see page 17). The brush that gives you the most control when creating washes is a filbert, a bristle brush with a flat profile and a tapered, broad face.

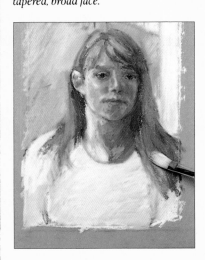

Colored Pencils

There are many types of colored pencils available, each with its own distinctive character and uses. Standard colored pencils have a dense, hard core that makes a shiny, waxy mark on paper. There are two types: both can be used directly on paper, but the water-soluble kind can also be used to create rich color washes. They are very useful when planning watercolor washes, as they blend into washes well and do not show through. Colored pencils are very clean to draw with, which means that you can sketch with them without fear of making a mess. Pastel pencils, on the other hand, have a soft, brittle, dusty core that makes a mat mark, which can be blended with a stump, but can rub off if not fixed (see page 31). You can use pastel pencils to create sharp definition or hatched detail in soft-pastel drawings, or for making color notes, or sketching on a moderate scale.

USING COLORED PENCILS

Choose your paper carefully; papers with a soft finish work best with colored pencils, and toothed paper gives you a "broken" look, due to patches of white being left in the indentations passed over when a mark is made. Used dry, colored pencils can be hard to erase, as the colored core produces a mark with a soft, waxy sheen; for this reason, work lightly at the start and build up depth of tone and color mixtures later. Before creating watercolor washes with water-soluble colored pencils, experiment on scrap paper until you can judge the correct ratio of water to pencil mark automatically. Drawing a line onto damp paper produces a rich, permanent color, and you may prefer to use this method rather than brushing in details on water-colors. (See also pages 38-9.)

DRAWING WITH PERMANENT COLORED PENCILS

As with all media where colors are mixed on paper by overlaying different shades, manufacturers of colored pencils provide a vast range. This reduces the need for mixing, but you should resist temptation and select only the most useful colors.

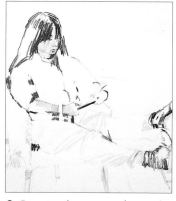

1 *Keep to simple values of color and tone at the start and work evenly through the whole drawing. Once you begin to put time and effort into capturing details, you will lose the opportunity to make adjustments.*

2 *Covering the paper surface with solid color can be a slow business, and can be frustrating when you are trying to draw short poses. You can save time by using lines or part shading to imply colors.*

3 *Don't assume that the fine, linear marks of colored pencil confine you to a small scale. If you are prepared to spend time shading, colored pencils have sufficient impact for larger areas.*

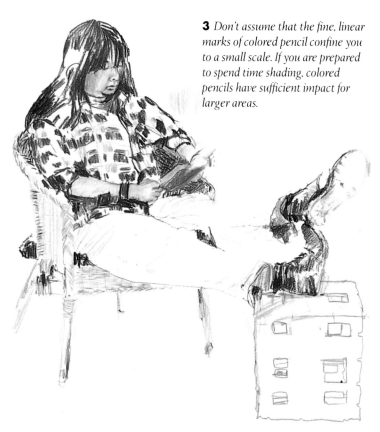

DRAWING WITH WATER-SOLUBLE PENCILS

Pencils with a colored core that is soluble in water (also known as aquarelles) are manufactured in two grades: hard and soft. The hard types make a less rich wash, but stay in place better; the softer grades shift more.

1 *Start by laying down a preliminary ground, using all the shades of color that will be needed to mix the observed hues. You can still adjust the dry work by erasing if necessary.*

2 *Once the wash created by brushing soaks into the paper, it is impossible to erase. Keep your initial draft drawing light to allow for delicate washes, which could still be amended by stronger ones later.*

3 *To increase the depth of tone and bring your washes up to the desired strength, make further applications of color. Applying water-soluble pencils to wet paper creates a rich mark.*

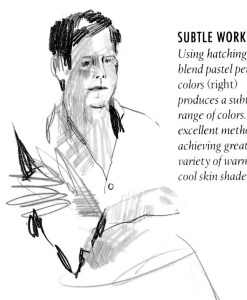

SUBTLE WORK
Using hatching to blend pastel pencil colors (right) produces a subtle range of colors. It is an excellent method for achieving great variety of warm and cool skin shades.

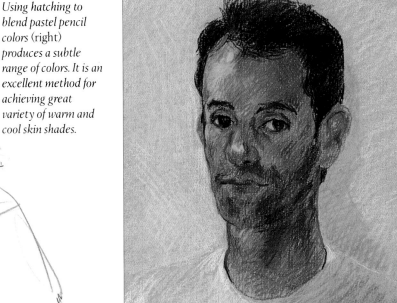

BOLD WORK
Using a dramatic approach with colored pencils (above) can result in a strong visual effect. As with any linear medium, working boldly makes an immediate impact and adds interest.

Sketching with Fiber-Tip Pens

Fiber-tipped pens are clean and convenient to use, and are particularly good for quick work. Because fiber tips do not leak or create a mess, they are very handy to use when traveling. The inks used in fiber-tipped pens come in a huge range of colors and are either water-soluble or spirit- or alcohol-based; for serious drawing, make sure you buy those pens designated as light-fast. If in doubt about permanence, make up a test sample by drawing lines in each color across a strip of durable paper. Cut the paper in half, hang one piece in a window and put the other half away in a dark place. Compare the two strips at intervals of one week, one month, then three and six months; do not use the colors that have faded noticeably.

FIBER-TIP TECHNIQUES

Fiber tips are either pointed or wedge-shaped. Narrow, pointed tips are suited to pencil techniques, and you can produce optical color mixing by feathering and hatching the strokes. Very fine tips can be used for skeletal structuring and for working directly from observation; their crisp lines can compensate for minor faults in proportion. Broad, wedge-shaped tips provide rapid color on a larger scale, and you can produce color mixes by overlaying the strokes of the pen. Experiment before you start, and check the tonality of the colors; it is best to keep color combinations simple because fiber tips cover a surface fast and there is no room for revision. A lively visual effect can be obtained by combining solid areas of color, made by broad tips, with line work, made by narrow tips. You can also use stippling or broken lines in areas of broad marks, to break these up and subdue their dominance. (See also pages 38–9.)

USING FIBER TIPS

Because fiber-tipped pens are a recent development, feel free to use them inventively and even experimentally. Their marks cannot be shifted, so observe your subject well and start by using fine tips and light colors.

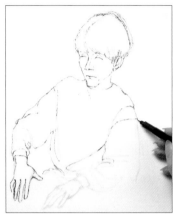

1 *Use a neutral-tone marker to sketch out the figure. Add definition with a thin, darker marker. Your work can't be erased so consider proportions and dimensions at an early stage.*

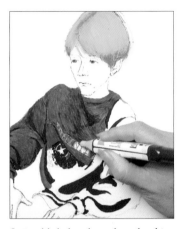

2 *Establish details, such as the shirt design, with a fine-tip marker, then fill in the background color with a broad tip.*

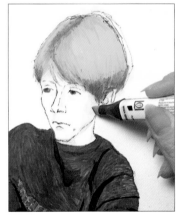

3 *Add highlights to establish the shadows and contours of the face.*

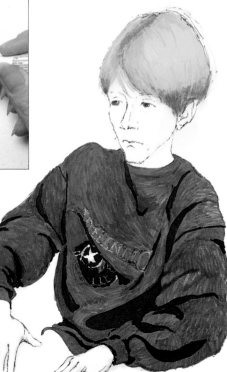

4 *The colors of the finished figure have a luminous quality, which contrasts with the delicate features of the face and hands.*

WORKING FROM PALE TO DARK TONES

Fiber-tipped pens can be unforgiving if you use a new pen at full strength. You can create a little more room for adjustment by using pale tones to start, or a fine tip that is nearly exhausted.

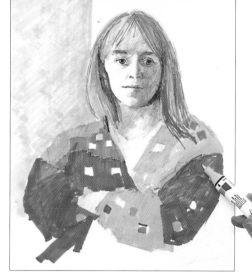

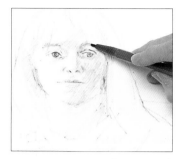

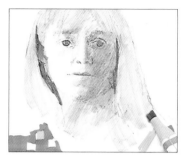

1 *When creating the first stages of a drawing, consider employing a pen that has had a lot of use. This way, the unerasable marks will be less heavy than with a new fiber tip.*

2 *After making a tentative start with a used pen, you can then place the light and medium tones on the drawing with more confidence. Don't forget that fiber-tip overlays darken rapidly, so apply carefully.*

3 *Once you have enough of the structure delineated to work with confidence, stronger colors can be applied freely to produce fresh effects on a larger scale.*

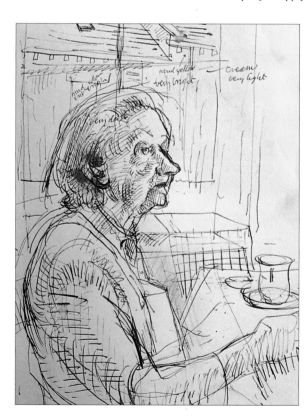

WORKING IN MONOTONE

Any single color fiber tip can be used for this technique, but keep to darker shades as very bright colors may distract from your drawing. Inventive and versatile use of descriptive marks is easily achieved with a free-flowing fine-tip pen.

BALLPOINT PENS

Ballpoint pens are primarily designed for writing, and produce an unvarying line. When using them for drawing, you will therefore need to generate variety and create interest by using combinations of techniques such as feathering, hatching, and stippling. (See pages 64–5.)

In this sketch, no attempt was made at fully detailing the drawing. Line and tone were used sparingly, and provide visual clues to the three-dimensional nature of the sitter's down-turned face and fall of hair.

You can turn the inflexibility of ballpoint pens to your advantage by suggesting more information than is actually shown. Here, the hatched lines create depth of tone, and the carefully observed linear marks imply form.

Nibbed Pens

Nibbed pens offer a wide range of marks in many sizes, but the quality and intensity of their marks depends on whether the nib is flexible or rigid. Of the flexible nibs, "cut" pen nibs that fit dip pen holders are responsive to the hand's pressure and produce a variable mark that spreads or tapers as the split in the pointed nib is opened or closed. The extra-wide nibs designed for calligraphy make a thick mark with the broad edge of the nib, or a fine line when drawing with the side of the tip. Steel crow-quill nibs are good for very fine marks. Standard fountain pens are much less flexible, and the tubular nibs of technical pens make an unvarying, mechanical mark or line. They are best used for making hatched, broken, and descriptive lines. Although disposable technical pens are inexpensive, the refillable types save money over time; start with a 0.5 nib, and shop around to find a brand that is easy to dismantle and clean.

INKS

Because all inks are hard to erase, observe well before working, and draw with confidence. If washing out fails to remove enough of the stain, use a fiberglass eraser or scrape the paper surface clean carefully by using the flat or point of a sharp blade. These methods must be the last stage in the drawing process, as the abrasions they cause on the paper will result in further applications of ink spreading out of control in the erased area. You can also make corrections by applying body white (gouache) over unwanted marks on a white surface, or by using rubber cement or flour and water to paste a paper overlay onto an area and drawing on this fresh surface.

DOUBLE PORTRAIT PEN DRAWING

Because pen and ink is a linear medium, it takes time to build up intensity of tone. Consider asking an elderly couple to be your sitters, and arrange the sitting so that they can chat and pose by turns.

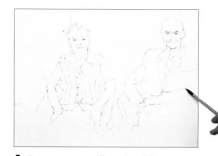

1 *Because you will not be able to erase your marks, draw lightly at the start, either using diluted ink, or drawing with a rigid pen that can be skimmed over the paper tooth, such as a reed pen.*

USING PENSTROKES TO DESCRIBE TEXTURE

A wide range of textural and atmospheric effects were created here by a readiness to use all the textures that stippling, dotting, and line breaking allow.

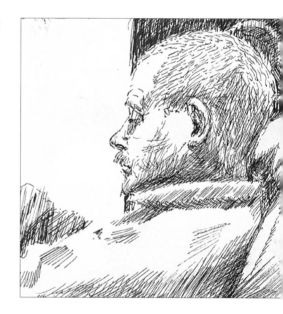

Although wooden pens are stiff, they are superb drawing instruments. Bamboo and reed pens can produce an extremely wide variety of marks, depending on the nib edge and the angle at which you use them.

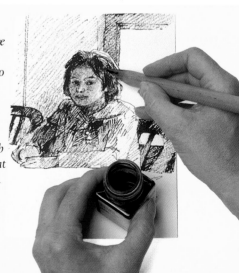

2 *Start to build up the tone using such techniques as open hatching, dot and stipple, and broken strokes. Broken strokes allow you to adjust your drawing if necessary.*

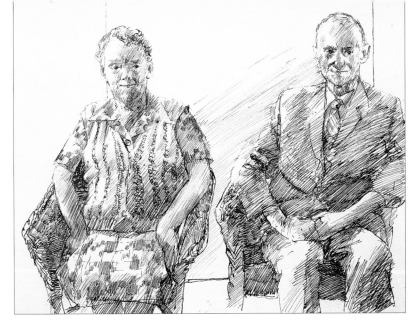

3 *Once you have checked the layout and structure, work as freely and boldly as you choose. Even at the final stages, continue to step back and observe freshly.*

USING A TECHNICAL PEN

The tubular nibs of technical pens produce an even line of a specified width; this mechanical effect is offset by great precision. If you think the linear character might suit you, use less expensive disposable pens until you are certain of the effect.

1 *Use a very fine nib to draw a skeletal draft. This way, any amendments will leave little trace and will be outweighed by subsequent broader marks. Make sure you stand back and evaluate the drawing at each stage.*

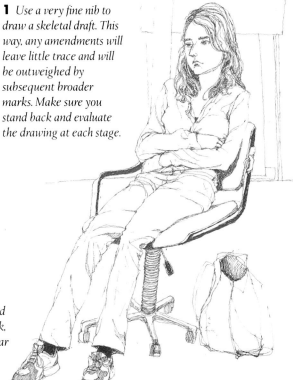

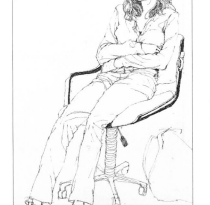

2 *When you are satisfied with the basic framework, begin to develop the linear structure evenly. Check the dimensions and proportions, paying particular attention to the white shapes contained by the ink lines, which must be sized correctly.*

3 *Now begin to make firmer strokes of the pen, building up the darker tones of the drawing until they reach the desired strength. Note that the shapes framing the sitter's head have been added only at this stage.*

Brush Drawing with Ink

LOOKING AT OTHER MEDIA

Brush drawing is a fast and descriptive method of using ink, and wide tonal ranges can be expressed by using diluted non-waterproof types. One essential purchase is a good-quality soft-hair brush, even if it seems expensive; it is hard to paint well with a poor-quality brush that sheds bristles and doesn't come to a good point. If you buy only one brush, start with a large size. It is possible to make small marks using a large brush carefully, but trying to cover a large area with a small brush is laborious. There are two kinds of soft-hair brush. Natural-hair brushes are good for drawing work, but are very costly. Synthetic brushes can be stiff to use, but they give you full control and are good starters; buy the best-quality large pointed one you can afford. Never leave a brush in water, even for a short time; once the bristles have bent, you cannot control the point. After use, wash brushes out thoroughly in soap and warm water.

TINTS AND WASHES

Tints can be unpredictable. Until you gain experience mixing them, make up measured dilutions in a mixing tray, and rinse the brush between changes. Even when you know the tint strength, the depth of tone when tints overlap or cross can be surprising; each wash excludes a little light from the paper, so two pale washes create a medium-dark one, and three, a dark wash. You can build up subtle tones with this method. For definition, add pen lines later. Water-soluble colored inks are good for monotone washes, but they do not take further layers well; waterproof inks do not dilute well and are best used for overlays of brilliant color and for large-scale work.

MAKING A BRUSH DRAWING

It is important to get yourself prepared before brush drawing. By stretching your paper first, you can prevent buckling, and preparing graded dilutions of washes saves drawing time. To get the most consistent results, mix washes to measured dilutions, and test each one on scrap paper before you begin.

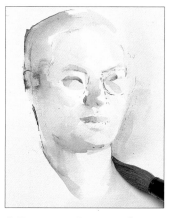

1 *Because washes cannot be amended once they sink into the paper surface, keep your opening statement very pale to allow for any necessary changes to proportions, dimensions, or structure.*

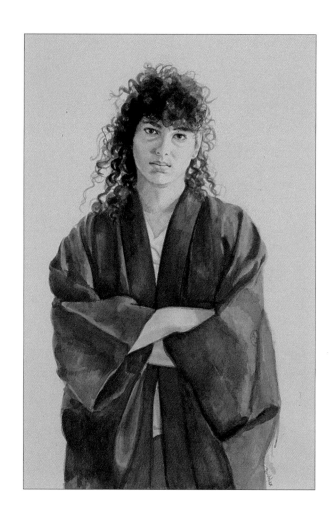

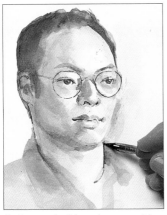

2 *Start to build up the tone with overlays of washes. Keep the edges of washes damp to continue them, as accidental dry overlaps will appear darker.*

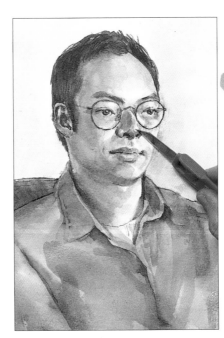

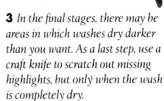

3 *In the final stages, there may be areas in which washes dry darker than you want. As a last step, use a craft knife to scratch out missing highlights, but only when the wash is completely dry.*

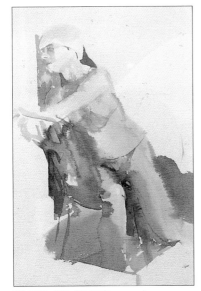

WASHES AND DETAILS
Making brushed washes in ink enables you to encompass a broad range of tones and textures very rapidly (left). Combine this with brush drawing that expresses fine details with ease.

WORKING BROADLY
Used with confidence, brush drawing is the ideal way to capture short poses and transient movements (above).

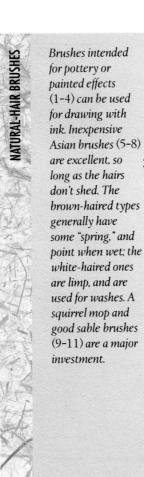

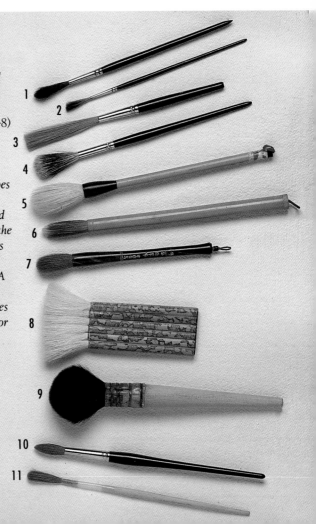

NATURAL-HAIR BRUSHES

Brushes intended for pottery or painted effects (1-4) can be used for drawing with ink. Inexpensive Asian brushes (5-8) are excellent, so long as the hairs don't shed. The brown-haired types generally have some "spring," and point when wet; the white-haired ones are limp, and are used for washes. A squirrel mop and good sable brushes (9-11) are a major investment.

1
2
3
4
5
6
7
8
9
10
11

Water-based Paints

LOOKING AT OTHER MEDIA

Using water-based paints for drawing offers an interesting alternative to dry media for the figure artist. If you choose to do brush-drawing with watercolor, keep in mind that the effect you achieve is fixed once the wash is dry. Watercolor washes soak into the paper, and the transparent result reflects light brightly from the surface; for this reason, white paper is most often used. Watercolor washes look best when they are crisp, so apply them confidently. If you need to create some structure, draw outlines with a water-soluble colored pencil, but do this lightly to avoid merely filling them in with washes. You can create subtle variations by overlaying washes of other colors, making sure that the previous wash is completely dry, but each new wash excludes more of the white paper and darkens the tone of the drawing. Try out each possibility on scrap paper, noting the strength of the washes; mix lots of each wash, as it is better to have too much than to run out.

OPAQUE AND SEMI-TRANSPARENT MEDIA

Gouache and poster color have a powdery surface presence that lightens on drying, giving a pearly, pastel-like translucency; this is unsatisfactory for glazes, however, so you need to mix the final color wash in advance. The opaque quality of gouache and poster color also enables you to adapt work, because it provides a degree of covering power, as do tempera and acrylic colors. These have the advantage of not "sinking"—the loss of gloss and lightening of colors when dry. Acrylics can be thinned and used like watercolor washes, while tempera washes lend themselves to glazing techniques and overlays. You can make watercolor semi-transparent by adding opaque white to a wash.

WORKING WITH GOUACHE

The opacity of gouache allows you to apply solid areas of flat color where required. When working on large areas of paint, gently sponge off any surplus, without rubbing it; you don't need to sponge off small details.

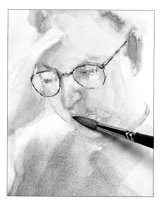 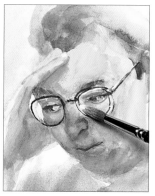

1 *Where features may be hard to define, for example, because of a sitter's slight head movements, apply the paint lightly so that any adjustments will be easy to perform once you have laid down the basic pose and shapes.*

2 *Here, the glasses were spaced too broadly and the bridge of the nose needed reduction. Allow the base to dry completely, redraw where necessary, and cover superfluous marks with thick gouache, laid on flat without overbrushing.*

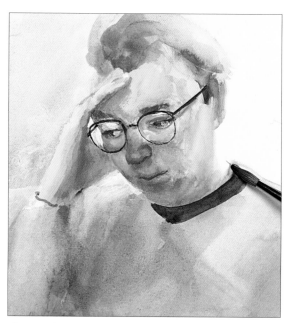

3 *Once the correcting coat of gouache is dry, lay another wash over it to adjust the balance of color and tone. Blend in final details, to give definition to the finished work.*

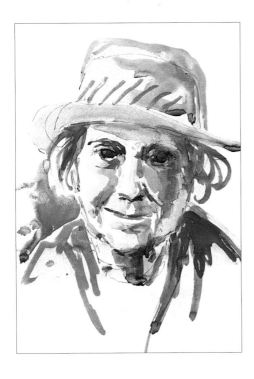

BRUSHING ACROSS FORM

Brush drawing has the dual advantages of speed and subtlety. You can quickly realize a sensitive portrait by using brushwork to show delicate transitions of color.

RAPID BRUSH DRAWING

Multiple subjects in motion call for a rapid method of setting down information. Use quick brush drawing to catch the action and to capture it in color.

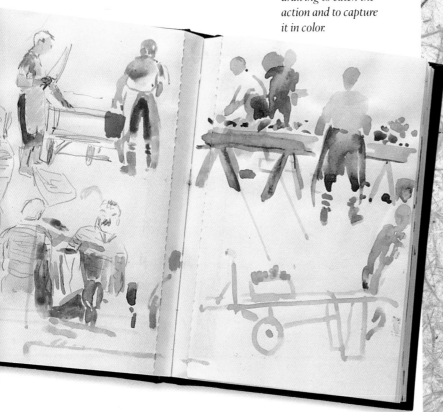

LAYING-DOWN WASHES

Get everything ready before you start to work; washes can be laid down quickly, and tend to look best when you execute them fast. Always stretch the paper beforehand, using gummed paper tape (see page 17).

Use a large brush to lay down washes on damp paper. They will spread evenly as they disperse into the water. In opaque media, the colors will lighten slightly as the washes dry.

As washes blend with the moisture, their edges are undefined. To create a more formed edge, dampen the paper only as far as the required limit of the color. Slight guidelines may first be drawn with aquarelle pencil.

To make beautiful broken and linear textures, drag less moist washes with a coarser brush when the paper is dry. Take care when doing this with watercolor paints, as these set quickly and allow you no time for adjustment.

Special Effects

LOOKING AT OTHER MEDIA

Many special effects can be obtained by combining media to achieve textures, contrasts, or broken color unobtainable by using solely one medium. Always experiment with any combination, as the charming effects you produce can sidetrack you onto pure mark-making rather than capturing a scene; convincing work comes when you use media that together provide an economical solution to the problem of representing a particular look. Be careful when combining media that have different tonalities, because the stronger one can overpower the weaker; the effects of pencil are often diminished by the richness of charcoal, and gouache can seem dull when set beside brilliant waterproof ink. Similarly, watch out for unexpected effects: for example, the surface pigment of gouache can cause the lines made by pen and ink to spread over it. You can also achieve special effects by lifting wet media off the paper surface, using blotting or tissue paper, sponges, or cloths.

COMMON MEDIA COMBINATIONS

Popular, well-tried combinations include chalk and charcoal, and gouache and pastels or chalk. Watercolor washes create a stable surface to which you can add other media work to produce strong, complex colors and broken textures. If you apply pastel first, take care not to overbrush a wash, since this can shift the base colors. Gouache can be used to rescue watercolor work marred by drawing errors, and can be a useful veil for lightening dominant areas or reducing over-vigorous pen work. Body color, or white gouache, is often used to add highlights to various media. You can scratch out any medium with a blade, but do this at the last moment, because of the broken paper surface fibers this creates.

WHITE CHALK AND CHARCOAL

White chalk and charcoal mix together to create a range of grays. Each is a fast medium, and when used with a colored paper—which serves as a medium tone—you can soon draw complex effects.

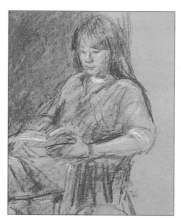

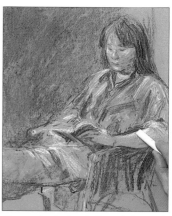

1 *Start by blocking in faint areas of tone, to help to gauge the right dimensions. This makes corrections easier in early stages, when they are most likely to be necessary.*

2 *Use both the chalk and charcoal from the start to establish the full range of tones. As you build up the drawing, keep observing the different tonal intensities.*

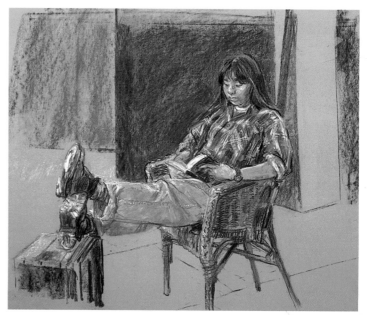

3 *The speed and flexibility of both these "soft" media allow you to get a crisp, fresh effect. Because you can erase charcoal marks easily, you can make radical changes at any time.*

SCUMBLING, STIPPLING, SPATTERING, AND LIFTING OFF

Each of these effects adds interest to a drawing, if used carefully. Scumbling is the technique of applying two or more random washes; stippling creates controlled areas of fine dots to create textures; spattering makes wonderful spotted and splashed effects; and lifting off watercolor when a wash is still wet removes color. Practice these effects on scrap paper first.

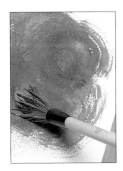

There are two stages in scumbling. First, swirl a random wash onto the paper, to act as an under layer. Then lay a second wash thinly on top, to soften or vary the effect.

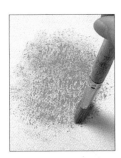

To create stippling, load the flat tip of a bristle or other stiff brush with just enough paint for the bristles to make dots. Hold the brush vertical, and apply the tips to the surface.

For spattering, load a stiff brush with paint and scrape it with a ruler or your thumbnail, to produce a random, spotted texture. Mask off the areas you do not wish to spatter.

Before lifting off wash, let it dry slightly. If you try to remove a very wet wash, it will run back into the "gap" and fill in the texture of the paper again. Vary the amount of wash you lift off by the way you crumple the material, and the pressure you apply.

RESIST TECHNIQUES

There are various resist techniques, where the surface of the paper is sealed or masked, and a wash is then applied. They offer quick methods of representing complicated patterns on fabrics, or for capturing diverse backgrounds and settings.

You can use colored wax crayons or plain wax candles to seal the surface of the paper, which will then resist a watercolor wash.

You can apply a wash immediately after drawing with a wax crayon or candle. The waxed area will remain impervious to numerous washes.

Oil pastels also resist watercolor washes. They offer you greater color options and more definition than wax crayons or candles, but are less stable on paper.

The soft consistency of oil pastels makes it easy to smudge them, so always brush your wash on gently, and don't try to overwork it.

Liquid masking fluid is another resist option. It is, however, hard to see as you apply it to the paper, so work against the light for accuracy.

Once the wash is dry, rub off the masking fluid carefully. You can repeat the process to create further resist effects.

Masking tape also shields paper. Cut it to shape on a cutting mat, using a sharp craft knife. To avoid damaging the paper, peel the tape off slowly.

To create more complex patterned effects, you can color in the peeled areas with a second wash, or re-mask parts or the whole and apply another wash.

Creating Effects with Textures and Objects

The use of unusual textures and objects, which can usually be gathered for free, add character to mark-making. For example, using frottage or taking an impression of a texture, is a quick way to reproduce light reliefs. Place a sheet of thin, smooth paper over a textured surface, such as wood, stone, or fabric, and rub the paper with a soft drawing medium—pencil, crayon, graphite, or wax—until the desired tonal strength is achieved.

USING PAPER AND FABRICS

Collage is another quick way to create a special effect; remember, however, that newsprint and magazines will fade and yellow, so use acid-free sources for durable work. You can cut areas from paper that you have already toned or colored, but don't cannibalize your recent work; it is wise to put work away for a while and look at it again before destroying it. A cut or torn edge has all the vitality of a drawn line, and if you use textured paper, fabric, or other applied items, these will define form with their surface interest. Make sure the base sheet is durable, and choose a glue to suit the weight of the collage material.

DRAWING WITH FOUND OBJECTS

Many interesting effects can be made by drawing with unconventional tools. Try drawing with a twig or stick dipped in black ink, or use a sponge, fabric textures, or found objects to produce magical results in wet media. Leaves, feathers, flowers, and similar surfaces must be lightly coated with damp household soap before paint is applied and they are evenly pressed onto a surface; the coating of soap prevents their natural oils from rejecting the medium.

FROTTAGE

Frottage is a fast way of adding texture once you have identified a suitable light surface to rub. Watch out for the scale of the surface, because a rubbed mark will invariably convey the size of its source.

Keep your eyes open for useful or interesting textures, and collect a variety to use to create effects. Here, the baked surface of a building brick makes a slight stipple on the paper when it is rubbed over.

You don't have to use the texture of large-grained wood to represent wood literally; it is too big, and it will not be in perspective. Instead, use it to create a pattern of tones, for example.

MAKING DRAWING TOOLS

Cut a goose-quill pen from a feather with a sharp knife. Sharpen the tip of a twig to make a nib, and squeeze a hand-held reservoir to provide a flow of ink. Use an old toothbrush for stippling, and lay down quick washes with a trimmed sponge.

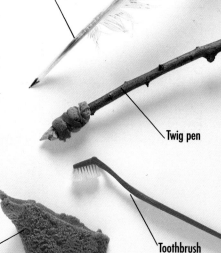

Quill pen

Twig pen

Sponge

Toothbrush

COMBINING COLLAGE AND DRAWING MEDIA

You can introduce collage materials at any point, and in combination with any medium, to reclaim a portion of a drawing or to make a quick, bold effect.

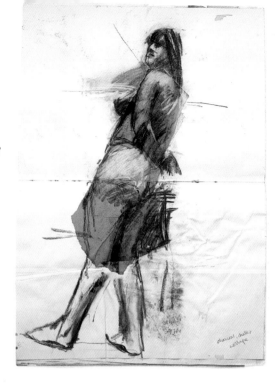

When you use unusual textures to apply wet media, such as ink, the quality of their printed marks is different from drawn or painted marks. Look out for anything that can be used in this way.

You can create unexpectedly beautiful and atmospheric textures with an old towel. Experiment with the way you fold the towel, how much paint you use on it, and the degree of pressure you apply.

Utilize wrapping and packing materials, such as corrugated cardboard and bubble wrap, to achieve bold, dramatic effects. However, make sure beforehand that your drawing is large enough to contain their scale.

Smaller items, such as flowers, leaves, and feathers, may remain identifiable when used to apply paint. Turn this to your advantage by using them to build a basic texture into which to work, or as a random filler.

MAKING COLLAGE PORTRAITS

When collecting pieces of colored paper from periodicals and magazines to make a collage portrait, remember that achieving the right tone is as important as matching color.

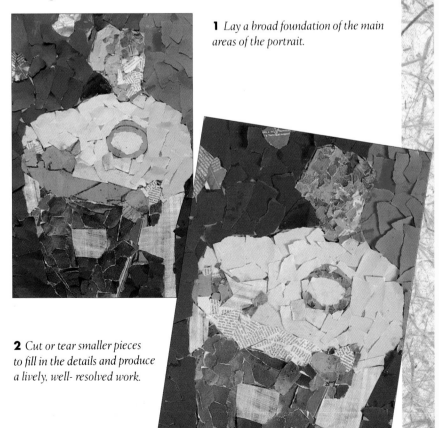

1 *Lay a broad foundation of the main areas of the portrait.*

2 *Cut or tear smaller pieces to fill in the details and produce a lively, well-resolved work.*

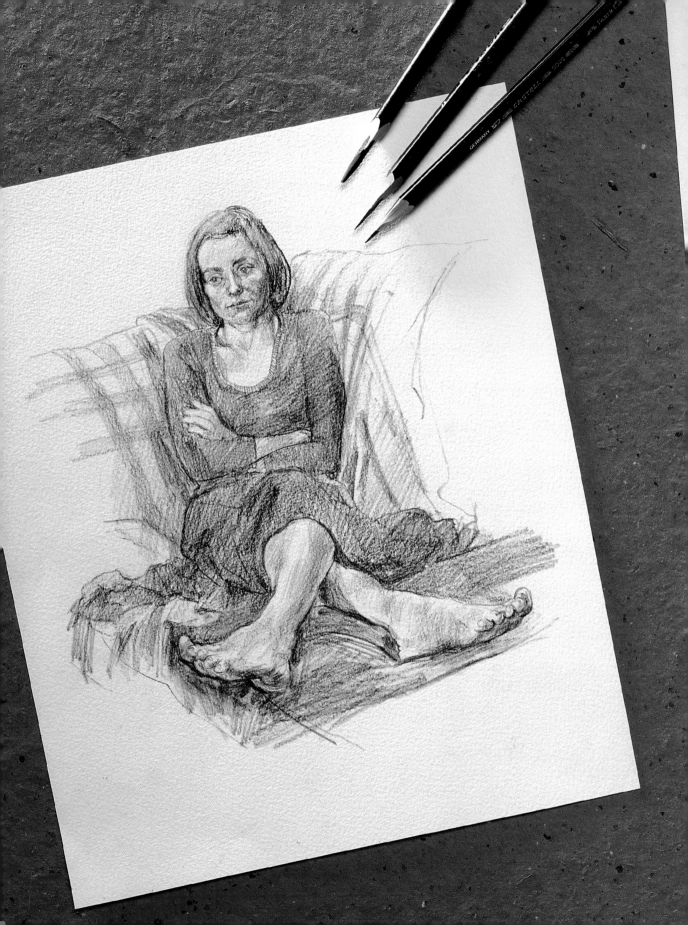

3

Observing Detail

SEE ALSO
REFERENCE FILE
PAGES 130–3

Comparing Body Shapes

OBSERVING DETAIL

In general, the height of an upright adult figure is equal to approximately seven-and-a-half times the length of the head—which may be referred to as the x-height; the span of a figure's outstretched arms is approximately equal to that of its height. There are, of course, exceptions to these proportions, and although the main forms of the torso and limbs are basically cylindrical, their dimensions and contours have infinite variations, depending on age, weight, race, and gender. The best way to become fluent at sketching this fascinating human diversity is to observe and draw the differences wherever and whenever possible.

OBSERVING THE DIFFERENCES

You can become aware of the differences in body shapes by looking out for the most obvious factors first and including them in your work. These include gender differences: males often have stronger arms, wider backs, and broader shoulders compared with female bodies of the same weight, which are usually broader at the hip and carry the forearms at a different angle. Age is a related factor: the childish figure, when gender differences are less manifest, is typified by a comparatively large head and light musculature; and although full adult height can be governed by race and gender, one of the effects of aging is to reduce this. With age, muscle tone and skin tension are lost, leading to a less erect posture, and a decrease in physical activity or a sedentary lifestyle can change body shapes at any age, by thickening waistlines and decreasing leg muscles. Conversely, regular exercise builds up muscle, but in different ways: swimming demands suppleness, while football or boxing require more solid development.

THE MAIN TYPES OF BODY SHAPES

Body shapes change throughout life, and also take place within a context determined by gender, race, and physical type. Broadly speaking, there are three types of body shape for both women and men. Ectomorphs are lean, and their spare frames are not filled out by eating. Endomorphs are bulky people with broader figures, who may tend toward being overweight. Mesomorphs usually have an athletic build and show good muscle definition.

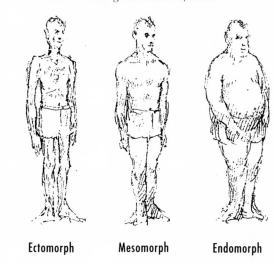

Ectomorph Mesomorph Endomorph

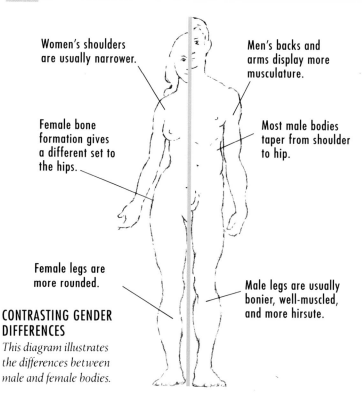

Women's shoulders are usually narrower.

Men's backs and arms display more musculature.

Female bone formation gives a different set to the hips.

Most male bodies taper from shoulder to hip.

Female legs are more rounded.

Male legs are usually bonier, well-muscled, and more hirsute.

CONTRASTING GENDER DIFFERENCES

This diagram illustrates the differences between male and female bodies.

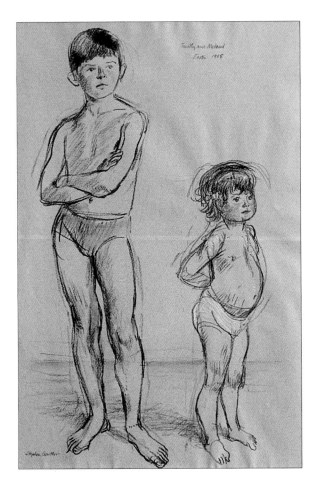

COMPARING AGE GROUPS

The changes in body scale during development give a special interest to comparative studies of children. Sketching groups of young friends enables you to capture the differences.

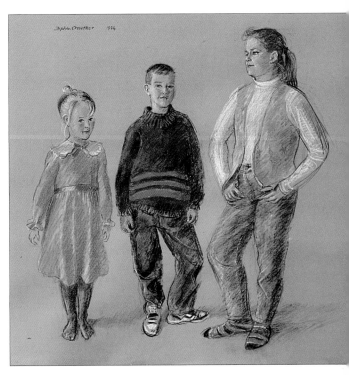

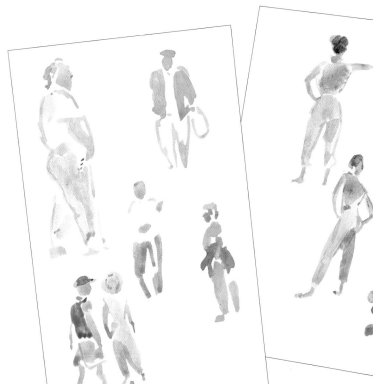

SKETCHING MOVING BODIES

You can learn much about body shapes by making quick sketches of people as they pass by. Use a fast medium, such as brush drawing (see pages 60–63), and make up washes beforehand.

71

Perspective

Perspective is the name given to any drawing method that conveys depth of space. By careful observation and accurate recording, you can represent space effectively and convey depth intuitively—provided you use both eyes to see. Our stereoscopic vision gives us accurate judgements of distance and depth, which is why using photographs as a sole source of reference leads to flat drawings. The devices that help you represent the third dimension are simple to apply, once you understand how they work.

VERTICAL PERSPECTIVE

Draw big figure outlines low down on a sheet of paper, and small figures high up on the same sheet. As real distance diminishes apparent size, this device will create the illusion of depth. Drawing big figures over the small ones reinforces the illusion of depth, as overlapping contour lines also imply distance. This is vertical perspective.

LINEAR PERSPECTIVE

Linear perspective needs a standpoint, so draw a horizon line on a new piece of paper: this is the eye level. Mark a point on this line: this is the vanishing point. Now draw a figure by a railroad that runs toward the vanishing point. All receding horizontal lines lead to a vanishing point—upward if they are below your eye level, like the track, downward if they are above—so remember how size diminishes the further away it gets, and decrease the size of the track ties and the gaps between them as they recede from view. This is single-point perspective; a road that meets the horizon line at an angle will need a different vanishing point.

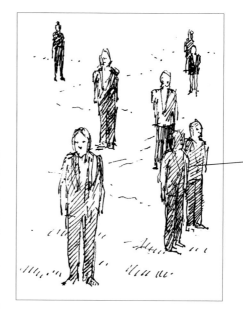

A variation on vertical perspective, overlapping the figures provides another clue to depth in a drawing. Both this and vertical perspective can be used quickly or on the move.

VERTICAL PERSPECTIVE

This is the simplest drawing device to show distance, which is easily managed, whatever the level of skill or experience. Just arrange upright figures to create the illusion of depth.

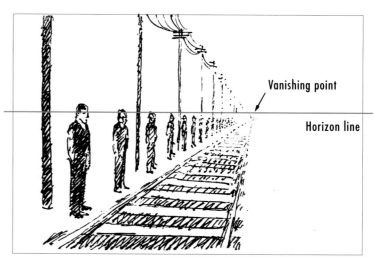

Vanishing point

Horizon line

LINEAR PERSPECTIVE

In basic one-point linear perspective, there is a single vanishing point. Multiple vanishing points can be incorporated in more complicated scenes.

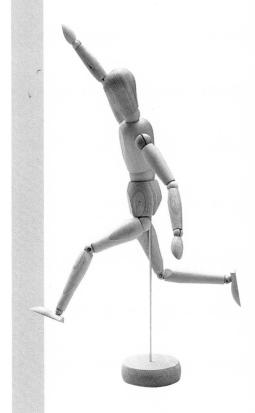

Artists use maquettes, or manikins, when a live sitter is not available, when a pose might be difficult or uncomfortable to maintain for long periods, or to try out ideas for poses to make several figures relate in a composition. The simple elbow, wrist, knee, and foot joints of maquettes move on the same planes as human ones, and can be manipulated into lifelike positions, but there are no faces, fingers, or toes, so these must must be added from life.

AERIAL PERSPECTIVE

Also called atmospheric perspective, this turns on the mixture of dust and moisture in the atmosphere that reduces apparent tonal strengths and makes distant dark colors appear lighter. Distant objects have a cooler, paler, bluish cast, so adjust your color mixtures to take account of this.

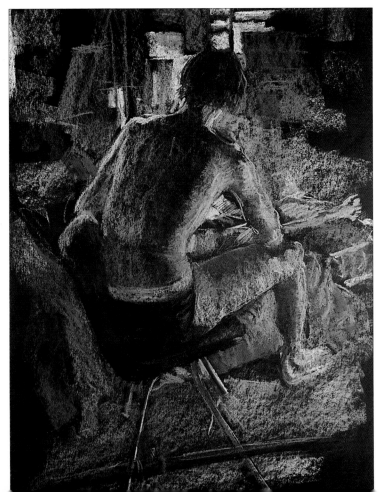

BACKGROUNDS AND SETTINGS

Even the most generalized or undefined settings should be drawn in perspective. Any visual clues that do not show conformity to the basic principles of perspective are likely to jolt the viewer into disbelief, and the drawing will thus lose credibility.

Foreshortening

Foreshortening describes the illusion of shorter length seen in any object that is not exactly vertical to your line of sight. This effect was described in the railroad exercise on linear perspective (see page 72); when you decreased the space between the track ties as they receded from view, you were drawing increasingly foreshortened gaps. If the figure had been asleep alongside the track, you would have had to draw it foreshortened. As with perspective, foreshortening can be managed easily, as long as you concentrate on observation and disregard any preconceptions about what you think you see.

DRAWING FORESHORTENED FIGURES

Draw a grid-like "box" to enclose a standing figure facing you, by making roughly equidistant vertical lines down the sides and center, and horizontal lines at the base, knees, navel, shoulders, and a head length above the head. Then draw the grid again, but this time lying down. The vertical lines are now horizontal and lead to a vanishing point, like all receding horizontal parallels, and the lines across the grid have diminishing gaps, like the track ties. Now draw the prone figure inside this grid; with its feet nearest you, you will see mostly legs, a short chest, and a very short head. Having the head nearest you gives you the reverse: a large head and shoulders, and shorter legs. These irregular body sections require subtle calculation to appear three-dimensional, and it's best to observe them from real life. If you don't have a sitter, prop your non-drawing arm comfortably so you can see it pointing towards you in a mirror. While its width stays roughly the same, the length is condensed into a short span; observe it carefully and draw this short, wide shape.

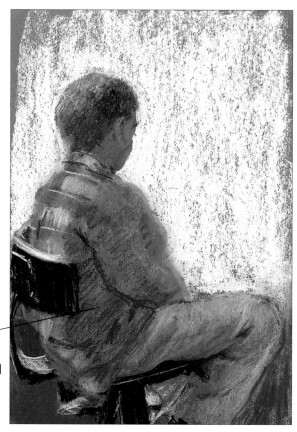

Children and adolescents with part-formed bone structure are good subjects for profile and three-quarter rear views.

THREE-QUARTER REAR VIEW

Don't be tempted to draw more than you can see. Here, the features recede, and overstating them would result in an inaccurate profile effect.

THE LITERAL APPROACH

Reserve the right to represent exactly what you see. However odd your common sense may tell you the pose looks, this is what your view is in reality.

From above and to one side, face is condensed into tiny area.

From below, features follow curvature of head, and forehead is condensed.

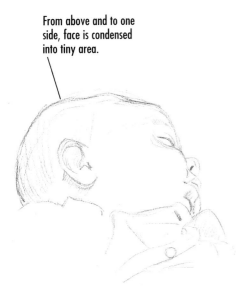

Foreshortened small limbs produce compact shapes.

DRAWING A NEWBORN BABY

The tiny scale of a new baby makes foreshortened views easy to see, and the minute features will not lure you into enlarging them and losing their proportions.

Allow your sitter to assume a natural, comfortable pose, and enjoy the challenge of the extraordinary shapes that result from a foreshortened view. Set down every form honestly, and you will create the illusion of three dimensions with accuracy. Be very careful not to try to "normalize" any curious shapes; changing them will only produce strange forms. On this occasion, draw what you see, not what you know to be there.

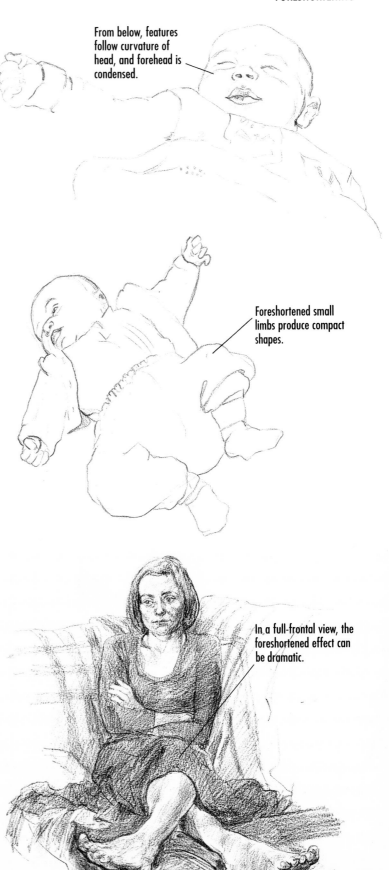

In a full-frontal view, the foreshortened effect can be dramatic.

Figure Details

OBSERVING
DETAIL

Like body shapes, figure details display a wide variety, according to age, race, gender, and type. To give a small selection of examples, in heavy-set endomorphs, bony joints, such as shoulders, knees, and elbows, are less apparent than in lean ectomorphs. Make sure you allocate greater width to the knee than to the elbow, as it is a much larger joint, whatever the development around it. Observe the set of the head on the neck, which itself must sit between the collarbones at its base, well below the shoulder line. Even when the torso is hidden by voluminous clothes, wind or gravity will define its contours; aim to draw a sufficient bulk to show the solidity of the ribcage. Shoulder joints have flexible profiles with circular movements; take care not to reduce the distance between the armpit and shoulder point, or the arm will appear to be half-severed. Raised arms and armpits are best depicted by careful observation of tonal changes to show the concave form, and fleshy areas can be defined in the same way to reveal convex forms. Remember that all figure details are affected by foreshortening, particularly when a limb is seen square on.

CAPTURING THE CONTRASTS

Set up a drawing project with yourself or a patient sitter, where the aim is to show the character of contrasting figure details: taut and slack, sharp and round, and hard and soft can all be seen within a condensed area in the human figure. From this, progress to studies that indicate the sitter's mood and personality by posture, body language, or individual use or working of a feature. Make studies of movement, too; a person's gait, for example, can convey many character features.

NATURAL FRAMES

Sometimes a pose presents a portrait detail framed naturally by a geometrically shaped area, such as arms and shoulders. This helps you to capture the proportions accurately and easily.

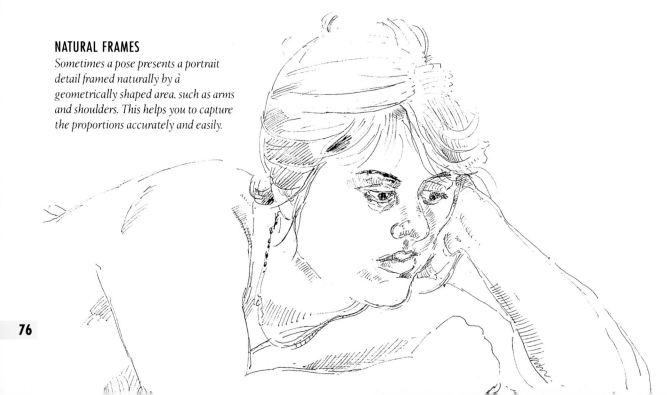

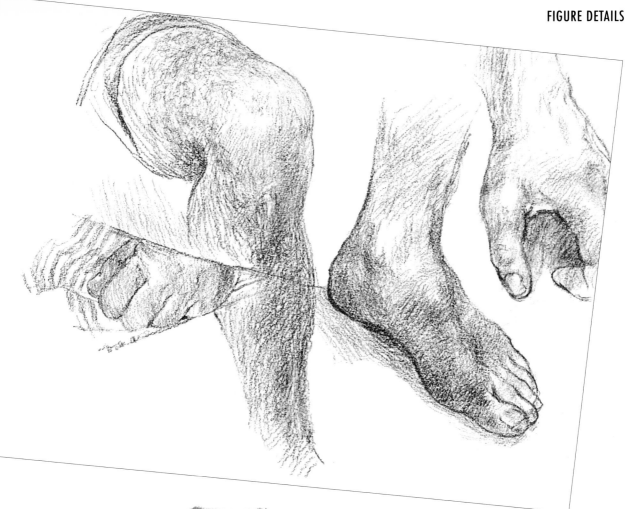

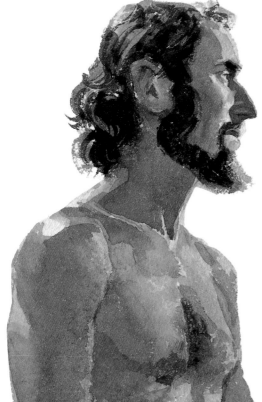

MAKING USEFUL NOTES

Although it is preferable to draw complete figures, to give yourself practice in every aspect of figure sketching, be ready to make quick studies of details for reference.

UNDERLYING STRUCTURE

Lean body types display more of the underlying muscular and skeletal structure. Viewed from three-quarters on, the neck arises at a slight forward angle out of the sharp collarbone. The joint of the near shoulder is rounded and full, while the far one is barely visible, due to foreshortening.

77

Skin and Hair

OBSERVING DETAIL

Skin and hair call for a careful choice of media, matched to the qualities you want to capture. Thoughtful observation, coupled with the experience of the media you gained in Section 2, will guide you to the best choice. Learning to choose the right medium for ease, speed, and truthfulness to your subject is a crucial skill.

When dealing with hair, remember that although it may be arranged, cut, or piled up in many ways, it always stems from the shape of the skull beneath. It helps if you begin by considering the overall shape of the head. When depicting plaits, waves, or curls, try to hang on to the three-dimensional form, or you may spoil an otherwise sound drawing with two-dimensional hair. Pay attention to tone, as even in the darkest hair casts shadows and highlights that help show form.

Next, consider the texture of both hair and skin. Hair may be dense and smooth, frizzy, coarse, or sparse and fine, while skin textures vary according to age, race, and gender. You will even see differences in the same face, with perhaps a smooth brow, a flaccid jaw, and papery fine laughter lines, each needing a descriptive mark.

COLOR

If you are working in color, easy-to-mix media, such as pastels and watercolors, will give you most freedom; but be prepared to spend time on careful mixing. Skin colors in particular can be complex. In some media, special "flesh tints" for Caucasian skins are offered, but these are ineffective, as no one's skin is an overall flat pink; shadows may be blueish or greenish. Just as unrealistic is blocking in just one dark color to represent black or brown skin. The prevailing light and the surroundings affect colors, too.

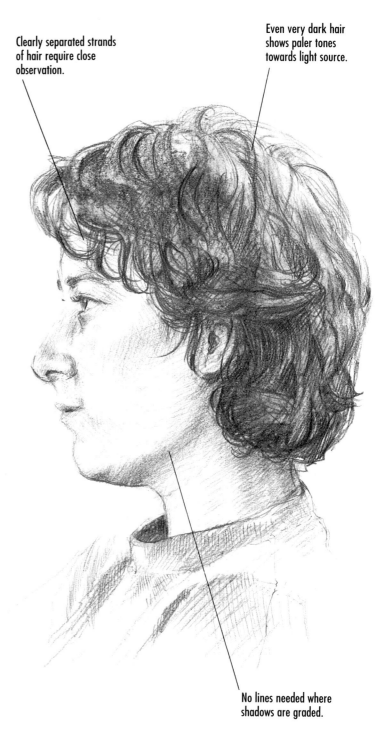

Clearly separated strands of hair require close observation.

Even very dark hair shows paler tones towards light source.

No lines needed where shadows are graded.

DEPICTING LIGHT EFFECTS

Depicting dark hair color is not always necessary, as you can draw only the cast shadows to show the form. If you choose to shade the hair, look for and show any variations of tone.

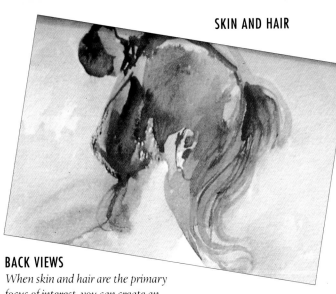

USING PASTELS FOR SKIN AND HAIR DETAILS

The clarity, immediacy, and blendable properties of pastels make them an expressive choice of medium for portraying skin and hair. However, make sure you work them steadily and don't muddy their richness by overworking them.

1 *In the early stages of establishing form and structure, use open hatching to depict the strong, brilliant colors that are seen in the shadowed areas when you work against the light.*

2 *Once you have set down the proportions and dimensions of your sitter accurately, look to strengthen the colors or make any necessary adjustments by redrawing more strongly.*

BACK VIEWS

When skin and hair are the primary focus of interest, you can create an effective image by treating the large values simply, and by indicating details economically by changes in tone and color.

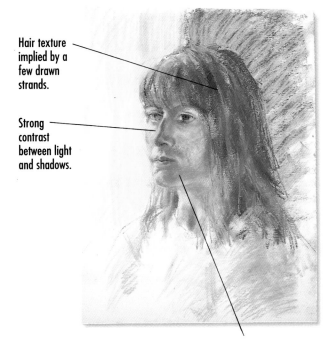

Hair texture implied by a few drawn strands.

Strong contrast between light and shadows.

3 *Adding the final details and full strength of tone reinforces the rich, luminous qualities of skin and hair in the shadowed areas, and helps you to capture their strong tones.*

Form shown through tone and color.

FACIAL HAIR

Beards, mustaches, and eyebrows, no matter how full and bushy, grow from the face, so try to assess the form beneath, even if invisible, and follow the perspective of chin, lip, or brow. Look for visual clues, such as highlights or shadows, caused by the fall of the light. These clues may reveal the forms, particularly in cases where a beard or mustache hides or masks the jaw or upper lip. Facial hair can be a strong indicator of character, so give it due attention, but avoid a "hair-by-hair" study. For beards, mustaches and eyebrows, a rough blocked overall statement, checked for tone and contour, is best initially. Once you have achieved the general effect, you can choose how much to leave as broad mass and how much to draw in detail. By drawing the eyebrows finely, for example, you could convey the hair-growth direction, and this could also be indicated by picking out a few light-catching hairs on a beard or mustache.

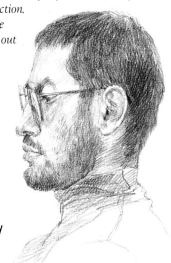

When drawing a beard or mustache, you can describe the direction of its growth by showing a number of clearly seen hairs in profile or at its edges. Don't try to draw every single hair.

SEE ALSO
REFERENCE FILE
PAGES 134–5

Hands and Arms

**OBSERVING
DETAIL**

Hands are expressive indi-
cators of emotions and
states of mind, so it is worth
taking time to understand
their physical make-up. Put
simply, fingers are all cylin-
drical and jointed in the same
way, but they seem complicated because each
moves independently of the others, creating
its own shapes. Their range of movement is,
however, limited: they are either straight or
bent, whether holding, gripping, pointing, or
pressing. In contrast, arms pose fewer
drawing problems than hands, for the most
part, so long as you check their lengths. Make
sure you observe individual variations, and
pay attention to the flatter planes that are
near the wrist in all but the fleshiest persons.

GETTING TO KNOW YOUR HANDS

As an exercise in familiarizing yourself with
hands, examine your own: are they tapered or
spatulate, stubby or delicate, attenuated, broad-
jointed, or dimpled? To show its form, place
your non-drawing hand flat in directional
light and draw the shadows cast by it. Then
clench your fist and draw its triangular
profile, completed by the thumb, with its
larger, lower, offset joint. Open your hand
again and note how the palm tapers toward
the wrist, which is a flexible link to the colum-
nar arm. Make a series of sketches of your
hand in various positions, making sure that
you observe the relationships between the
fingers and noting their characteristics. Once
you have established the solidity and pro-
portions, you can add details, such as creases,
hair, veins, and nails; including a wristwatch
or one or more rings helps describe contours.
When drawing other people, look for the
relationships between pairs of hands or
clasped hands, and be aware of their size in
relation to the rest of the figure.

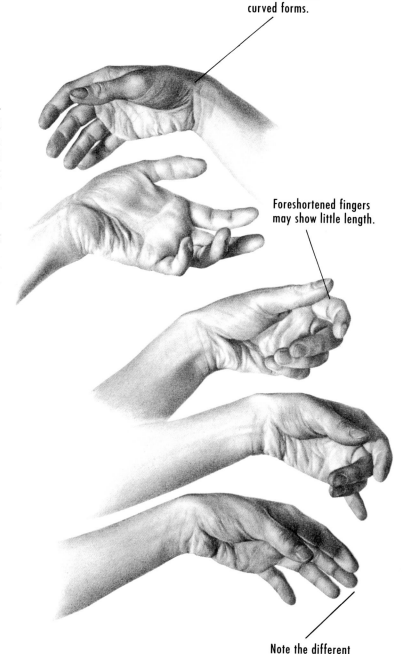

Expect to see heavy
cast shadows on
curved forms.

Foreshortened fingers
may show little length.

Note the different
lengths of fingers.

HAND STUDIES
*Graphite or pencil studies give you the
chance to describe the subtlety of tonal
changes on hands in a variety of
positions. Make sure you portray
transitional changes gradually.*

CLASPED HANDS

Until you have gained experience in making studies of two hands clasped together, expect to make changes and adjustments as you go along. Choose a fluid medium, such as gouache, that allows this to be done easily.

1 *When starting a study, work loosely and give yourself plenty of room for adjustment. Draw freely, and manipulate the medium on the surface while it is still wet.*

2 *The covering power of gouache helps you to redefine drawings simply. You need only continue until you have realized the form, leaving the details until later.*

QUICK STUDIES

To make lightning-fast sketchbook studies of hands in a number of positions, use water-based paint applied broadly with a brush.

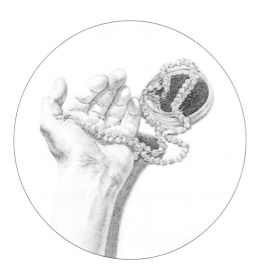

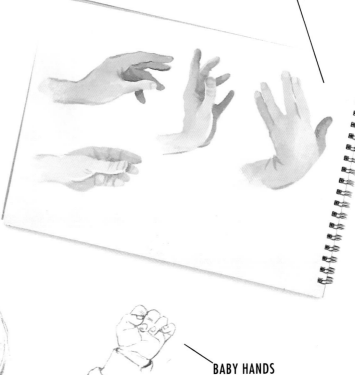

PORTRAYING LIGHT

Take special care not to overestimate or over-emphasize the bounced reflections of light that may be on the shadow side of the wrist or fingers.

BABY HANDS

Drawing a sleeping baby's hands gives you the chance to explore the tiny proportions and details for longer spells than when the child is awake.

SEE ALSO
REFERENCE FILE
PAGES 136–7 ▶

Feet and Legs

When drawing legs and feet, it is vital to make careful observation of their relative proportions compared to the rest of the body. Don't fall into the elementary error of drawing legs the same size as arms: they are much larger limbs, designed to hold up the entire body, and their muscles are correspondingly bigger. In the same way, feet are longer extremities than hands; their bony arch and the shortness of toes, compared to fingers, gives them a more solid, substantial look. The ankle is a more robust joint than the wrist and again is larger. By keeping these facts in mind, and by making continual comparisons as you add information to your drawings, you can avoid errors and produce accurate depictions.

MAKING STUDIES OF FEET

Because you are less likely to find bare legs and feet to sketch, except in warm weather, use yourself as a first sitter. Prop up a mirror and make a thorough observation of your own feet and legs. Unless you have a low arch to your foot, you should see a rising instep abutting the ovoid ankle, which has protruding, bony sides. Make sure that you draw the correct dimensions of the curving big toe joint and the width of the ball of the foot, otherwise they may have a flipper-like appearance. Pay attention, too, to the toes; they share the columnar, circular form of fingers, but extend much less. Keep checking the entire foot for perspective, and do the same if you or your sitter are wearing shoes, which often have a shape very different from the feet that they are covering.

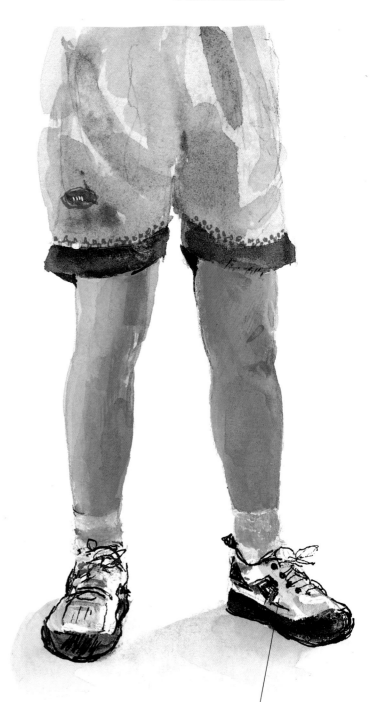

PAIRS OF LEGS AND FEET

If the feet and legs are together, draw them in perspective and in relation to each other, rather than attempting to draw each one as a separate entity. Look at them as a composite shape, and observe the relative dimensions within this.

Shoes must curve with the feet and obey the laws of perspective.

BARE FEET AND SANDALS

When drawing bare feet or feet in sandals it is important to depict the curved taper of the toes and their joints, and the diminishing size of toenails.

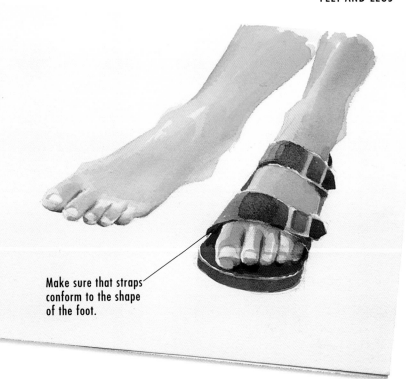

Make sure that straps conform to the shape of the foot.

CROSSED LEGS

Crossed legs present complicated shapes and angles, so use a medium, such as gouache, which allows you to make alterations easily.

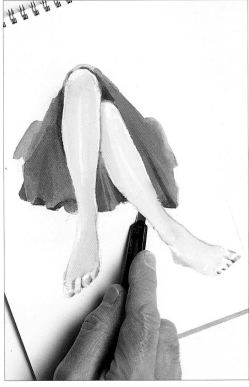

1 *Where the thighs are concealed by a skirt, concentrate on the lower legs as a pair, and use the negative space to set down their dimensions accurately.*

2 *If you need to build up confidence, block in the basic shapes using a diluted wash, and sharpen the details later with fresh, full-strength washes. Errors may be scratched away carefully with a sharp blade.*

FORESHORTENED LEGS

Drawing even heavily foreshortened legs presents no problems, as long as you remember that only the length is visually shorter, while the width remains unchanged.

83

Clothing

As well as protecting us from the elements and keeping us warm, clothes are an immediate guide to the image of ourselves we wish to convey. Bring an artist's observation of clothing into your sketches, and you will capture your subject's individuality more effectively. For instance, clothing is a good indication of climate: to create an impression of cold weather, draw your sitter huddled in a winter coat; to show a hot temperature, draw him or her in tennis shorts and tennis shirt.

LOOKING CLOSELY

Think of clothing as "body wrapping," and use it to bring out the solidity of the wearer. A dressmaker's mannequin can be useful in showing how clothes hang and gather, but you can gain experience in sketching fabrics by examining clothes hung up in a closet. Pay particular attention to folds and creases. Light materials generally fall into small, fine creases, while thick or stiff fabrics have mostly broad folds, or stand away from the body. Look out, too, for the small surface changes that differentiate fresh, crisp clothing from worn or shabby clothes.

TEXTURES AND PROPS

Glossy materials are fascinating subjects: compare the glitter of gold lamé with the gleam of wet oilskin, or the sheen of satin, and bring out their differences in your sketches. Even impersonal work clothes and uniforms may incorporate plastic, in hard hats for example, and metal, in badges and accessories. Use hats, headscarves, and other headgear as special features. When drawing on location, include the "props" people carry or use, such as shopping bags, umbrellas, or shovels; these can unify a drawing.

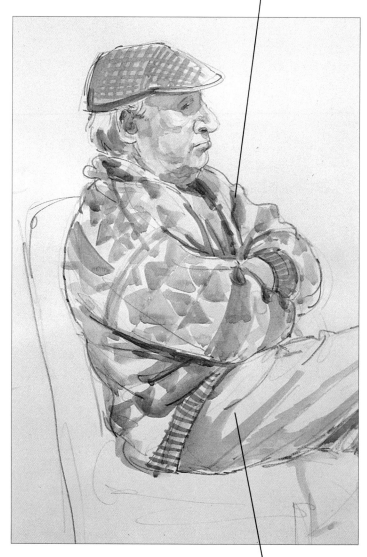

You can generalize when depicting complicated patterns, as long as your simplified version follows contours in perspective.

PATTERNS AND CONTOURS

There is no need to spend a lot of time slavishly drawing details of printed or knitted fabrics, unless this is vital. Look at how you can treat them economically.

Use the direction of folds in garments to describe form. Use their size and depth to suggest the weight of the garment.

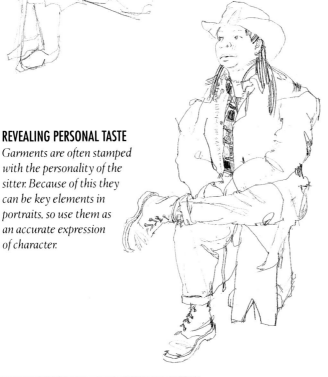

ACCESSORIES

Don't neglect the chance to include accessories, such as hats or umbrellas, because these props can often be great aids to depicting character and identity with authenticity.

Many items of clothing can act as props. Favorite hats, an old sweater or a well-loved pair of shoes are often a part of the wearer. As a souvenir of a particular sitter during a distinctive period of their life, they can serve as a date marker.

If your sitter likes to wear hats, including one in your drawing will give it a stronger identity.

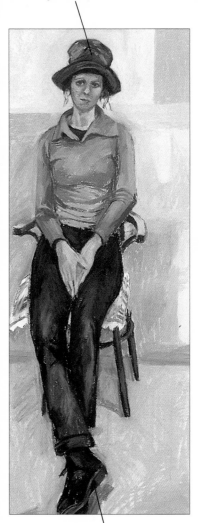

REVEALING PERSONAL TASTE

Garments are often stamped with the personality of the sitter. Because of this they can be key elements in portraits, so use them as an accurate expression of character.

REGIONAL COSTUME

Factual recording is an important function of drawing. Seize any opportunity to capture historical, local, or national dress whenever you have the chance.

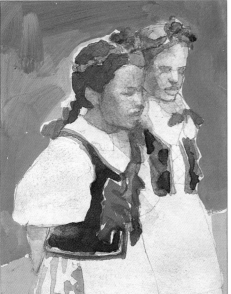

Shoe style is a very personal choice, and can provide a lot of information about a particular sitter.

Faces:
General Proportions

To draw faces in proportion, you need to pay particular attention to the dimensions of the features and the spaces between them. Faces follow the curvature of the rounded bones beneath the skin, so for accurate proportions, don't plot the features out like a flat map, but concentrate on their solidity. When starting to draw heads, use a medium that can be easily amended, and make a broad outline that looks plausibly human before concentrating on the features. Once you can identify the structure and proportions that are determined by the skull, you will have the "bones" of a good portrait, in every sense.

THE PARTS OF THE SKULL

Whatever their features, race or type, all faces are underpinned by similar skulls. The cranium, or whole skull, is capped by a domed box, the calvaria, that houses the brain. It may be hidden by hair, but its varied contour is near round when seen from above, and it is wider to the rear of the center. The upper facial skeleton joins rigidly to the calvaria, and here are found the orbital openings, the cavities into which the eyes fit, the cheek, or zygomatic, bone, and the upper jaw. A bony ridge, the superciliary arch, runs along the upper edge of the orbital openings and shows just below the eyebrows. The lower margin of the orbital openings is the halfway point of the face. When the head is level, this lower margin is on the same plane as the top edge of the ear opening; remember, though, that in perspective the tilt of a head may incline and foreshorten this plane, so observe the apparent distances closely when placing the ears and eyes in a drawing.

A knowledge of the underlying bones and muscles helps you to be aware of what supports and moves the skin, hair, and flesh you see on the surface. Ally this to meticulous observation, and look closely to distinguish between the basic structure and the fleshy superstructure that also carries the moods and emotions that make up the individuality of the sitter.

TINY FEATURES
The characteristic round, domed forehead and small features of infants and babies call for care in recording their proportions.

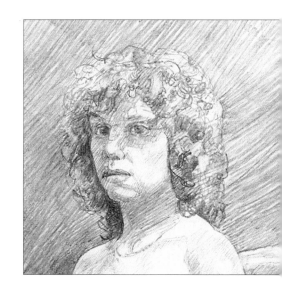

YOUNG ADULTS
Although faces are broadly symmetrical, even the most balanced features are rarely totally regular. Note any slight irregularities and set them down without exaggerating them.

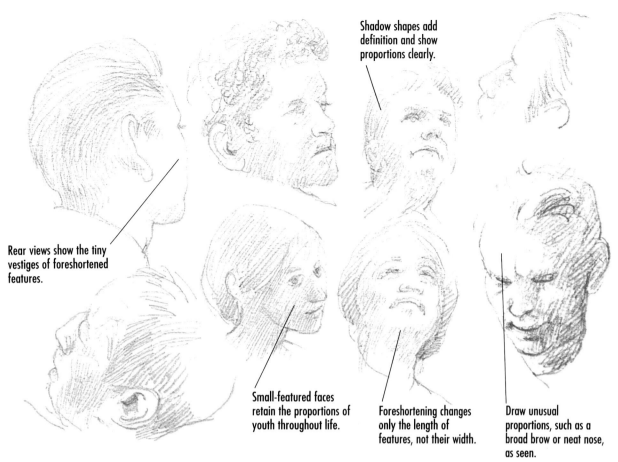

Shadow shapes add definition and show proportions clearly.

Rear views show the tiny vestiges of foreshortened features.

Small-featured faces retain the proportions of youth throughout life.

Foreshortening changes only the length of features, not their width.

Draw unusual proportions, such as a broad brow or neat nose, as seen.

PROPORTIONS IN PERSPECTIVE

Observing faces from different angles changes their proportions. Foreshortening can hide a strong jaw or prominent forehead, and can accent a previously unnoticed feature, such as an ear.

STRONG FEATURES

It is relatively easy to identify and set down the proportions of a face that has generous or noticeable features, or with strong coloring. A sitter with strong, dark features is an excellent subject for gaining experience in drawing faces.

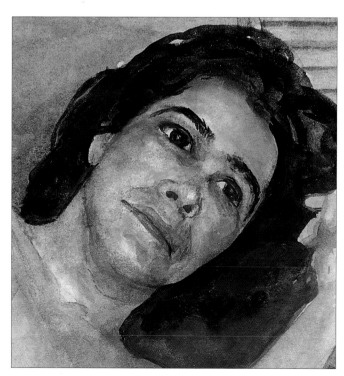

Eyes

Because it is natural to make eye contact, there is a tendency to give too much attention to eyes in the early stages of a drawing. This is usually a mistake, as it can make it difficult to structure the portrait later on. Your first task is to show the three-dimensional nature of the eye structure. For an easy start, choose someone sleeping, or find a friend who will pose with eyes closed. This avoids the distraction of the model's gaze, and allows you to study the overall shape of the eyeball and surrounding of the eyes and bony protrusions.

Try a profile to see the curvature of the eyeball and how it fits into the socket. Look for cast-shadow information, which helps reveal the form, and compare differences in widths of upper and lower eyelids. Like brows, these vary according to age, race, gender and mood. The iris will be partly occluded by the upper lid, and probably a little of the lower one, too.

JOINT FOCUS

Rely on careful observation to determine the positions of irises and how they are varied by perspective, and when you see both eyes, draw them as a pair. If you tackle each one individually you may have problems in making them appear to track together, so assess them together and relate back frequently to the whole head. The position of any reflected light in the eyes is governed by the light source, so you need to place this carefully to maintain the illusion of joint focus. Keep tonal values appropriate, too. Highlights are often tiny, while shadow darkens even eyewhites, and if one side of the face is more brightly lit than the other, there will be distinct tonal variations.

THE EYE IN CONTEXT

The best way to study the eye's structure is to draw it from the side. The eye fits into the orbit of the skull and is overshadowed by the protruding brow.

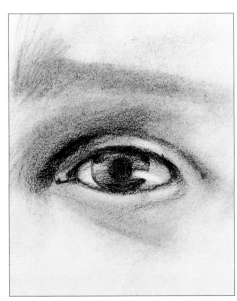

FRONT VIEW

Eyes reflect light sources, and if you light a sitter from two directions you can expect to see highlights on both sides of the eye. Make sure you don't over-emphasize them.

Brush drawing is a good way of quickly capturing expressions and the tonal range of eyes.

The eyeball fits into the "socket" under the brow bone.

The shadowing effect of the top lid and light on the lower eyelid show up best in profile.

Adding highlights to the upper lid emphasizes its curve over the eyeball.

The set of each eye must conform to the curvature of the skull.

DRAWING FROM DIFFERENT ANGLES

Plan to spend time making studies of a friend's or sitter's eyes. Drawing each eye from many angles as you talk reveals mood changes expressed by the eyes.

The best view of eyelashes is in relief against the skin, with the eyes closed.

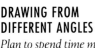

Spectacles can be a helpful aid to making a fine drawing. They make it easier to assess the angle of the brows and head, and provide a visual link between eyes, nose and ears. To start, give yourself room to maneuver by choosing a medium you know is easy to erase, and make some quick, light sketches, assessing and adjusting as you go. Once you pull the drawing together around the spectacles, your work will acquire a cohesion you could not achieve by drawing each item alone. Make sure you assess the tones carefully, as shadow and reflected light give substance to the lenses and reveals the space between these and the head.

Spectacles can also help you express the sitter's personality. Sunglasses block eye contact and give a slight air of mystery, while strong reading glasses magnify the eyes and give them extra impact.

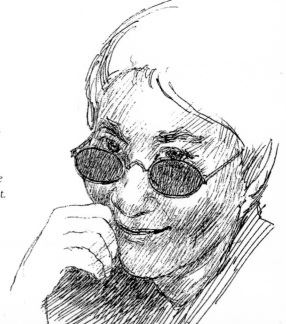

Ears

OBSERVING DETAIL

Artists who gloss over ears, seeing them as an unimportant—or too difficult—aspect of portraiture, are missing an opportunity to convey character, as these are singularly distinctive features. Ears are not easy to draw, but the key to success is to focus on the three-dimensional aspects initially, rather than beginning with a linear rendition that can create a flat effect. Choose a broad medium, such as chalk or charcoal, which allows you to make easy adjustments, and concentrate on exploiting cast shadows or highlights that will give the ears an illusion of depth. This applies equally whether you are showing the inner whorls of the ear or depicting its emergence from the skull. Try to see the overall structure, with the ear radiating from the ear opening into which it funnels sound, with the larger part above and the lobe below this orifice.

SCALE AND DEPTH

As usual, rely on direct information to deduce the scale and depth of the ear, and its angle to the head. Note the effect of hair, which may shadow or partly obscure an ear, or give it extra prominence if tucked behind.

Earrings, like spectacles and clothing, are an indication of your sitter's tastes, and offer a further stamp of character to the portrait. They will also help to show any variations in the level of the ears, which are often set slightly differently.

So much variety calls for plenty of practice, so make studies of ears, using friends or family as models, or any people who are content to sit still long enough to allow you to contemplate the forms and planes. Always start with a general statement; don't delve into detail until you have a sound framework.

EARS IN CONTEXT

Ears can appear strange in isolation, so draw them in the context of their surroundings. To save time in creating the setting, use a fast medium, such as charcoal, or a watercolor wash over oil pastel.

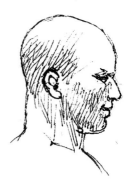

PLACING THE EARS

The bottom of the eye sockets is the mid-point on the face. The ears line up with the brow and the end of the nose. The front of the ear should flow into the side of the face without a break.

DRAWING SIDE VIEW

When drawing ears, include the adjacent information from the hair, neck, and jaw, to help you define the basic shape. Just drawing outlines can be vague, so work fully from the start.

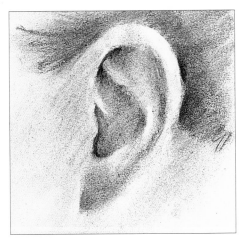 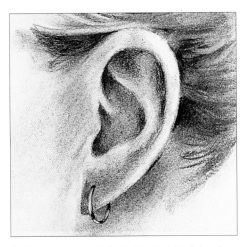

1 *Block in the tone using a flexible medium, such as graphite, that will allow you to make adjustments easily at a later stage.*

2 *Once you are satisfied with the initial sketch, develop it throughout the drawing and refine the details.*

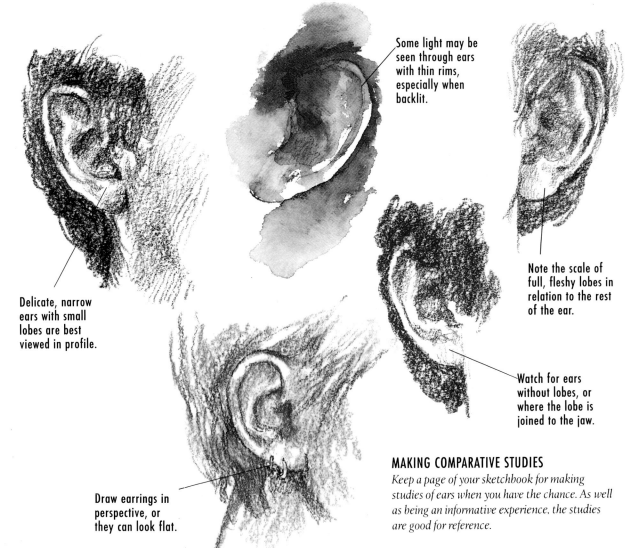

Some light may be seen through ears with thin rims, especially when backlit.

Note the scale of full, fleshy lobes in relation to the rest of the ear.

Delicate, narrow ears with small lobes are best viewed in profile.

Watch for ears without lobes, or where the lobe is joined to the jaw.

Draw earrings in perspective, or they can look flat.

MAKING COMPARATIVE STUDIES

Keep a page of your sketchbook for making studies of ears when you have the chance. As well as being an informative experience, the studies are good for reference.

SEE ALSO
REFERENCE FILE
PAGES 138–9

Noses

To give form to a nose you will need to think in terms of tone, not line. It is vital to show the way it stands out from the face, and if you restrict yourself to purely linear marks, you are likely to achieve a flat, two-dimensional effect. Lines serve to mark the boundaries of tonal changes, and while they may be perfectly adequate to depict a profiled nose against a contrasting background, or even a three-quarter-view nose where the bridge and nostrils contrast with darker or paler cheeks, they won't help you to tackle the graduated lights and darks of a nose in a full-face view. Choose a medium that enables you to build up tones, such as wash or charcoal, and settle down to study the basic form and the way the tonal variations express them.

The top of the nose is part of the skull, but the rest is a cartilaginous structure that is independent of the skull, like the ears, so there are equally great variations in size, shape and characteristics, again influenced by gender, race and age.

DRAWING PRACTICE

Before embarking on a portrait, build up confidence and fluency with a special study of your own nose, starting by angling the light over your head for a full-face view. Take a good look in the mirror, and you will notice that although the surfaces on your face are not truly flat or level, there are definite planes that catch the light. The front planes of the nose may be highlighted, and if your lamp is a little in front of you, light will also catch the bridge, and perhaps the upper curves of your nostrils. Cast shadows in the creases behind the nostrils and under the tip of your nose help to define the forms and planes.

DRAWING NOSES IN CONTEXT

Although making isolated studies of noses is often invaluable (see opposite), it is best to draw them in relation to the other facial features, including the perspective of the whole head.

1 *When plotting the relative position of the nose in the face, block in all the features loosely at the beginning, and allow yourself room necessary for making corrections.*

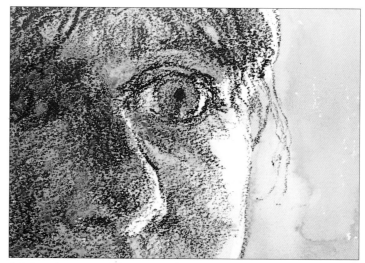

2 *When drawing a sidelit nose, carefully observe the tonal values. Give the shadows sufficient depth of tone and render the highlights pale enough to make the nose's protrusion plausible.*

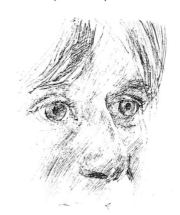

USING DIFFERENT MEDIA

Consider switching between media during a sitting. This will speed your progress as you respond to the different qualities of each medium and the marks it makes.

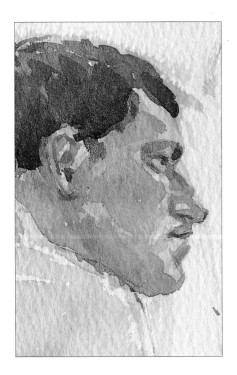

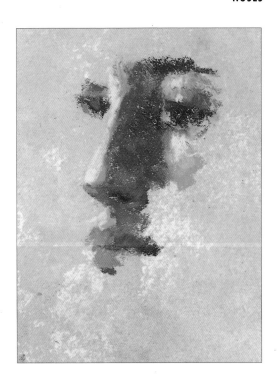

PROFILE VIEW

The view of a nose in a profile (left) may appear to be the easiest angle from which to capture its shape, but be careful to set down the size accurately.

THREE-QUARTER VIEW

Seen from this angle (right), the nose obscures part of the eye farthest from the viewer, and part of the cheek. Cast shadows can also hide part of the face.

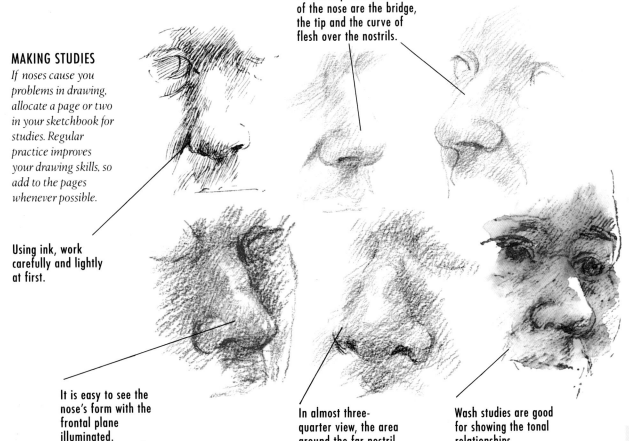

The most prominent areas of the nose are the bridge, the tip and the curve of flesh over the nostrils.

MAKING STUDIES

If noses cause you problems in drawing, allocate a page or two in your sketchbook for studies. Regular practice improves your drawing skills, so add to the pages whenever possible.

Using ink, work carefully and lightly at first.

It is easy to see the nose's form with the frontal plane illuminated.

In almost three-quarter view, the area around the far nostril appears smaller.

Wash studies are good for showing the tonal relationships.

93

Mouths

OBSERVING DETAIL

When you begin to make studies of mouths, you will discover that you have a means of conveying a good deal about your sitter's mood and character. Mouths are the most expressive of all the facial features, and the most mobile, with the shape changing when stretched in a smile, or half-open in speech. What the mouth is doing affects the whole face. Smiling, for example, causes a sideways extension of the circular muscle, the *orbicularis oris*, which opens and closes the mouth. This pushes up the cheeks, changes the apparent shape of the eyes, and even slightly moves the nose.

As with the other facial features, gender, race and age are responsible for diversity and change. Female mouths are usually softer and fuller than those of males, particularly in youth; age often narrows lips and brings character in the form of smile and "whistle" lines. But before you begin with individual differences, you need to understand the structure of the mouth. It does not stretch in flat lines across the face; the lips follow the shape of the jaw and teeth. Try to assess the three-dimensional form, without too much initial linear emphasis, which will flatten the effect.

TONE AND COLOR

Even when working in monochrome, you can shade for color as well as form. So if your sitter is wearing lipstick, be prepared to employ strong tone, as reds, although bright, are dark in tone. If unsure of the tone, half close your eyes, which reduces the impact of the color and shows tonalities more clearly. The same technique will help to assess higher tones, such as reflections on lip gloss or teeth, if they're visible. In fact, these are often shadowed and darker than you might expect.

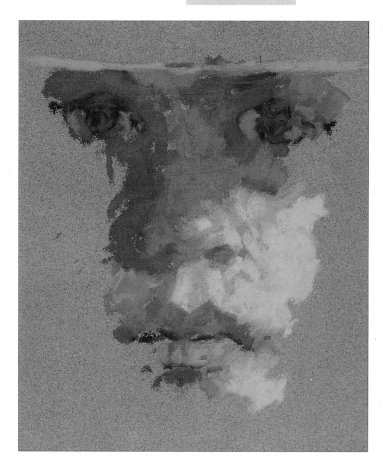

MOUTHS IN CONTEXT
It is easiest to gauge the true dimensions of an individual mouth by drawing it in relationship to the other features, as these help to establish its proportions and position.

BABY MOUTHS
Compared to that of an adult, a baby's mouth is short, with full curves and sharp tapers at the corners. To record this, study a sleeping baby.

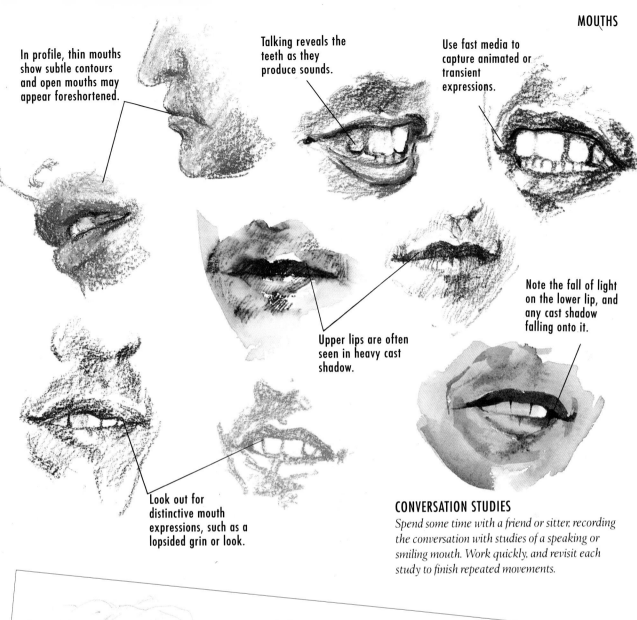

In profile, thin mouths show subtle contours and open mouths may appear foreshortened.

Talking reveals the teeth as they produce sounds.

Use fast media to capture animated or transient expressions.

Note the fall of light on the lower lip, and any cast shadow falling onto it.

Upper lips are often seen in heavy cast shadow.

Look out for distinctive mouth expressions, such as a lopsided grin or look.

CONVERSATION STUDIES

Spend some time with a friend or sitter, recording the conversation with studies of a speaking or smiling mouth. Work quickly, and revisit each study to finish repeated movements.

SKETCHBOOK STUDIES

When studying individual features, it is best to draw the whole face whenever possible. Studies of mouths alone may be too vague to be of much use as reference.

95

Young Faces

OBSERVING
DETAIL

The proportions of young faces are quite different from those of adults. At birth, the calvaria, the upper part of the skull, is nearer adult size than other bones, making the head large in relation to the face and giving it a simpler and more curvilinear shape than in an adult. The high, rounded forehead slopes in towards the nose, and the top of the head slants up to the crown, then curves around and turns in towards the neck at a sharp angle. Make sure you observe and draw these proportions well, or your images will resemble a miniature adult. Children's facial features also have particular characteristics: among the most immediately obvious, the small teeth of a child make for a small mouth, the soft upper lip slopes back to the nose, and a small jawbone gives a neat chin. In addition, there is an outward thrust to the cheeks, which is most easily viewed in profile. However, as in all figure and portrait drawing, don't assume anything. Children's features are as varied as those of adults, so always trust your eye, not your preconceptions, and be prepared to see all kinds of variations.

PLANNING A DRAWING

When drawing young faces, always spend time observing them before you start to draw. The constantly changing facial expressions of young children demand a rapid response, so use a "quick" medium, such as charcoal or diluted washes, which has the tonal range to capture smooth, soft skin and fine hair. With babies and small children, it is often best to make quick studies over several sittings and to combine the best of these in one drawing, adding the finishing touches in a final session.

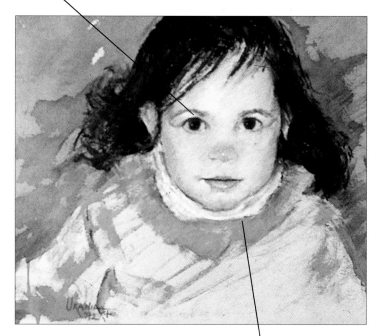

The clarity of work in the features holds the attention.

Loose sketching is enough to establish hair and clothing.

FOCUSED DETAIL

When time is short, concentrate your observations on the main center of attention, and handle ancillary details as briefly as possible. The strength of acutely observed material will lend conviction to the broader areas that need no further development.

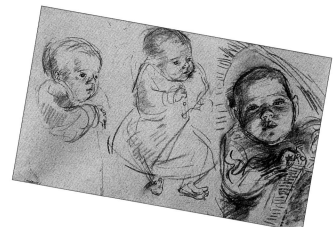

MAKING SEVERAL STUDIES AT ONE SITTING

Sleeping children move and stir or change position on waking. Regardless, continue sketching. Unfinished sketches are useful to jog your memory and document different aspects of the form and structure of your tiny model's head and features.

DRAWING BABIES

Most very small or newborn babies sleep peacefully for quite long periods of time, giving you the chance to draw their tiny details at leisure. Choose an expressive medium, as you will want to convey some subtle tones.

 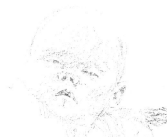 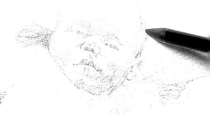

1 Make your initial draft a general one because the proportions of babies' faces are very particular, and you may need to make some adjustments before you get the relationships between the features and the head shape correct.

2 Keep the development even throughout the drawing, and don't forget to include any background information, however much or little you wish to depict, because this invariably helps to create a proper setting for your subject.

3 Although the subject is one of great delicacy, you should still aim to use the complete tonal range, to show form and contour. Don't avoid using the darker shades just because you are drawing a tiny baby.

DRAWING OLDER CHILDREN

Children who are too young to speak often have to be followed about and sketched whenever they settle for long enough. Older children, however, often take an interest in the sketching process, particularly if they like drawing.

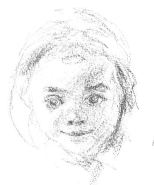 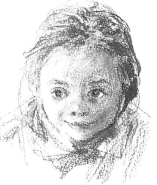 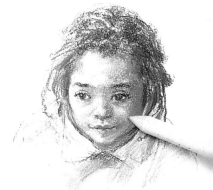

1 Ask a child busy making a picture to look up regularly so that you can add further information to your sketch. Work quickly in a fast medium, such as artists' chalks.

2 A good way to build up strength of tone is to use all the colors lightly from the start. Remember that white is valuable for its mixing quality, on white or colored paper.

3 When using artists' chalks, try to preserve their lovely crispness by not overworking them; use a paper stump for very subtle blending or for working on tiny details.

DRAWING ADOLESCENTS

Take care to observe the details that show that your subject is not yet fully grown. Softer features, a narrower jaw, and youthful softness of skin all need to be conveyed to distinguish youth.

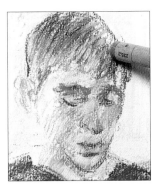 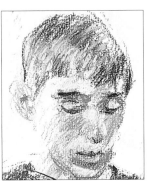 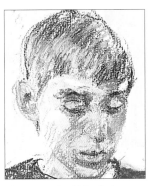

1 Try to depict the bone growth that shows approaching maturity, and makes the features larger in relation to the crown.

2 Using blends of pastels, you can record the nuances of tone that define form. Remember to add cool colors, for instance, in areas of shadow.

3 In your final blend aim to achieve the right tones and color temperatures, using a stump or by drawing over preceding colors.

97

SEE ALSO
REFERENCE FILE
PAGES 138–9 ▶

Adult Faces

OBSERVING
DETAIL

The muscles, flesh, and skin that conceal the skull provide an endless range of variations, but it is vital to delay adding detail until you have established a broad likeness. Start by drawing the faces you know best, because you will already be familiar with them, and if possible, ask members of the same family to sit for you; "family likeness" rests as much in the breadth of the brow or the length of the jaw as in the shape of the nose.

WORKING METHOD

The first concern is to establish that the features and the spaces between them are in the right relationship to each other. Use an erasable medium, such as a 2B pencil, which enables you to adjust the dimensions as you go along. Work on the whole drawing as fast as you are able, and stand back regularly to check your progress. This method saves a lot of labor, compared to the "jigsaw puzzle" approach of adding finished features one by one, which only sacrifices good work to the eraser if the end result fails to capture scale and proportions. Remember to take the effects of foreshortening (see page 74) into account; features that appear telescoped or obscured require careful observation, and neglecting this could ruin your drawing. In the same way, don't ignore the negative spaces around the head, which are particularly useful for checking the dimensions and form. Once you are satisfied with the general effect, reinforce and develop it, and don't be surprised if you have to make late changes. Finally, cover your tracks: remove any superfluous marks to leave a clean, economical image, then add details.

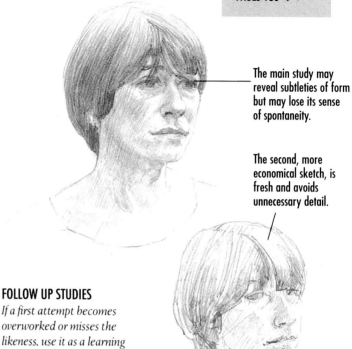

The main study may reveal subtleties of form but may lose its sense of spontaneity.

The second, more economical sketch, is fresh and avoids unnecessary detail.

FOLLOW UP STUDIES

If a first attempt becomes overworked or misses the likeness, use it as a learning experience. A second, briefer sketch often has more freshness and form than the earlier version.

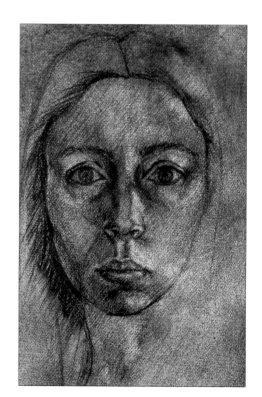

CREATING MOOD

You can raise the emotive content of your work by paying attention to lighting, expression, and concentrating on selected areas. Use strong lighting to add drama to a simple view.

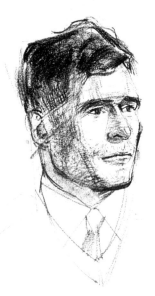

ACHIEVING ECONOMY

One of the hallmarks of a good drawing is economy. Don't overstate values that can be shown strongly and simply, but aim to use as few telling marks as possible.

MAKING A WHOLE IMAGE

To avoid creating problems of space within the picture when omitting backgrounds, consider posing your sitter against a simple, neutral ground that you can show with ease.

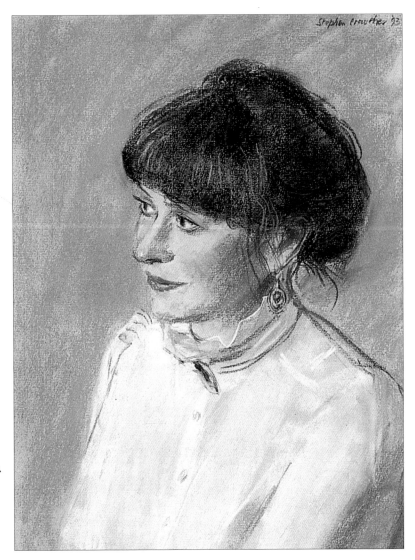

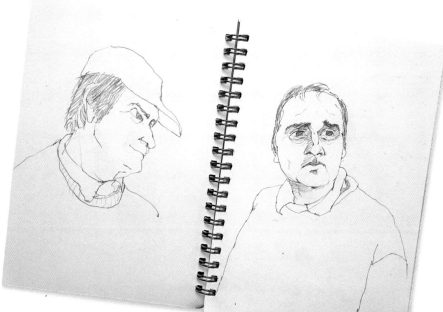

RAPID STUDIES

Fill your sketchbook with random drawings of passers-by, fleeting acquaintances, or people busily engaged in a task. Constant practice will raise your level of skill.

99

Elderly Faces

OBSERVING DETAIL

The character stamped on an elderly face by the passage of time is a wonderful subject, but be careful not to fall into caricature. Look to convey the qualities that are unique to your sitter, such as dignity, whimsicality, or tranquillity, honestly and without exaggeration. In addition, observe and portray the details of age on a face. There may be a loss of muscle tone, and accumulation of body fat can lead to a smoothing out of facial contours. You may see more evidence of the underlying bone structure—the orbital openings in the skull are clearly visible in some elderly people, and hair loss and baldness reveal the shape of the cranium. The cheekbones may be more prominent, and fleshy features, such as the lips, may recede, while long-term exposure to sun and wind can show as freckles, wrinkles, and creases. Most elderly people accept such effects of aging, but if your sitter is sensitive to them, use backlight to cast shadows on the face and minimize these effects.

ARRANGING A SITTING

Elderly people can be very patient sitters, giving you the chance to draw detailed portraits. Practice talking while you draw, as elderly sitters usually enjoy conversation, and you can then work over extended periods. Make sure your sitters are warm and comfortable, don't ask them to sit for too long at a time, and arrange regular breaks. Extended sessions of this kind can give you enough time to work in "slower" media, such as pen and ink or fine pencil, and to use accumulative techniques like crosshatching, or subtle color mixes in pastels or washes. When you're outside, sketch elderly people reading in libraries, resting on park benches, or riding on public transportation.

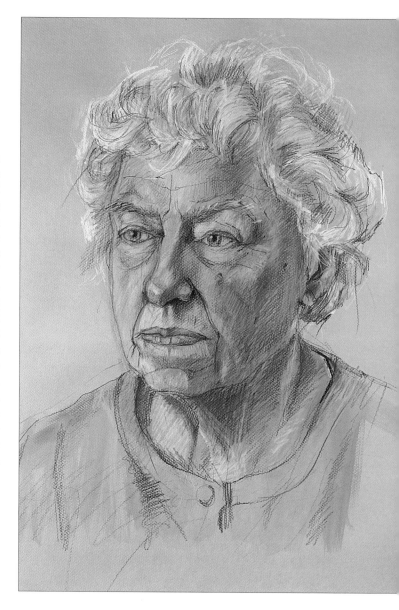

AN EXTENDED SITTING

A calm, composed older person who is happy to sit for a longer timespan offers the ideal opportunity to develop more detailed aspects of your work. Study the more subtle tonal changes, and render skin and hair with due attention to their surfaces and qualities of light reflection.

INDIVIDUAL PORTRAITS

Individual portraits have a unique fascination, since they give you a legitimate reason to examine your sitter's appearance in detail. Remember that this is a privilege, and your model will respect your desire to make an honest portrait by careful observation.

1 *Habitual expressions leave their mark as creases and laughter lines. Plot the position of these with care, because misrepresentation, caused by poor observation, leads to distortion.*

As the flesh tightens, the shape of the skull is more visible.

The jaw muscles slacken in most people.

2 *Once you have established the correct proportions, flesh out the individual characteristics of your sitter by adding stronger tones and filling in more detail.*

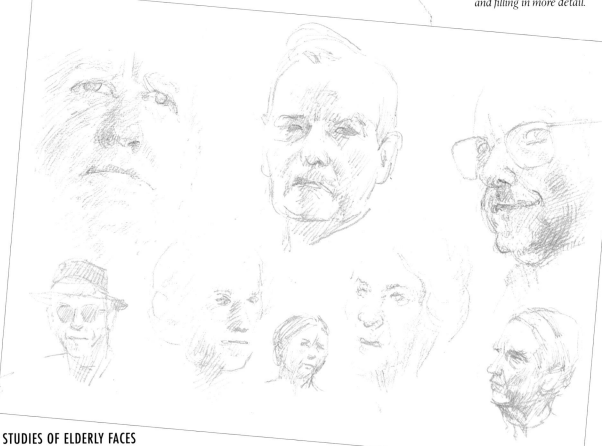

STUDIES OF ELDERLY FACES

The contrasting effects of time and character on elderly faces can be best studied if you devote one or more sketchbook pages to these comparisons, noting the similarities and differences.

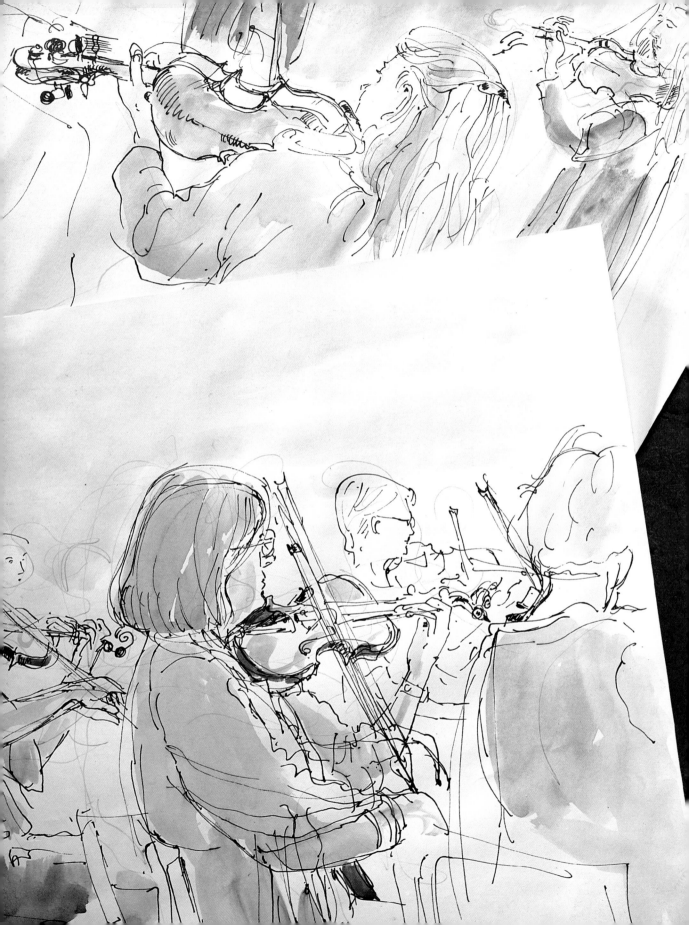

4
Workshops

Familiar Situations

Complicated subjects are tempting, but if time is short, ration what you attempt. Either limit the size—simply draw smaller—or choose the most interesting passage and make shorthand notes of the rest. If there is more time and the situation feels comfortable enough, consider making several studies, one to look at tonal relationships, for example, one to record color, and one to give you a sense of two- and three-dimensional layout. Remember that you won't be able to get the latter from a photograph—only your eye will help you design in three-dimensional space. In certain situations, however, photographs can be a useful back-up.

Getting into the habit of regular drawing in a sketchbook will raise the level of your work in the same way that keeping a diary improves writing skills; in both cases, the frequent number of entries and the act of description increase fluency. As you try to capture familiar figures in real-life situations, you will improve the immediacy of your response, gain in skill by practice, and develop resourcefulness. Problems in drawing can melt away when tackled regularly in this way.

LITTLE AND OFTEN

Small amounts of work mount up, even in a busy schedule; sketching for twenty minutes a day adds up to over two hours a week, and is better for your drawing than one long session at infrequent intervals. Start a sketchbook project over a set period, say a month, with the aim of accumulating drawings—some quick and spontaneous, others more sustained—of familiar or close contacts in safe, friendly situations. Use anyone as a subject: newsboys, diner or restaurant staff, neighbors, or fellow members of a group or club, so long as you are able to draw them often.

AVOIDING FALSE ECONOMIES

Unless you have to, don't draw on both sides of a sketchbook page. As well as being a direct response to your own visual experience of people at a specified time, your drawings are a visual reference library for creating further work. If you wish to combine or edit drawings later, working from two that happen to be back to back is nearly impossible. Also, using only one side of the paper avoids sacrificing the drawing that is on the reverse side, if you choose to remove a sketch.

FAMILIAR BELONGINGS
Look for sitters holding familiar, well-used belongings, such as bags, which contribute to your expression of their identity.

DRAWING AT HOME

Not every companion may be happy to spend hours posing for you, but in a relaxed, familiar situation, most family members will forget that they are being drawn.

DRAWING IN A STORE

If you shop locally, you may be familiar enough with the retailer to ask if you can draw him or her in the sales area during a quiet spell.

OLDER SITTER

Ask an older person, comfortable in favorite clothing, for a sitting, and produce a unique memento of them.

OUTDOOR GROUPS

During warm weather and at leisure times, people congregate in parks and open spaces, providing you with groups to draw.

PEOPLE AND ANIMALS

Animals and pets that require regular care or exercise can make a stimulating addition to the drawing agenda, and keep the human subjects amused at the same time. Cats, dogs, rabbits, and ponies are often easily accessible, but consider drawing someone with a more unusual pet, such as a reptile or a parrot, or visiting a zoo to draw spectators with wild animals, or a farm where there may be animals, such as goats.

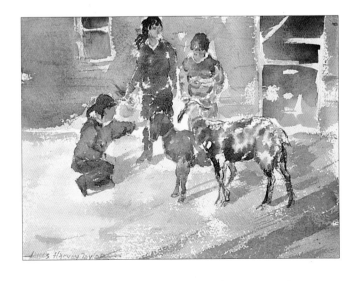

Working in Familiar Surroundings

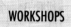
- Using heavy or messy media
- Setting up a situation and returning to it frequently
- Controlling and experimenting with lighting

WORKSHOPS

There are several advantages to working in or near your own home or workplace, or in familiar, well-known surroundings. You can work best where you feel safe and confident; family and friends are likely to be willing to be sitters, particularly if they are involved in a leisure activity; and you can use the messier media, such as charcoal and pastels, in a setting that you can protect before starting, and can clean up easily afterwards. In addition, sketching in familiar situations gives you practice in drawing people involved in occupations that are sedentary or that display only a limited range of movements, before you embark on more complex subjects, those including movement or travelling to settings further afield.

CONTROLLING THE LIGHT

You can control the light source in familiar situations, choosing low light by screening or curtaining windows, or placing your subject against the light source to give a dark, somber effect. Experiment by using direct lighting from an overhead source, or secondary lamps that can be angled to cast shadows with defined edges or bounced to give a background glow. Consider making a series of drawings of the same subjects in differing light conditions.

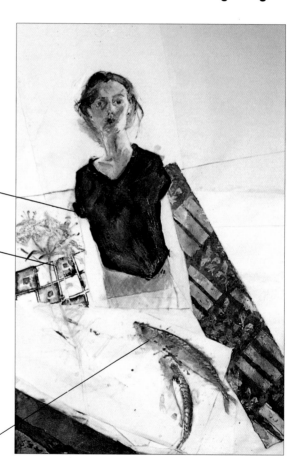

When making a quick drawing, ask the subject to wear some plain clothes in solid colors.

The bold use of pattern and collage contrasts with the white paper and solid areas of color.

Take the opportunity to draw fascinating incidentals that are a foil for the main subject.

CHOOSING YOUR SITTERS

Consider your sitter's comfort when choosing whom to draw. A subject engaged in a favorite activity needs to be stationary for some time to allow you to capture the pose. However, if you have two sitters they can converse while you draw, enabling you to concentrate on your work. (Drawings by Barbara Walton)

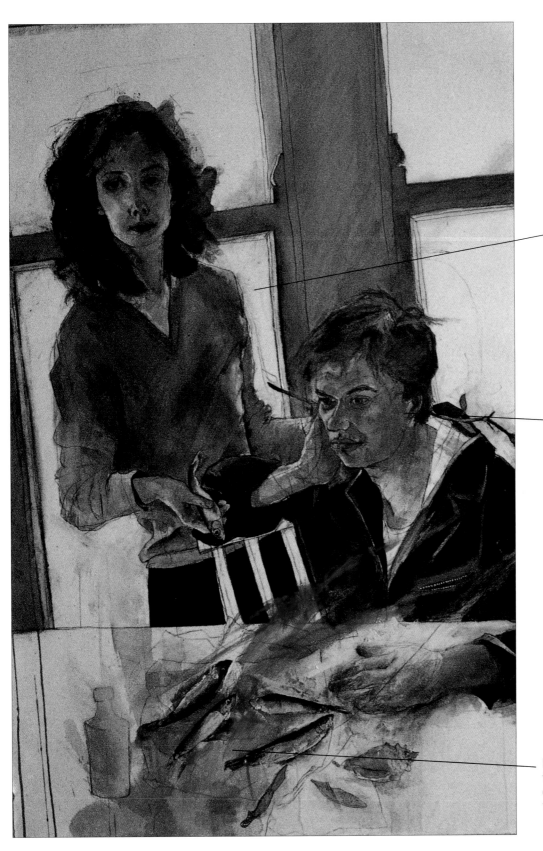

A figure against a strong light source appears extra dark.

Use extra contrast nearby to help you to focus attention.

Props add a variety of form and color, but can distract attention from the main subject.

Developing a Subject

WORKSHOPS

As you develop the habit of sketching frequently, you will realize that being able to draw one sitter regularly is a great advantage. Recording the kind of detail that is possible only when a sitter is familiar to you adds dimension to your work, as you seek out new ways to express subtle qualities. Your earlier drawings will have accomplished the initial stage of developing background awareness of the sitter's appearance and characteristics, and you will thus be able to amass a more detailed range of useful studies. This kind of intensive work, based on one or possibly two sitters, should always be founded on genuine observation; take great care that familiarity with your subject doesn't slide over into making careless assumptions about their appearance. Your objective should be to record a close acquaintance through several activities and in different situations.

MAKING A COMPLETE RECORD

Showing your sitter in new occupations or locations provides you with fresh perceptions and gives you the opportunity to try out more complicated or innovative techniques. If possible, follow your subject through daily life and draw them relaxing, sleeping, travelling, cooking, working, or following a pastime. Expect to mix sketches that are visual shorthand for rapid movements with more intensively observed, developed work when your sitter is at rest. These studies will give you the chance to record the changes in appearance that are caused by physical circumstances: heat, cold, fatigue, rest, hunger, satiation, good health, and ill health. Draw your sitter in different lights; sunlight and outdoor shadows can reveal their solidity, while a direct light on the face can show tiny details of form.

Consider the relationship between the two faces, and draw them in the correct scale.

ADULTS AND BABIES

An adult holding a baby is a good subject to develop. An intimate and reciprocal relationship is on show, with the added dynamic of two figures of very different sizes.

Use the stance or posture of the adult to convey the interaction between the two subjects.

FOLLOWING A SUBJECT

Following one person as they move about will force you to draw economically. Capture the essential shapes and tones as quickly as possible, and be prepared to return to a study if a similar pose occurs.

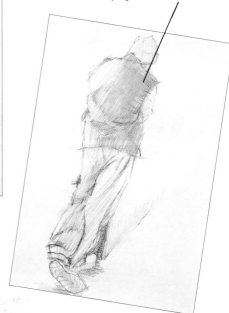

Seen from the back, this figure-hugging gesture changes the nature of the garments and makes them appear more close-fitting; in this position, the folds describe the underlying contours.

In this stance, the simple shape of the dark, sleeveless jacket and the wide folds in the paler, loose pants are good contrasts in tone and style. Always look at how clothes depict basic shapes.

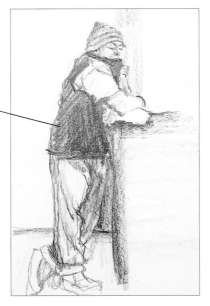

With the subject at rest for a moment, the stance conveys a quieter, more pensive mood, enhanced by the contrast with the inflexible counter. Look out for the characteristic postures that sum up the mood of your subject.

When following a subject who is moving about, much of your work will be concerned with capturing the poses of the whole figure. However, remember to focus on different parts of the person. This detailed study records facial features.

DISPLAYING A SERIES

While developing a subject, you may produce drawings, part views, and even unfinished sketches which, while too slight to merit displaying on their own, may work effectively as a combined group. Window mounting is a good method of presenting them, as you can design the apertures to display only the areas you wish to show.

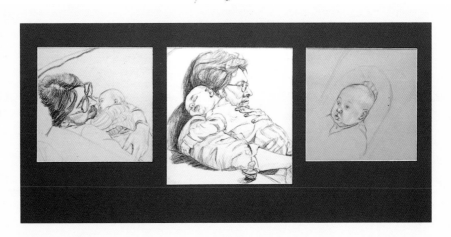

Working with the Same Subject

WORKSHOPS

Each time that you make a new study of the same sitter, you reinforce your knowledge of the particular form and structures of a unique individual. As you accumulate more visual experience, be prepared to tackle drawing any pose, no matter how foreshortened or seemingly untypical, in order to study a full range of physical shapes and develop telling likenesses. Simple, repeated movements allow you to observe your sitter going about the routine movements that are involved in a relaxed, comfortable task; and a sleeping subject gives you the chance to draw the sitter in the least self-conscious poses of all.

Observing and depicting individual •
poses and movements

Building up a visual library •
of one sitter

Gaining experience in drawing •
fine details

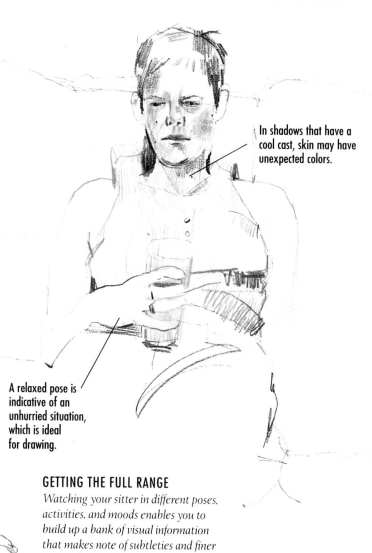

In shadows that have a
cool cast, skin may have
unexpected colors.

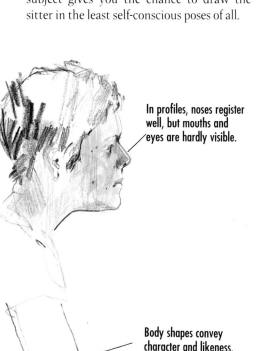

In profiles, noses register
well, but mouths and
eyes are hardly visible.

A relaxed pose is
indicative of an
unhurried situation,
which is ideal
for drawing.

Body shapes convey
character and likeness.

GETTING THE FULL RANGE
*Watching your sitter in different poses,
activities, and moods enables you to
build up a bank of visual information
that makes note of subtleties and finer
details. (Drawing by John McFaul.)*

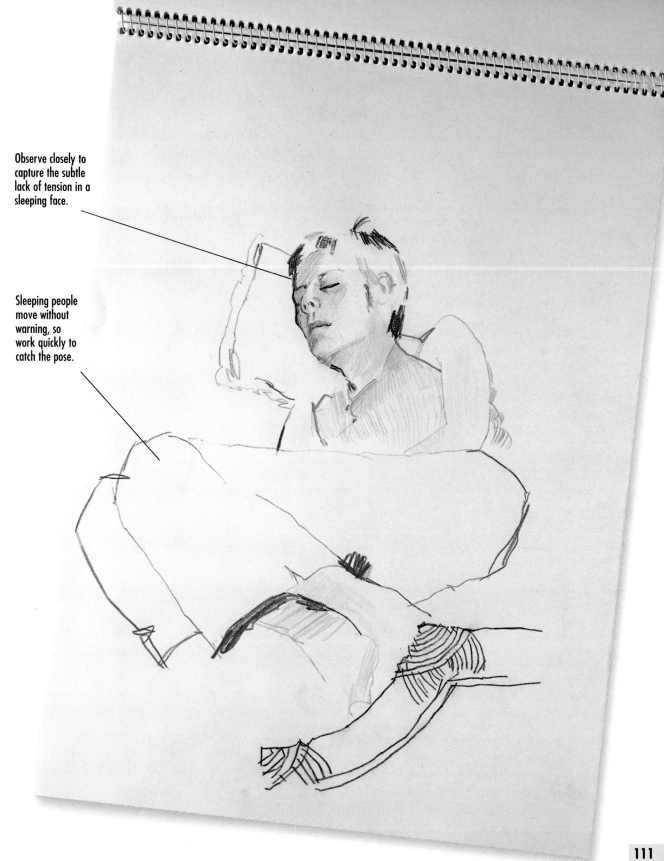

Observe closely to capture the subtle lack of tension in a sleeping face.

Sleeping people move without warning, so work quickly to catch the pose.

Studies of Character

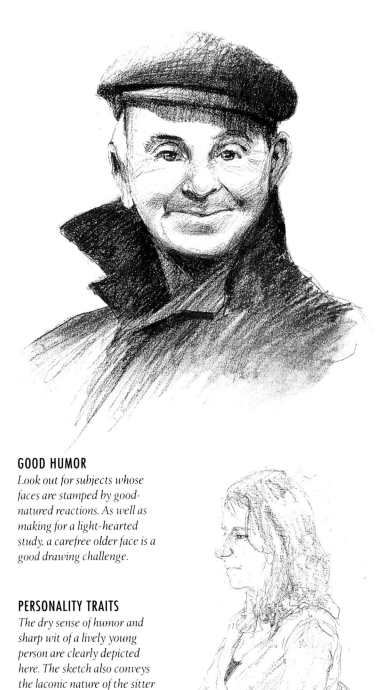

Character resides in the details and characteristics that allow you to convey the personality of your subject; these may be posture, skin texture, coloring, hair, or any unique combination of such factors. Because looking is an act of choice for the artist, anything that stimulates your wish to observe is valuable, as your enthusiasm will enrich your drawing. Remember, though, that your role as an image-maker is a sensitive one; unsubtle characterization can be a distressing experience for a sitter who witnesses your results. A major aspect of learning is evaluating your performance so that you can build on strengths and overcome weaknesses. This is particularly relevant to making studies of character. If you are aware of a tendency to overdraw or under-draw dimensions, for example, you will be able to correct this when sketching characterful features.

SKETCHING CHARACTER

Consider asking a robust, elderly person to be your sitter; someone whose appearance has been shaped by time and experience will be comfortable with it, and is unlikely to be too disconcerted by a sketch that errs on the side of over-emphasis. Whoever you decide to draw—and young people are just as idiosyncratic as older ones—take time beforehand to decide what their characteristic features may be. The identifying quality can be a combination of elements, such as bright-red hair with creamy skin and freckles, or one particular aspect, such as the beautiful feathered effect of fine black hair on the nape of a neck. Look out for features that evoke recognition, such as the crinkle of laughter lines on a weather-beaten face, or the hunched posture of a child concentrating on a game.

GOOD HUMOR

Look out for subjects whose faces are stamped by good-natured reactions. As well as making for a light-hearted study, a carefree older face is a good drawing challenge.

PERSONALITY TRAITS

The dry sense of humor and sharp wit of a lively young person are clearly depicted here. The sketch also conveys the laconic nature of the sitter through careful observation of her pose in the chair.

SHOWING ACTIVITY

Drawing a person engaged in a familiar task that calls for absorption and concentration, such as knitting, brings out the settled, stable aspects of their character.

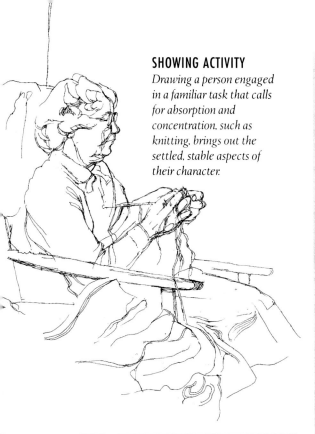

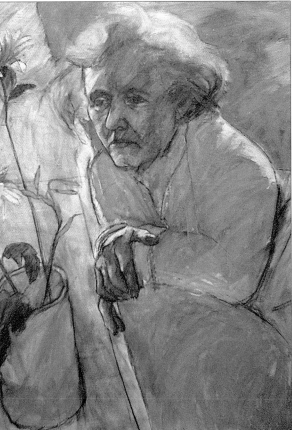

POSTURE AS A GUIDE TO CHARACTER

Like all body language, posture is a visual clue to psychology, and enables you to capture the mood of your subject, even when her or his face can't be seen. The droop of a dejected person is as clear to see as the bounce in the step of someone in an upbeat mood. Look for the telltale signs of fatigue in a slumped position, a languid sprawl of relaxation on a hot day, or the upright carriage of a confident person. Activities also influence posture: from being hunched over a difficult task during the day, the same subject's posture changes completely when dancing or playing a sport, for instance.

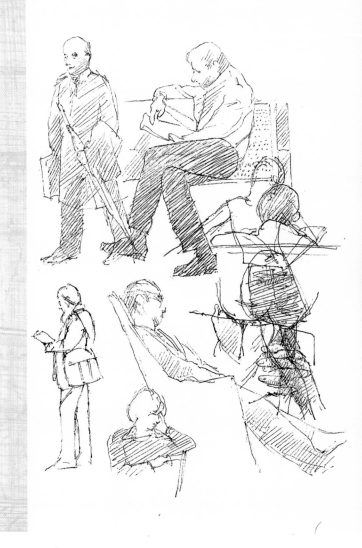

USING LIGHTING

Pay careful attention to the strength, direction, and quality of light that falls on your sitter's face. Use the lighting to emphasize or soften the features as you require.

Well-loved Subjects

WORKSHOPS

Drawing parents, relatives, and older friends whose faces you have known intimately over many years offers you the chance to record with fondness forms and features that you have seen many times. This familiarity also has its pitfalls; make sure you don't make assumptions about your subject, and check their proportions and dimensions thoroughly. Your knowledge of your sitter has been gathered in glimpses, and the new view you take when drawing can reveal previously unnoted aspects, even of a parent. Remember also that the character of the subject resides in body shape and posture and style of dress as well as in the features.

SETTING UP A SITTING

Ensure that your sitter is comfortable, and encourage them to wear clothing that represents them as they want to be seen; wearing a favorite garment can relax people and lead to a relaxed sitting. Consider setting up a situation where your sitter can chat to another person—a profile view allows you to record the liveliness and vivacity of a characterful subject, and to accurately depict their individuality and personality.

Observing closely and recording • familiar faces

Re-examining assumptions about • proportions and dimensions

Using textures and details • to capture individuality

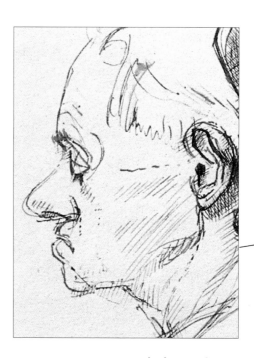

RECORDING CHARACTER WITH DETAILS
In addition to the "character" of the face itself, you can use a range of different tones and surface details to contribute to an effective study. Be sure to make use of the opportunities afforded by clothing to convey individuality. (Drawing by Stephen Crowther.)

In a study of two people of this type, you do not need to portray the subject in the background in as detailed a manner as that of the one in the foreground.

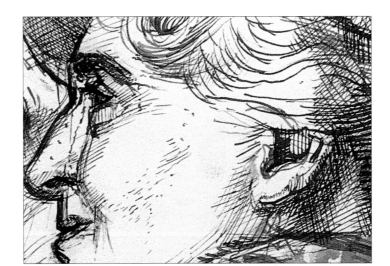

If your subject is usually seen full-face, the distance between the eye and ear in profile may be greater than you thought. The graying of head hair is not always repeated in the eyebrows.

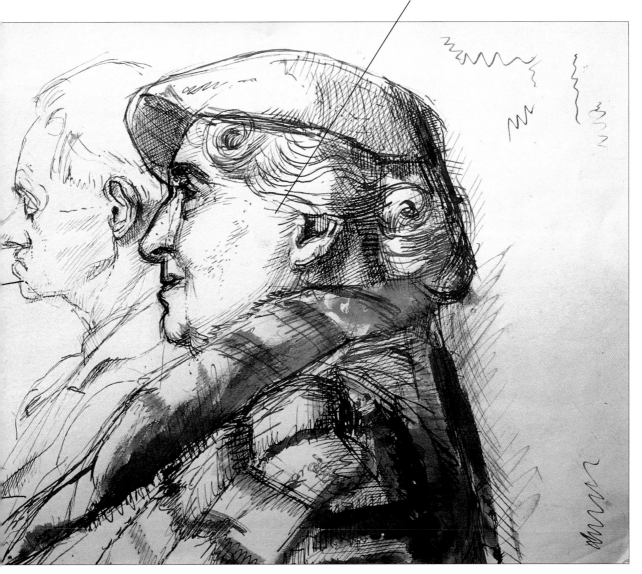

Children

Few drawings are more enjoyable to look at than those that capture the essence of a child. With the exception of babies, most of whom sleep a lot, few small children can stay still for long, unless they are engrossed in something. Older children and adolescents may be persuaded to sit for short periods, and are often genuinely interested in the progress of a sketch, but for most children, you will need to use all your experience of capturing movement. Spend plenty of time with your young subjects, watching them play, or perhaps get another adult to amuse them while you study them closely. Although children's heads are large in relation to their body size, and an infant face is small compared to that of an adult, don't assume that children's features are miniature.

CHOOSING A MEDIUM

The "quick" media, such as charcoal, pastels, chalks, and brushes, are best, as they give wide color and tonal ranges fast. Using a pencil or pen is fine for drawing a sleeping child, but can be frustratingly slow when sketching a moving child. Whatever you use, aim to have more than one session of watching and catching brief notes.

USING PHOTOGRAPHS

If, despite your best efforts, a child is too mobile for you to record details, such as the texture of skin or the sheen of hair, this is the one occasion when photographs can help. Make sure you take your own photographs from different angles, and use them to augment the observations you made from life. Don't work from only one photo, or you'll lose the child's natural liveliness.

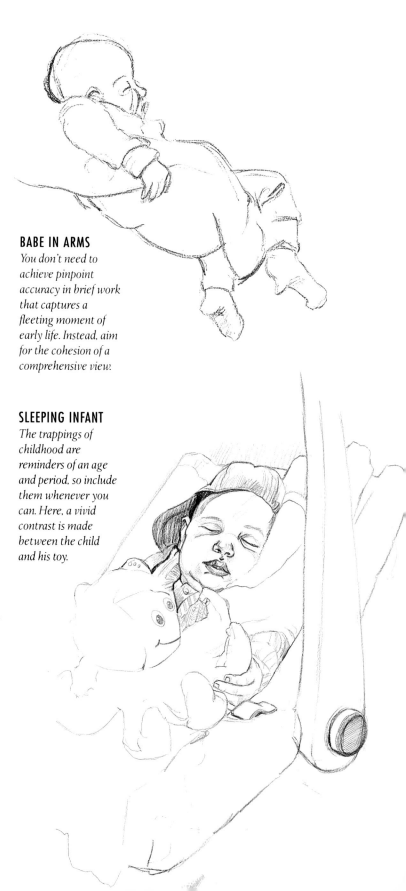

BABE IN ARMS

You don't need to achieve pinpoint accuracy in brief work that captures a fleeting moment of early life. Instead, aim for the cohesion of a comprehensive view.

SLEEPING INFANT

The trappings of childhood are reminders of an age and period, so include them whenever you can. Here, a vivid contrast is made between the child and his toy.

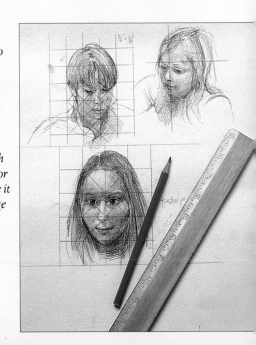

CHILDREN IN GROUPS

When they play together, children's attention is held, giving you a chance to draw those too small to pose. Choose quick media, such as pastels, to capture such groups.

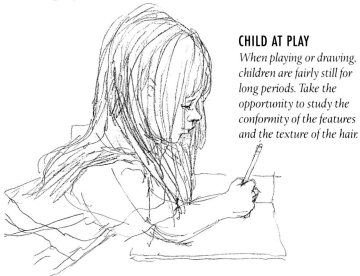

CHILD AT PLAY

When playing or drawing, children are fairly still for long periods. Take the opportunity to study the conformity of the features and the texture of the hair.

ADOLESCENTS

When drawing older children, who may have school work or who read for long periods, try using more difficult media, such as fiber-tipped pens.

JUNIOR PORTRAIT

If a child will sit still for a formal portrait, make brief and simple studies of the curvilinear form of the head, expressing this mainly through line.

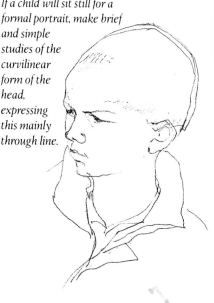

CREATING A COMPOSITE PORTRAIT

If you have made sketches of children on several different occasions, they are unlikely to be in the same scale. If you then want to use them together to create a single, composite drawing, you will need to adjust them so that they are all in proportion to each other. Choose one sketch that is about the right scale for your finished drawing. Divide it into squares, as shown on page 13. Divide your next sketch into the same number of squares as the first one, and enlarge to the same scale.

Effective Working Methods

Working quickly •

Sketching a fidgety subject •

Keeping details specific •

If a child is quietly reading, drawing, or playing, they will be looking downwards, so try to sketch from a low sitting position, so that you can see more of their features. Television or videos can often help to hold a child's attention, but some children become animated while they watch, so expect to work on a page of varying expressions, and add the details when you can. If you plan several sessions with children who did not know you before, they will grow accustomed to the activity; once they settle down, you will be able to work more efficiently. When your sketches contain enough information to make a final compilation, square them (see page 117) and transpose the chosen parts to a major drawing; this can be an end in itself or preparation for a painting. A last visit will allow you to finalize the likeness.

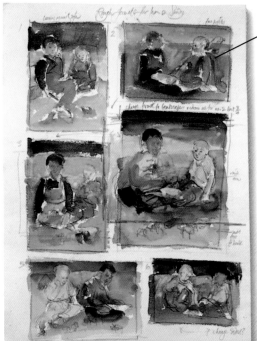

A selection of color roughs that experiment with various options for poses and clothing were drawn. Because they are all trials, keep them brief and use them later to choose which format works best.

Each study that you make of a child, however hurried or unfinished it may be, helps to reinforce your visual memory and accumulate more evidence, and contributes to the final drawing.

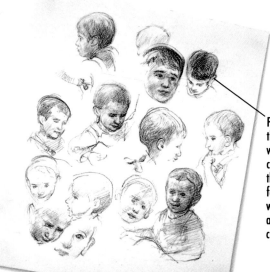

Part studies, such as these, are necessary when children move constantly. In addition, they help you to familiarize yourself with the dimensions and structure of children's heads.

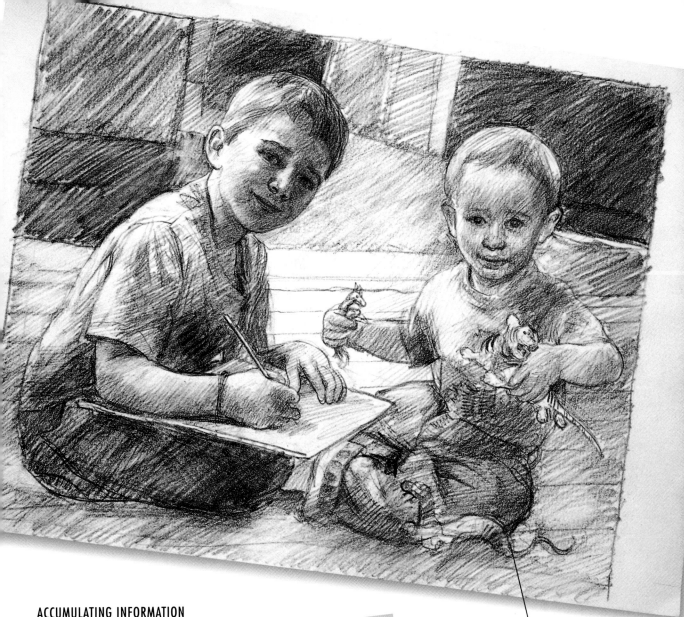

ACCUMULATING INFORMATION

The chances are that you will need to make several visits and drawings before you have amassed enough information to make your final composite sketch. Remember to use any photographs you take as memory aids, not as material for copying. (Drawings by Valerie Wiffen.)

Your final monotone drawing, probably made from a selection of rough sketches, should contain enough information about tone to paint from. Consider making one or more color sketches to supplement the monotone roughs.

Use photographs that you have taken yourself to supplement your memory of surface textures of skin and hair, and to remind yourself of any intricate patterns and tiny details.

Activities in Motion

Drawings of figures in motion are excellent practice, because they bring your skills to bear on a new area. Choose a fast drawing medium and use a drawing pad, or sheets that you can flip over easily. Erasing marks can take longer than drawing them, and you can save time by abandoning a sketch that needs major alterations; keep it for later, and move on to another. Activities with more limited, repetitious movements are the best place to start: people move slowly as they stroll or shop, or when swimming for pleasure. Choose a venue where you feel safe and comfortable, and be sure to dress for the weather, as you may have to sit still for a while.

CHOOSING YOUR APPROACH

There are several approaches to drawing movements, which can be used separately or combined together. First, use your visual memory. Focus on one figure at a time and make mental notes, observing the physical type, the effect of light on the form, the dynamics of movements, the characteristics of stride or gesture, and so on. When you have enough information, jot down a brief note, and aim to make a composite drawing by accumulating more visual clues. Next, try rapid hand-eye coordination. Work on a series of drawings simultaneously, adding extra material to each figure as you see it; this is most effective for capturing transient figures, such as runners, riders, skaters, and passers-by. Also try to draw a figure while only glancing at the paper occasionally, or not at all. There will be strange distortions, but you will capture much of the movement you observed.

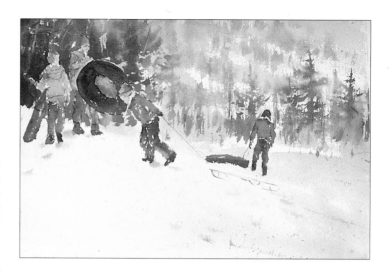

QUICK AND SLOW MOVEMENTS

Winter pastimes provide a good chance to observe mixtures of tempo. Sketching a fast sled ride downhill and the long trudge back up enables you to change your pace of drawing.

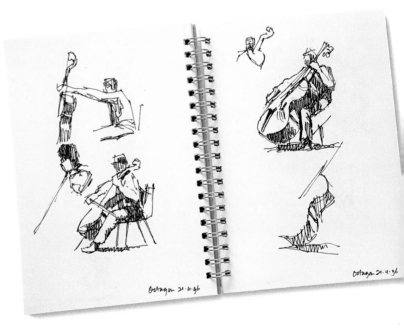

REPEATED MOVEMENTS

Although constantly in motion, musicians tend to move within a limited orbit, returning frequently to similar positions. Use this repetition of movement to make continuous drawings.

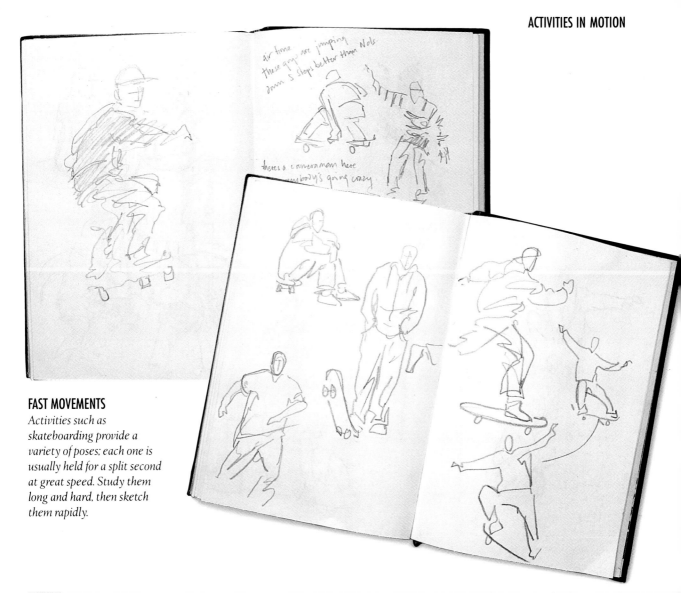

FAST MOVEMENTS

Activities such as skateboarding provide a variety of poses; each one is usually held for a split second at great speed. Study them long and hard, then sketch them rapidly.

HOW CLOTHING DEFINES MOVING FORM

When people are in motion, their clothing stretches and creases; these details help to define the movement of your subject. Look for the taut areas of fabric that reveal pull and thrust, the folds that show relaxed limbs or contracted muscles, and any patterns or logos that help you to see contours. Athletic or sports clothing is designed to allow movement, so even complete suits or uniforms are not restrictive, and will give with the activity. Use the opportunities provided by shorts and tank tops to practice drawing arms and legs from as many views as possible.

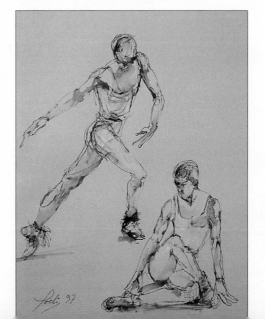

Some dance steps are repeated, but free-form movements may not be; even when resting, dancers are not stationary for long. To catch rapid action, practice hand-eye coordination.

Conveying Liveliness

WORKSHOPS

A performing orchestra or musical group provides the ideal opportunity for you to move between studies and add to each one as a player repeats a sequence or returns to a similar position. Observe the figures thoroughly, and be ready to watch their movements a number of times before you put down lines and tones on paper. Color washes are good for making rapid, descriptive notes on shades and hues; you can keep the washes simple, as long as you make sure that the line in the drawing describes form accurately, and the tone expresses depth to your satisfaction.

- Distinguishing between foreground and background effectively

- Practicing rapid depiction of line and tone

- Making simple color notes

When making color notes, apply flat washes quickly.

Although foreground figures are seen in the greatest detail, consider simplifying them to focus attention on the main area of interest.

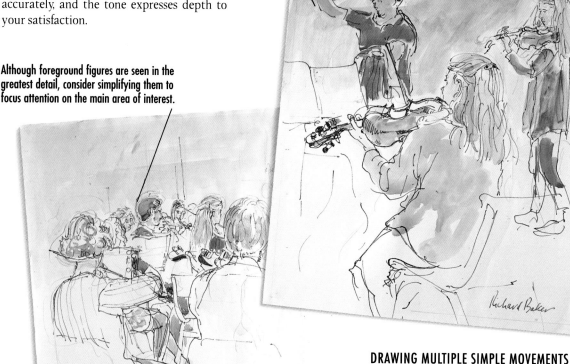

DRAWING MULTIPLE SIMPLE MOVEMENTS
In this study of orchestral players in rehearsal (right), the depth of field is indicated by overlapping forms that obscure parts of the background figures. For this type of sketch, use the fastest methods available, such as line and wash. (Drawing by Richard Baker.)

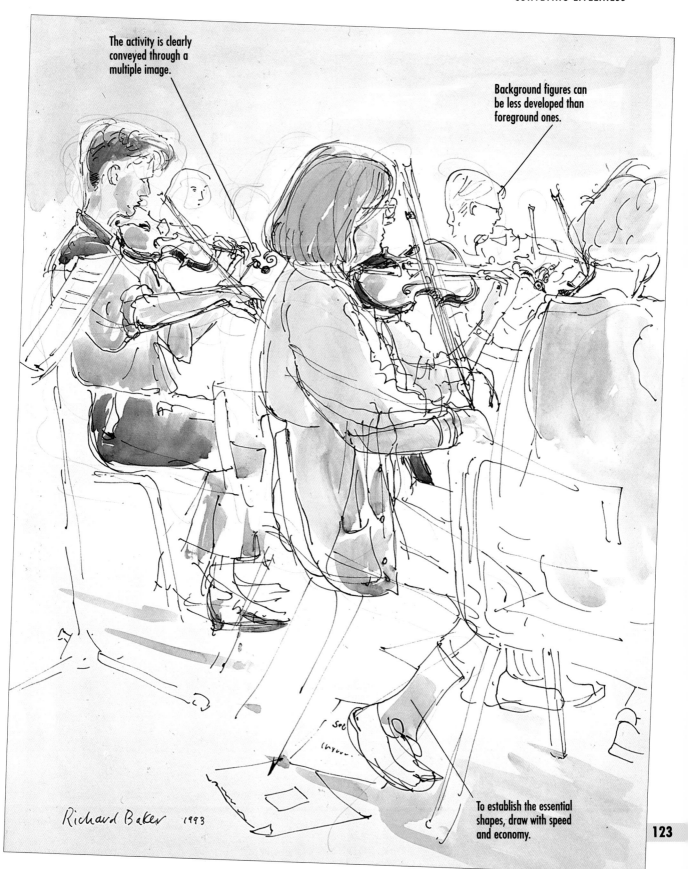

The activity is clearly conveyed through a multiple image.

Background figures can be less developed than foreground ones.

Richard Baker 1993

To establish the essential shapes, draw with speed and economy.

Getting the Effects You Want

A broad approach is healthy when learning to draw; everything is grist to your mill, and new areas of study open up possibilities constantly. As you gain experience, making random studies will provide enough material for you to achieve a more economical effect. Selection for emphasis is a key skill in getting the effects you want, and once you have eliminated the inessentials you will be free to establish descriptive detail in the areas where you want to focus interest. Fine drawing should be succinct, so omit unnecessary details as you transpose a sketch. If you choose a different scale, remember to square it (see page 13), and be ready to amend a faulty composition. Never practice these techniques on your original drawing, as this is your only source of reference once your sitter has gone. Keeping your original study means that you can try again if the next version is unsuccessful.

LOOKING AT COMPOSITION

The ability to compose a drawing, particularly where there are complex groupings, crowd scenes, or landscapes with figures, is best learned from a good role model, and the following exercise shows how an effective composition works. Fix plastic film over a reproduction of an admired artist's work that is large enough for you to see the main elements of the picture. Then use a colored marker to trace out the two-dimensional, or flat, plan. Trace the tonal scheme and main verticals, horizontals, and diagonal movements, using different colors or separate sheets of film, and make a color study, if necessary. Don't copy the reproductions, but use your discoveries about their layout to compose your own works.

REFERENCE STUDIES

Because it is not always possible to finish studies of moving figures, make your sketches on one side of a sketchbook so that you can refer to them easily later on.

In order to combine your sketches and fragments effectively at a later time, make sure that you keep the same vantage point and draw them from the same eye level.

ASSEMBLED CROWD SCENE

Although you may not have seen the actual crowd or group, the observed information used in creating it has the stamp of authenticity. You are also able to edit out unwanted detail.

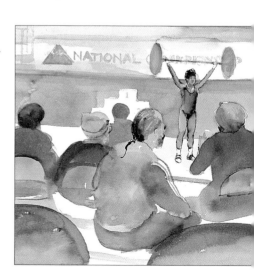

EXAMINING A COMPOSITION

Choose a reproduction or postcard and study the picture as explained on page 124, using a single sheet of plastic film for each aspect of composition, and tracing the relevant information with a colored alcohol-based marker.

The main movements through the composition.

The two-dimensional layout, or flat plan.

The tonal scheme, shaded in appropriate strengths.

CHOOSING YOUR EMPHASIS

If you attempt to record every minute detail, you will lose the character of your sitter. Instead, decide on the impression you wish to create and then concentrate on emphasizing those aspects, while simplifying the unimportant details.

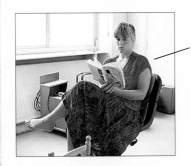

Remember that a camera cannot record exactly what is seen by the eye. Its mechanical image lacks the artist's ability to make a selection for emphasis from the constituent parts.

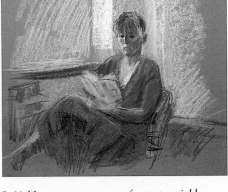

1 *Unlike a camera, you can focus at variable distances in the same sketch, and can choose to simplify much anecdotal detail, such as a distracting pattern on a garment or other fabric.*

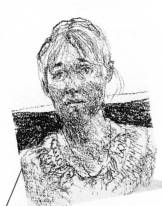

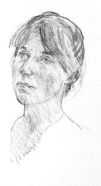

Because your first preliminary sketch should be more concerned with structure than with likeness, concentrate at this stage on the form and the bone structure of your sitter.

You can make further sketches to examine the tones that represent color, to look at the surface elements, such as skin, and to give more attention to the detail of the features and hair.

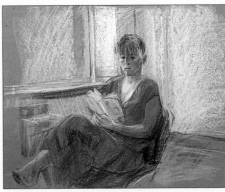

2 *By strengthening some elements and playing down or omitting others, you can create a dynamic design that leads the eye to the central focus of attention, the sitter.*

Selecting Your Subject

WORKSHOPS

* Choosing a stimulating view

* Simplifying evaluation by using a single medium

* Omitting aspects that are lifeless or incidental

If you are working with a friend or relative, the most difficult choice will not be which person to draw, rather, your decision will be about choosing a pose, that enables you to capture the view you want; if necessary try a few rough sketches first. Once your model is comfortable, you will need to examine him or her from various angles, then adopt the view that you find the most stimulating, well-balanced or dramatic, depending on your focus. Your task will be easier if you draw on a larger scale, as you will need room to note down all the information you can gather. Once you have two or three comprehensive drawings in which you have explored different aspects of your model, you will be able to make a wise choice for a major study.

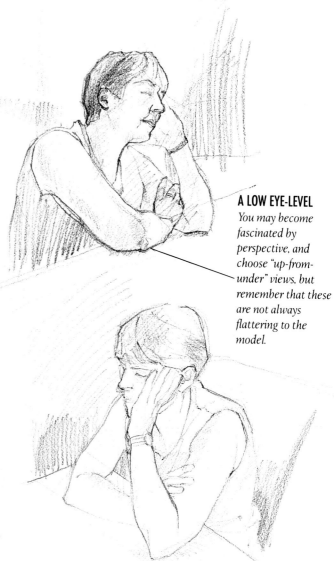

A LOW EYE-LEVEL
You may become fascinated by perspective, and choose "up-from-under" views, but remember that these are not always flattering to the model.

A THREE-QUARTER REAR VIEW
Although the extreme foreshortening gives interest to the head, the large area of blank body shape may cause you to reject a view such as this. (Drawings by Ian Fellows.)

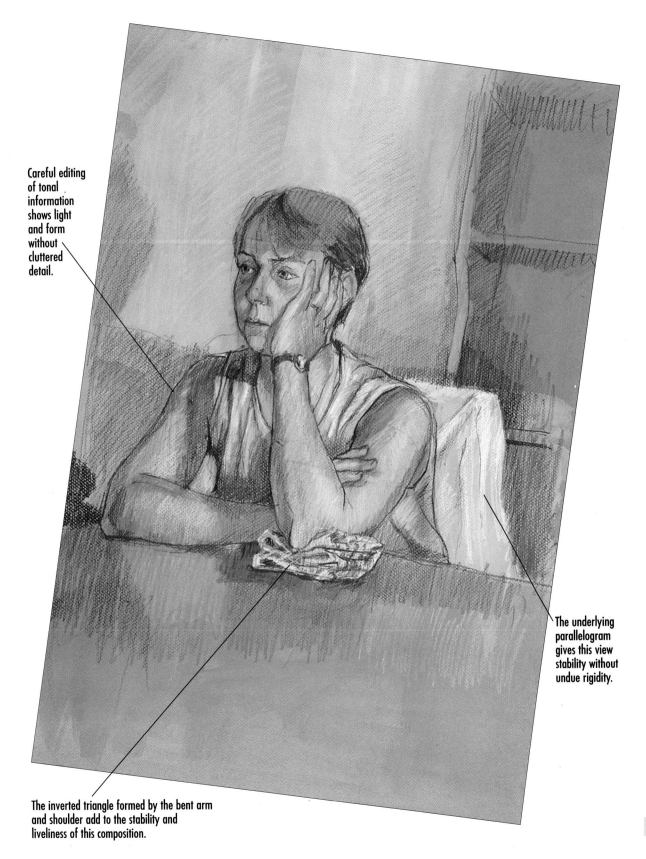

Careful editing of tonal information shows light and form without cluttered detail.

The underlying parallelogram gives this view stability without undue rigidity.

The inverted triangle formed by the bent arm and shoulder add to the stability and liveliness of this composition.

Reference File

The photographs in this section give you the chance to look at two-dimensional images of some of the subjects you see in the round, so study them well. They contain mechanical selections from the reality of three dimensions, but because they are flat, they enable you to examine the shapes and dimensions that you sketch when you work with living sitters. There is also the chance to inspect the images at leisure, looking for as long as you need to understand such matters as body balancing or foreshortening, without the pressure of keeping a sitter in a strenuous pose or of offending a stranger by staring at them. Remember, though, that photography can only provide a limited amount of information, and restricts tones in particular.

MAKING A START

If you decide to build up confidence by sketching from this section before working with a living person, keep this to a minimum; the real fun starts when you are face to face with your sitter and have on hand a wealth of visual information to draw on and to use. If you are immobile or have no sitter, use a mirror and draw the most obliging sitter of all—yourself. Happy sketching!

THE FIGURE IN MOTION

The British photographer Eadweard Muybridge (1830-1904) was born Edward James Muggeridge, but later changed his name to the one by which he is now best known. Muybridge lived in the USA from the 1850s, and was the first photographer to study the moving figure through rapid-exposure photographs. By freeze-framing movements that pass in a fraction of a second, he was able to reveal the exact positions of different parts of the body in action. Muybridge studied birds and animals as well as humans. For example, the series of animal locomotion photographs, which he made in the 1870s in the United States, proved that during the process of

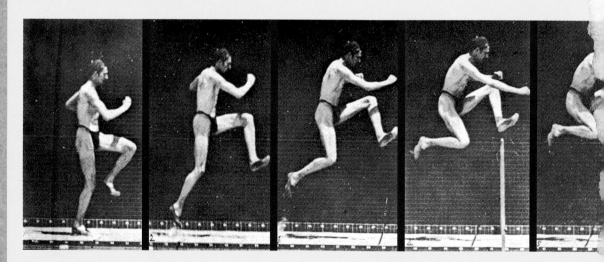

A single photograph cannot provide the reference material available from multiple timed exposures (see below), and can appear stiff and awkward. By contrast, studies of moving groups can be assembled from drawn fragments or from different scenes; here, observation lends accuracy and authenticity.

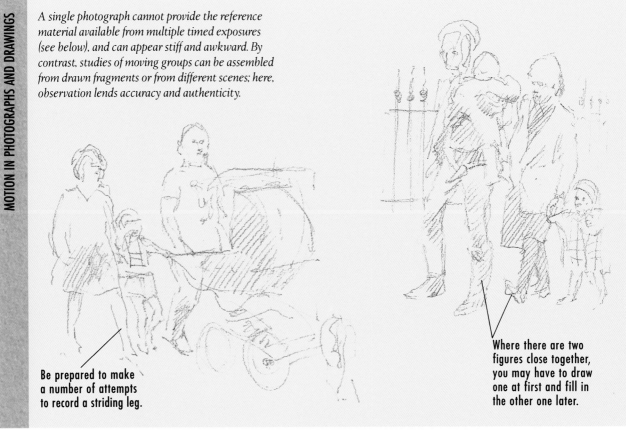

Be prepared to make a number of attempts to record a striding leg.

Where there are two figures close together, you may have to draw one at first and fill in the other one later.

trotting there are moments when all of a horse's hooves are off the ground. In 1881, he invented the 300" zoöpraxiscope, a device which projected animated pictures onto a screen, and was the forerunner of the movie camera. Muybridge's work made a revolutionary contribution to our understanding of sequential movement, such as walking or running, since the individual actions that make up the sequence occur too quickly to be perceived by the naked eye. Of his books, his *Animals in Motion*, first published in 1899, was of particular importance to artists as it showed thousands of men, women, and children, as well as animals, in action.

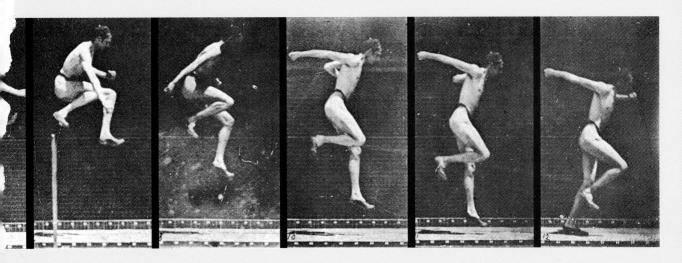

Male figures

The conventional, "ideal" male figure is wedge-shaped—broad at the shoulder and narrow at the hip. However, men and boys come in all shapes and sizes, so look for any number of variations. Small boys may be scarcely different in size from little girls, but adult males are taller on average than grown women, and have a heavier upper body than a woman of the same height. When drawing a portrait, note the stronger neck and heavier jaw on adult males; the other main physical difference is the lockable male forearm, carried at a different angle from that of a woman.

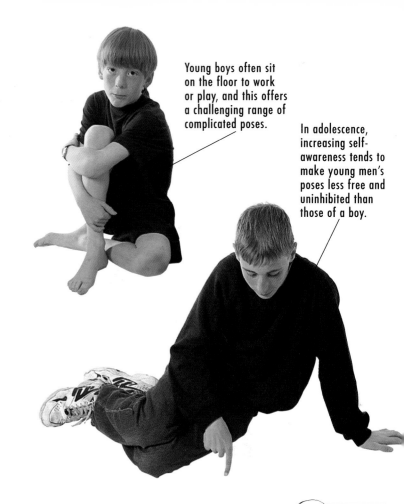

Young boys often sit on the floor to work or play, and this offers a challenging range of complicated poses.

In adolescence, increasing self-awareness tends to make young men's poses less free and uninhibited than those of a boy.

MALE PROPORTIONS

The head can be used as a unit of measurement in estimating proportions. When an adult is standing upright, with no foreshortening, it is a generally accepted rule that his body is approximately 7½ heads long. However, a baby is born with its head relatively larger than its body. As the child grows its head becomes relatively smaller in proportion to overall height.

| Infant | Toddler | Older child | Adolescent | Adult |

THE MALE TORSO

At some angles, the male figure's comparatively heavy shoulders and upper arms can make the torso appear slighter than it really is.

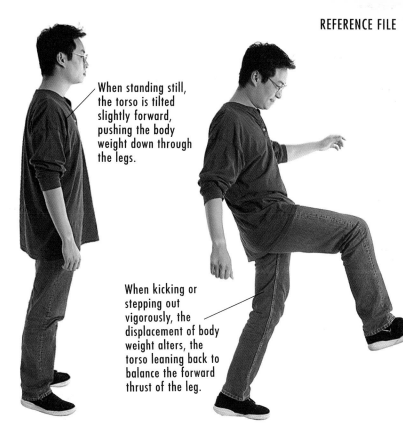

When standing still, the torso is tilted slightly forward, pushing the body weight down through the legs.

When kicking or stepping out vigorously, the displacement of body weight alters, the torso leaning back to balance the forward thrust of the leg.

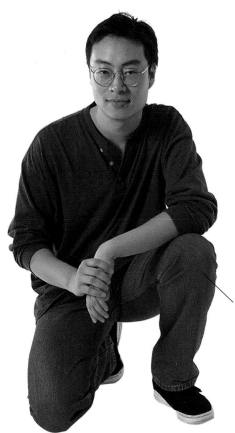

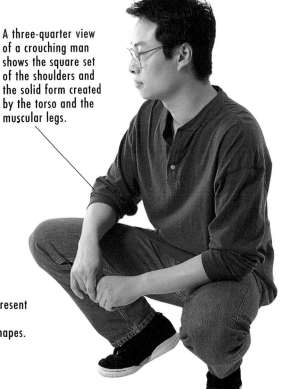

A three-quarter view of a crouching man shows the square set of the shoulders and the solid form created by the torso and the muscular legs.

Seen front-on, kneeling men present largely square, angular body shapes.

Female figures

Infants and young girls are often taller than their male equivalents, but adult females are usually shorter than men. Female figures in general display less muscle definition than more angular male ones, and while the upper body is heavier in men, women's body weight tends to be concentrated in the lower part, often around their hips.

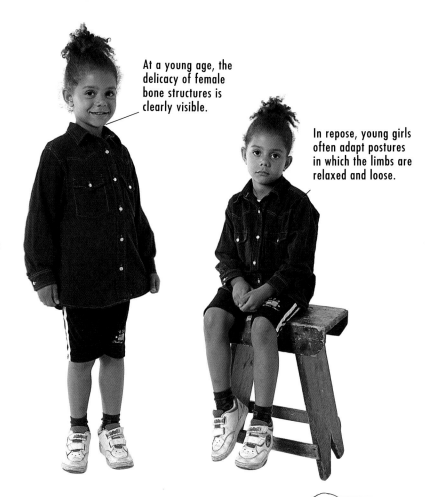

At a young age, the delicacy of female bone structures is clearly visible.

In repose, young girls often adapt postures in which the limbs are relaxed and loose.

FEMALE PROPORTIONS

The head can be used as a unit of measurement in estimating proportions. When an adult is standing upright, with no foreshortening, it is a generally accepted rule that her body is approximately 7½ heads long. However a baby is born with its head relatively larger than its body. As the child grows its head becomes relatively smaller in proportion to overall height.

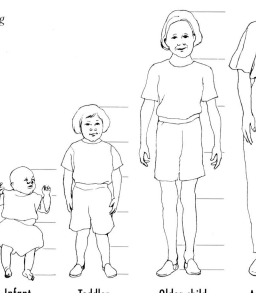

| Infant | Toddler | Older child | Adolescent | Adult |

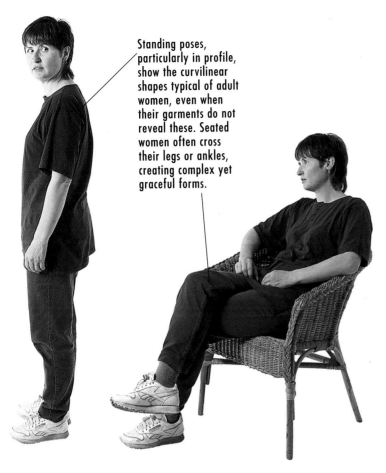

Standing poses, particularly in profile, show the curvilinear shapes typical of adult women, even when their garments do not reveal these. Seated women often cross their legs or ankles, creating complex yet graceful forms.

Women's arms are rounded, tapering progressively toward the wrists.

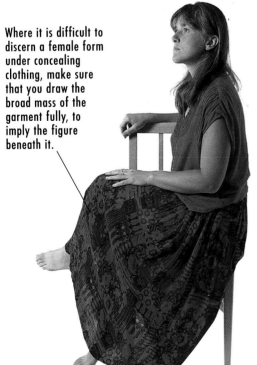

Where it is difficult to discern a female form under concealing clothing, make sure that you draw the broad mass of the garment fully, to imply the figure beneath it.

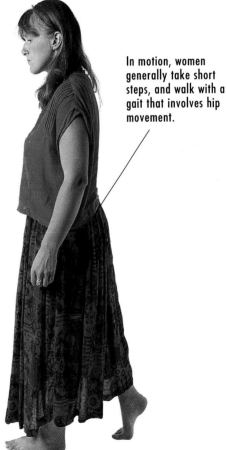

In motion, women generally take short steps, and walk with a gait that involves hip movement.

133

Hands and arms

There is a great variety in hands and arms to be observed and depicted. Baby hands have tiny palms and fingers, and children's fingers are relatively small compared to those on a fully grown hand. Adult palms can be broad or narrow, and fingers come in all types, from tapered to spatulate, and can be bony and broad-knuckled, fine, and well-fleshed. The condition of the hands and the muscle development of the arms indicate age and occupation as much as gender, and their arrangement can say much about character and mood.

The length of children's fingers, in relation to the rest of the hand, changes as they grow, becoming longer with age.

Don't forget to look carefully at the shape and color of the nails.

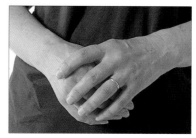

The fingers of one hand folded over another form a gently curved, cupped shape.

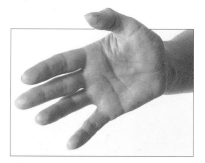

The angle between the thumb and the hand varies from one individual to another.

When drawing both arms, make sure that you treat them as a pair, not as two single limbs. Although they may hold the same pose, look out for any asymmetry.

Seen in profile, the arm tapers toward the wrist and the hand toward the fingers. This also shows the articulation of the fingers within the grip or the knuckle joints.

The negative space between the neck and the inner edges of the upper and lower arm defines the gentle curves of the forms. The female arm is generally slimmer and more delicate in shape, particularly between wrist and elbow, than that of the male.

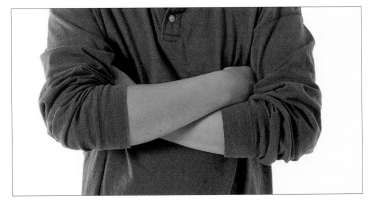

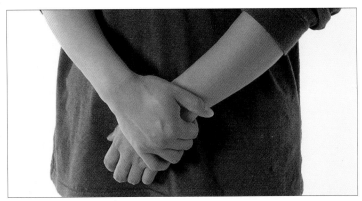

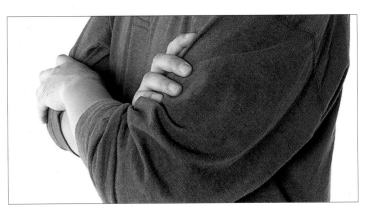

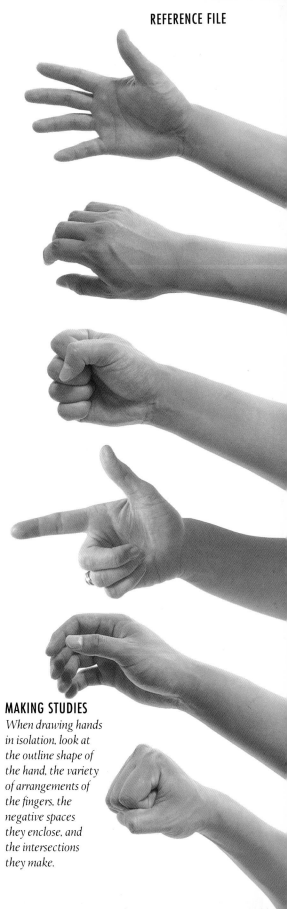

MAKING STUDIES

When drawing hands in isolation, look at the outline shape of the hand, the variety of arrangements of the fingers, the negative spaces they enclose, and the intersections they make.

Legs and Feet

Legs are our largest limbs and our feet are the carriers of our body weight. Make many studies of different legs and feet as these parts are not a uniform shape on every individual. Watch out particularly for foreshortening, which can create extraordinary shapes when looking along or down at legs, shortening the apparent length but still giving a view of the full width (see pages 74–5). Hirsute legs offer the chance to describe different textures; remember that you do not have to draw every single hair.

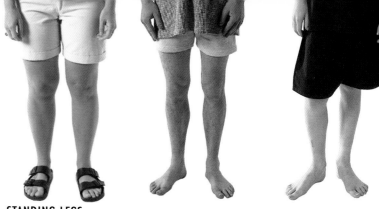

STANDING LEGS

Age, gender, and body type all have an influence on the length and shape of an individual's legs.

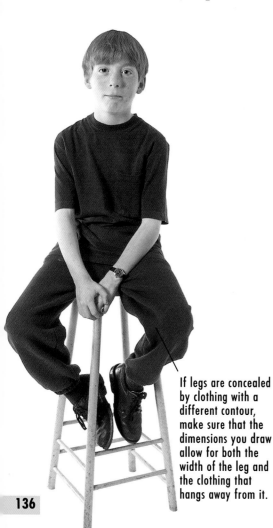

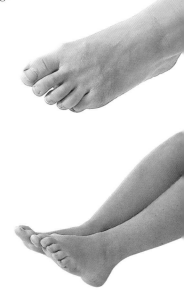

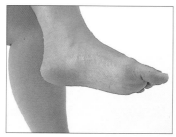

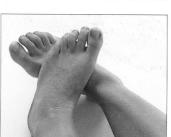

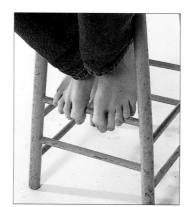

If legs are concealed by clothing with a different contour, make sure that the dimensions you draw allow for both the width of the leg and the clothing that hangs away from it.

FOOT STUDIES

Draw sketchbook studies of feet in as many positions and angles as possible. Note how quickly the contours change in profile, and how foreshortening reduces leg length.

TOES

Most people's toes taper from the big toe in an arc to the little toe, but there are many individual variations. The second toe is sometimes comparatively long and protrudes beyond the others.

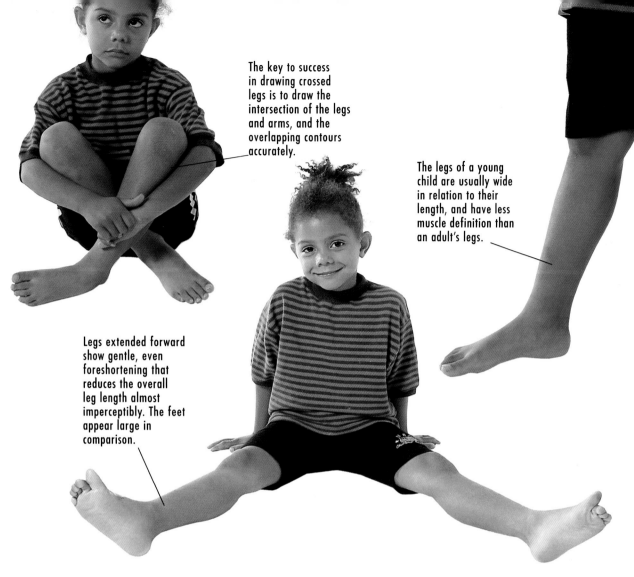

The key to success in drawing crossed legs is to draw the intersection of the legs and arms, and the overlapping contours accurately.

The legs of a young child are usually wide in relation to their length, and have less muscle definition than an adult's legs.

Legs extended forward show gentle, even foreshortening that reduces the overall leg length almost imperceptibly. The feet appear large in comparison.

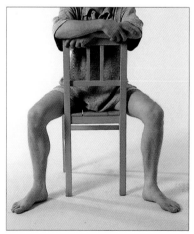

RELATED FORMS

Always draw legs with, and in relation to, any associated furniture; don't treat either in isolation.

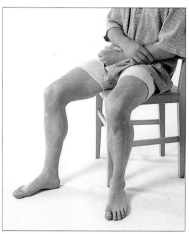

DIFFERENT PROFILES

In a three-quarter seated view, expect to see one leg in profile and the other with a foreshortened thigh.

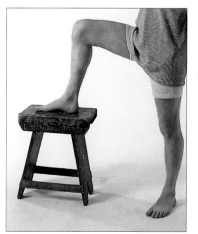

USEFUL SPACES

Use negative spaces in a positive way. For this kind of pose, draw the gap made by the legs and stool first.

Heads and necks

Although we may expect a sitter to look straight at the artist, many interesting character sketches can be made from three-quarter or even rear views. A sitter returning the viewer's gaze indicates positive interaction, while averted eyes give the subject a more passive role, possibly because he or she was not aware of being drawn. Concentrate on achieving a good likeness before you become entangled in details or adjustments.

If you are unable to see the features, draw what blocks your view, in this case an elaborate and concealing hairstyle.

Use the framing effect of hair to set off a face and to position the features in relation to each other.

You must work quickly to catch fleeting expressions. Smiles and laughter usually last longer than scowls or frowns.

When looking down at your sitter pay attention to perspective, which accentuates the apparent curvature of features around the form of the head.

Make sure that you resist the temptation to draw an outline on its own and then fill in the rest. Better results follow when you draw across the whole head as you go along.

Seen in perspective, the lenses of eyeglasses appear foreshortened, and the side of the face turned away is also reduced in width.

Even when a head is almost completely turned away from view, the features are recognizable from the tiny amount visible.

Seen from the rear, the ear is an important feature, so draw it accurately, paying attention to perspective.

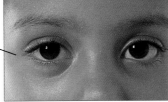

When sketching the eyes of children or young people, look to portray their smooth, unlined appearance.

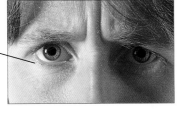

Fleeting expressions etch temporary lines on a young face, but over time they may make deep creases in an older one.

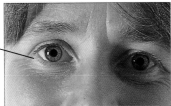

Creases, folds, and pouches around the eyes lend the stamp of character to a sketch, but be sure not to exaggerate them.

You can use the shape and growth of short hair to show form and direction on the nape of the sitter's neck.

With long hair, you can create decorative effects with curls, tendrils, and locks, but you have to imply the unseen neck.

Because of its surface gloss, smooth, well-brushed hair often displays considerable variations in tone.

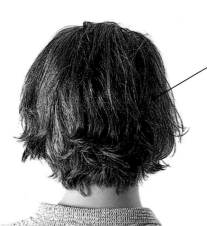

Drawing a sitter with unkempt or unruly hair is a good challenge in capturing shape and form.

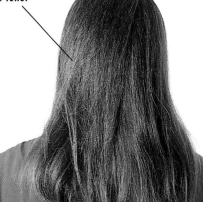

Gravity and Balance

Take some time to study the poses shown here, noting the body's natural inclination to keep in balance. The slightest departure from the perpendicular calls for adjustment of the hips, shoulders, and feet, and movement of the arms and legs to counter a loss of balance. When drawing a standing figure, begin by observing whether the weight is on one or both legs.

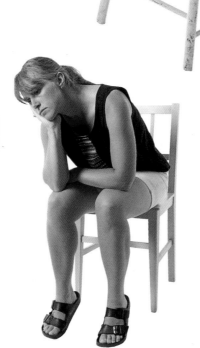

Because the heavy upper part of the torso is inclined forward, a figure perching on a seat uses the feet for stability and comfort.

Make quick sketches from different angles of a sitter in seated poses. These reveal the many aspects of balance, and make for lively drawings.

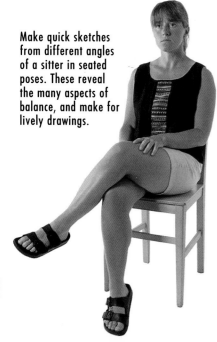

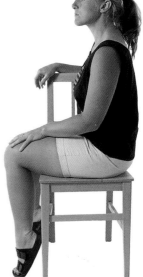

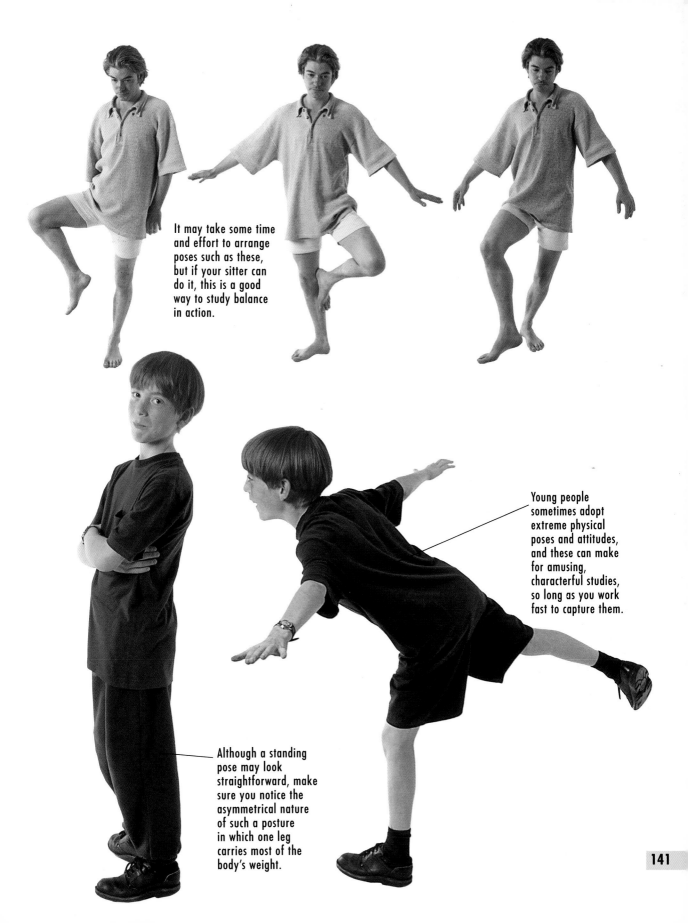

It may take some time and effort to arrange poses such as these, but if your sitter can do it, this is a good way to study balance in action.

Young people sometimes adopt extreme physical poses and attitudes, and these can make for amusing, characterful studies, so long as you work fast to capture them.

Although a standing pose may look straightforward, make sure you notice the asymmetrical nature of such a posture in which one leg carries most of the body's weight.

141

Index

Credits

DEDICATION
For my dear brother Jim, with thanks for all his loving support.

The publishers would like to thank all the models who participated in this book: Mr and Mrs Astling, Sebastian Bertrand, Samantha Bloom, Kelly Burgess, Deborah Cole, Tom and Matthew Collis, Ricky Cook, Penny Dawes, Anselm Duprey, Moira Govan, Selina Hall, Joanne and Alice McCain, Nina Nauth, Anna Parker, Sherri Tay, Isabella, Duval and Miles Timothy and Stephen Tse.

In addition the publishers would like to thank the following artists who submitted work for inclusion in the book:

Key *a* above, *b* below, *c* center, *m* middle, *r* right, *l* left

Richard Baker 76*l*, 88*a*, 113*al*; Susie Balazs 85*br*; Harry Bloom 81*r*, 83*r*, 88*br*, 91*a*, 112*a*; Poddi Clack 121*br*; Peter Clossick 29*al*; Stephen Crowther 32*a*, 49*a*, 57*bl*, 71*a*, 96*br*, 99*al*, 99*ar*, 108; Doug Dawson 51*ar*, 93*ar*, 94*ar*; Deborah Deichler 60*br*; Ian Fellows 100; Renee P. Foulks 80; Ruth Geldard 12*a*, 23*ar*, 25*r*, 67*bl*, 85*bl*, 105*ar*, 105*cl*; Tracey Gilbert 75*a*, 81*b*, 86*c*, 94*br*, 109*b*, 116*a*, 116*b*; Nick Hersey 19*bl*, 27*ar*, 27*b*, 28*br*, 47*al*, 50, 79*al*, 79*bl*; Terry Longhurst 12*al*, 77*bl*, 92*al*; John McFaul 54, 55*b*, 85*cl*; Ray Mutimer 63*al*, 84*a*; Jodi Raynes 22*br*, 25*bl*, 112*b*; Ann Roach 31*a*, 58*c*, 67*al*, 74*br*, 85*al*; Urania Christy Tarbet 96*ar*; James Harvey Taylor 73*al*, 105*br*, 120*a*; Janis Theodore 23*cl*, 81*cl*; Tig 9, 34, 35*a*, 121*r*; Yukihiro Tsujita 29*br*, 51*al*, 52*ar*, 52*bl*, 52*ac*, 53*ar*, 73*bl*, 74*ar*, 78; Barbara Walton 113*bl*; Judy White 63*bl*, 71*b*; Valerie Wiffen 6*b*, 8*a*, 8*b*, 22*ar*, 24*l*, 25*al*, 26*br*, 26*cr*, 27*al*, 28*ar*, 32*b*, 35*b*, 46*al*, 46*ar*, 46*b*, 47*cl*, 47*mc*, 47*cr*, 49*bl*, 49*bc*, 49*br*, 53*bl*, 55*ar*, 55*br*, 57*al*, 57*ac*, 57*ar*, 58*ar*, 59*al*, 59*ar*, 61*ar*, 61*bl*, 62*al*, 62*ar*, 62*br*, 64, 75*b*, 77*a*, 81*al*, 81*ar*, 83*l*, 87, 89, 90*ar*, 91*b*, 92, 95, 97, 98*ar*, 109*a*, 109*c*, 113*r*, 117*al*, 124, 125; Brian Yale 105*cr*; Marnie Yuen 12*br*, 30, 33, 48*al*, 48*ar*, 48*b*, 56*a*, 56*c*, 56*br*, 59*c*, 59*cr*, 59*bl*, 99*b*, 104*c*, 111*cl*, 117*ar*, 117*cr*, 117*bl*

Finally, the publishers would like to thank Dorothy Frame for the index.